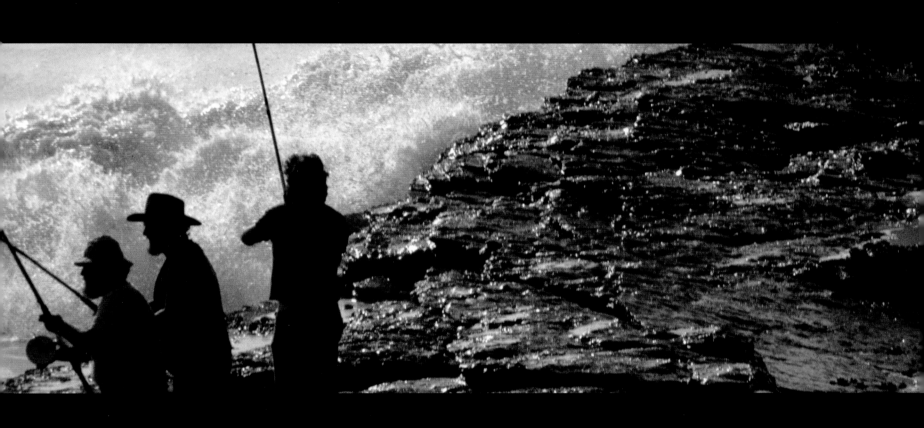

CHRONICLE BOOKS
SAN FRANCISCO

Photography by Hal Lauritzen

MARIN

Text by Beth Ashley

I would like to dedicate this book
to the memory of two fine and stalwart friends,
both lifelong Marinites,
who recently left us much before their time,
but not until leaving us the richer
for having shared their lives with us.

Bob Rossi and Dave Deetken
saw Marin as it was and as it is.
I think they would have appreciated this book.

H. L.

This book was supported
through the generous assistance of :

The Professional Division of the Eastman Kodak Company
The Nikon Corporation
The New Lab of San Francisco

Text copyright © 1993 Beth Ashley
Photographs copyright © 1993 Hal Lauritzen

First paperback edition 1996.

Library of Congress Cataloging-in-Publication Data
Ashley, Beth.
 Marin/by Beth Ashley: photography by Hal Lauritzen.
 p. cm.
 Includes index.
 ISBN 0-8118-1424-6
 ISBN 0-8118-0022-9 (hc)
 1. Marin County (Calif.)—Guidebooks. 2. Marin County
 (Calif.)—Pictorial Works.
 I. Lauritzen, Hal. II. Title.
 F868.M3A78 1993
 917.94'620453—dc20 93-2678
 CIP

Printed in China

Edited by Carey Charlesworth
Map illustration by Rennea Couttenye
Book and cover design by Adelaida Mejia Design, San Francisco

Distributed in Canada by Raincoast Books
8680 Cambie Street
Vancouver, B.C. V6P 6M9

10 9 8 7 6 5 4 3

Chronicle Books
85 Second St.
San Francisco, CA 94105

www.chroniclebooks.com

BODEGA BAY
DILLON BEACH
TOMALES
TOMALES BAY
MARSHALL
INVERNESS
TOMALES POINT
POINT REYES STATION
OLEMA
POINT REYES
DRAKES BAY
GULF OF THE FARALLONES
POINT REYES NATIONAL SEASHORE
PACIFIC OCEAN
BOLINAS
BOLINAS RIDGE
STINSON BEACH

SONOMA COUNTY
MARIN COUNTY
PETALUMA
SONOMA MOUNTAINS
BLACK POINT
NOVATO
NICASIO
IGNACIO
SAN GERONIMO VALLEY
FAIRFAX
SAN ANSELMO
ROSS
KENTFIELD
GREENBRAE
LARKSPUR
CORTE MADERA
MT. TAMALPAIS STATE PARK
MILL VALLEY
MARIN CITY
MARIN HEADLANDS
SAUSALITO
POINT BONITA
HAMILTON AIR FORCE BASE
CHINA CAMP
McNEAR'S BEACH
SAN RAFAEL
SAN QUENTIN
TIBURON BELVEDERE
ANGEL ISLAND
SAN FRANCISCO
101
1

CONTENTS

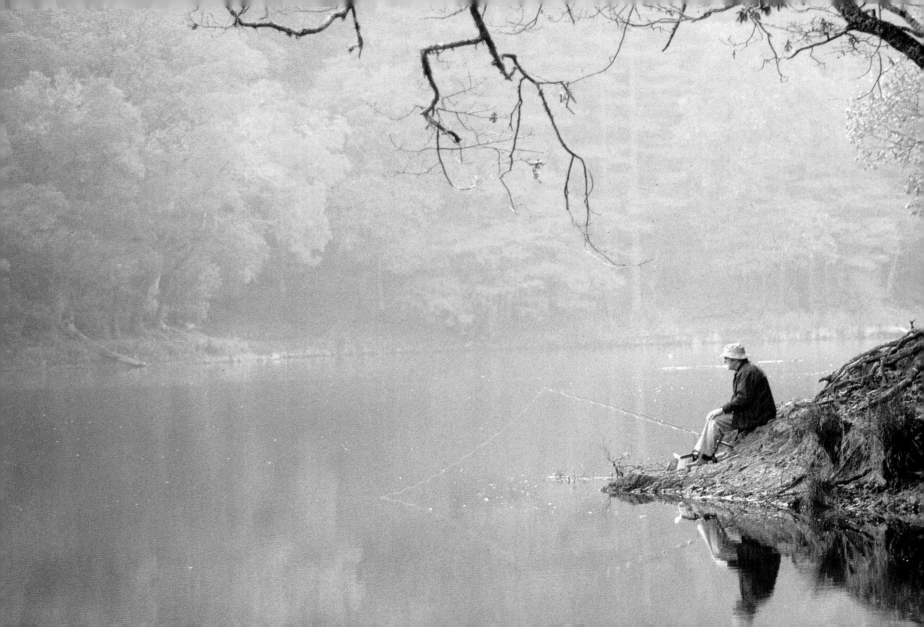

FOREWORD

This book originated in the mind's eye—and camera lens—of Hal Lauritzen, who has been photographing Marin County for years and who got the impassioned idea that something must be done to preserve its natural glories. He decided to create this book, as a vehicle for showing off Marin's great beauty, and as a rallying point for those who would keep it unspoiled.

Hal and I met in the spring of 1991 on a press tour of the Russian Far East. He mentioned that his book was well under way and I was immediately mournful. "Oh, I wish we had met sooner," I said. "I would have loved to write that book." I had been writing about Marin County for seventeen years as a reporter for the *Marin Independent Journal*. I have lived here since the 1940s, and my love for the county goes deep.

A few months later, Hal phoned to ask if I were still interested, and together we began this memorable project. For Hal, much of the work was already done: he had thousands of slides, taken over a period of years. He sorted through for favorites, and looked for blank spots in his collection. Then out he went, Nikon in hand, to grab yet one more evocative, affectionate shot. For me, writing the book meant exploring Marin from one end to the other by car, on foot, and in the stacks of the California Room of the county library. When I needed help, I got it from a raft of willing Marin residents, who met me in bistros and coffee shops for breakfast, lunch, and dinner or welcomed me into their homes. Don Deane and I sat on bar stools at Smiley's saloon in Bolinas. Peter Behr and I walked the gardens of his Inverness home. Phil Frank met me for early morning coffee at Sausalito's Caffe Trieste. I pestered dozens of people by phone—for population statistics, information on wildflowers, the latest word on development plans for Hamilton Air Force Base—and quizzed the rangers at the Headlands, Point Reyes National Seashore, and Angel Island to the point of mutual exhaustion. My data filled dozens of notebooks, hundreds of scraps of paper. The entire project was a joy. More than once I found myself smiling in sheer pleasure over what I was writing about. Though I groaned at the inadequacy of my words, the finished manuscript brought great satisfaction. It is a small love offering to the county that has given me so much—wonderful people, indelible beauty, a lasting home. I am forever grateful to Hal Lauritzen.

—Beth Ashley

INTRODUCTION

Places, like people, have their fifteen minutes of fame.

In 1978, Marin County—then a little-known enclave across the Golden Gate Bridge from San Francisco—was thrown into the national spotlight by an NBC television special on what purported to be Marin's self-indulgent lifestyle, "I Want It All Now."

Home screens showed images of the California dream in extremis: kids who went to birthday parties in limousines, couples more likely to divorce than stay married, a population of lotus-eaters who indulged themselves with hot tub parties and peacock feather massage. The response from residents was immediate and outraged.

Some Marinites threatened to sue the program producers, and a member of the Marin Board of Supervisors demanded equal time for "the real people" who live here. The protesters said the Marin they loved was entirely different from the one NBC depicted—it wasn't a place of fads and high-priced fancies, but an area of surpassing natural beauty, crisscrossed by hills and surrounded on three sides by water. If NBC wanted symbols, the right one was not a hot tub, but Mount Tamalpais, Marin's most visible and best-beloved landmark, which looms over much of the landscape.

If Marin had its share of sybarites, they continued, that should not be surprising: who wouldn't want to live here, including the idle rich? Marin, after all, sits next door to a sophisticated, world-famous city but is far enough from the urban rat race to contain huge redwood forests, wild beaches, and fields full of cows. From the mansions of Ross and Belvedere to the hideaway cabins of the San Geronimo Valley, Marin is home to a wide spectrum of people: beach bums and artists, gays and straights, churchgoers and hippies, homeless people, working stiffs, and people whose other car is a vintage Rolls Royce.

Outsiders might characterize Marin as the epitome of California hipness, but for its residents its charm lies in its eclecticism. It is home to dozens of distinct communities and a hundred different lifestyles, each adding color to an already rich landscape. It has one of the world's most famous movie studios, Lucasfilm, at Skywalker Ranch; it has one of California's best whale-watching vistas, at Point Reyes Lighthouse. Marin has everything, the residents say: high tech and a rich history, urban amenities and unspoiled wilds.

Marin's first residents were Indians; the next, Franciscan padres from Mexico. Every Marinite knows Mission San Rafael Arcangel, where the county's recorded history began, and each takes pride in other artifacts of the county's variegated past, from Indian digs to the several beaches where Sir Francis Drake may—or may not—have landed in 1579.

By most standards, Marin's history is not very old. Serious settlement began with the first Mexican land grants in the middle of the last century. Its first industries—timber, a brickyard—were established during the boom of the Gold Rush. By the turn of the century, Marin had become a refuge for San Francisco's rich, who built Victorian mansions on the hillsides of Belvedere and Sausalito and railroads to link the south part of the county with coast resorts and timber companies in the north.

Until 1937, Marin was a rural enclave, a distant adjunct to the city across the bay. The only access to San Francisco was by ferry from Sausalito; the most direct route to the East Bay was by ferry from San Rafael. But distances telescoped when the Golden Gate Bridge was opened in May 1937, and Marin became a bedroom community for the city beyond. World War II changed things even more; a shipyard rose on the shore of Sausalito, and hundreds of out-of-state workers came for the duration and stayed for the rest of their lives.

In the half-century since the war ended, Marin has blossomed. It has become—if home prices are any measure—one of the world's most desirable places to live. The corridor from Sausalito to Sonoma County, its border to the north, has filled up with subdivisions, condo communities, high-tech businesses, and shopping malls. In recent years, concerned citizens have warned that Marin hillsides might be leveled for landfill, its farmlands wiped out by developers, its open space paved over for homes.

Yet beyond the urban corridor, stretching north to south along Highway 101, the county remains an untamed paradise. By some miracle of citizen forethought and fortitude, more than 40 percent of Marin County land is in permanent open space—parks and forest and public seashore. Ninety-six thousand more acres are in agricultural use.

Gary Giacomini, a Marin old-timer and veteran politician, thinks it was the hills that made present-day Marin. "The hills divided one town from another, so each could develop its own character." The mountain ridge that divides Marin's urban east from the great rural expanse of the west "kept development from spreading to the coast until we all got smart enough to save it."

Peter Behr, Marin's elder statesman and onetime state senator, believes Marin was saved from overdevelopment because the Golden Gate Bridge came so late. When the rest of the world discovered Marin, he said, it was still rural "and thus became more beloved."

Behr credits a long line of private conservationists and enlightened public figures for keeping so much open space. Talking in his Inverness home, he remembered the battles almost wistfully: "The things we had to fight for are now taken for granted."

Marin is the most environmentally conscious of California's counties, Behr said, and "the hub of a growing wheel" nationwide.

For all the love lavished upon it, Marin isn't perfect; recent years have brought trouble to paradise. Traffic has turned to gridlock on the main roads, the cost of housing has grown prohibitively, and a statewide drought—that seemed to have broken by the mid-1990s—brought years of water rationing for most of the residents.

Residents grapple continuously with the question of development versus status quo, new highways and apartment houses versus the countrylike ambiance they yearn to preserve. Most of the time, when push comes to shove, they vote not to change. They love Marin as it is, and defend it with their votes, their time, and when need be, their wallets.

A decade and a half after television reduced its riches to satire, Marin enjoys a new kind of celebrity: visitors come to marvel, not to ridicule. Thousands of tourists arrive every year, on Gray Line buses, convention excursions, and sightseeing tours from Japan. They come over the Golden Gate Bridge, one of the world's most glamorous portals, and pass through the Rainbow Tunnel, a painted arch over the entrance highway. Beyond the rainbow lies Marin, in eye-popping glory: waterfront towns, homey villages, vast dairy ranches, a picture-book mountain, the wilderness next to the sea.

Visitors love what they see, but no one loves it more than those who have come and stayed.

They are blessed and they know it: they live in Marin.

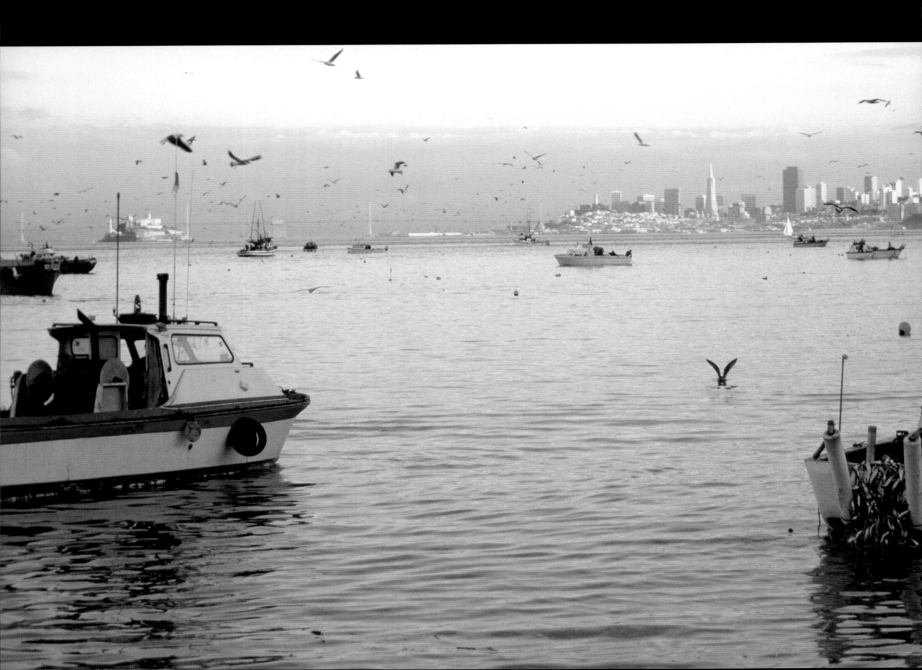

Sausalito is so lovely to look at that people are sometimes surprised to find, beneath all the glamour, a genuine town. What looks like a Mediterranean resort to outsiders is in fact a small village with a proud history and fiercely loyal residents.

SAUSALITO

It's easy to see why visitors confuse appearance with reality. From offshore, as you approach aboard a ferryboat from San Francisco, Sausalito has the postcard charm of the Cote d'Azur: houses and trees perched on a steep hillside, a waterfront lined with boutiques and restaurants, and sailboats bobbing on the tide.

No wonder tourists flock here, their cameras cocked and their wallets open. A long stretch of the downtown is dedicated to their pleasures: art galleries, novelty stores, upscale eating spots, and fairytale views of the San Francisco skyline.

The residents, however, have retained much of Sausalito for themselves. They have kept their favored hangouts, their private festivals, even their own shops, on a side street just a stone's throw from the tourist track on Bridgeway, the city's main drag. The people who live here know that the town's real charms are in its neighborhoods, its laid-back lifestyles, its people.

Sausalito has attracted an improbable mix of residents in its two-hundred-year history. The first visitor was probably the Spanish skipper Don Juan Manuel de Ayala, who anchored offshore in 1775 and took water from Sausalito's plentiful springs.

The first settler was William Richardson, a British seaman who jumped ship in San Francisco in 1822 and went into business as a trader. In Sausalito, he built a waterworks from which he sold fresh water to sailing ships resting in the bay. In 1836, the Mexican government gave him title to all the lands from the Marin Headlands to Stinson Beach. On a hill above Whaler's Cove in southern Sausalito he built the first house in town, a one-room adobe hacienda.

Other settlers came, particularly during the Gold Rush, but few stayed permanently. Among the first longtime settlers were British sea captains, whose ships carried grain to the Orient but spent months at a time in San Francisco Bay.

The British were Sausalito's first society, according to town historian Jack Tracy, who wrote *Moments In Time*. "The British pulled out all the stops for visiting captains and relatives," Tracy wrote, "(with) champagne suppers at the yacht club or in comfortable villas, musicales and impromptu theatricals." You can still sense a British aura to the hillsides where they built their homes: winding streets, hidden gardens, stone walks and tree-shaded stairways linking one part of town to another. Some of their homes still remain, wood-shingled mammoths, with turrets and porches and intricately framed windows looking out to the bay.

The British laid claim to what is still known as the Banana Belt, the hillside region where the sun usually shines, a few miles removed from the area to the south known as Hurricane Gulch, where the wind blows and the fog pours over the hills from the Golden Gate. People still come to the gulch to live anyway, loving their views and remoteness.

In the early days, Sausalito had a flourishing fishing industry. Fishermen and sail makers and boat builders settled in the "garlic belt" near the water. These settlers—Portuguese, Italians, Chinese, and others—built humbler homes, wooden cottages that still survive in the blocks downtown.

During World War II, Sausalito had an invasion of southern blacks and blue-collar workers from the Midwest who came to work at Marinship, a Bechtel Corporation shipyard that was started from scratch on the north edge of town. In three years, seventeen thousand workers at Marinship, working twenty-four hours a day, built ninety-three ships. When the war ended, the yard closed down, leaving a carcass of old buildings and ship's ways that are still being transformed to new uses.

"Marinship really changed the town, opened it up," said resident Phil Frank, a noted cartoonist, talking over a cup of coffee in Sausalito's laid-back Caffe Trieste. To accommodate the new residents, he said, "people built small cabins and mother-in-law units all over the hills, a lot of which are still there, many of them still illegal."

Also left was a wartime settlement known as Marin City, built in a bowl of land to the west of Sausalito but linked to it by history and regional government. For decades Marin City, inhabited largely by blacks, struggled to find an economic base of its own; by 1996, ground had at last been broken for a unique public-private partnership project that would create hundreds of construction jobs, permanent retail jobs, a 187,000-square-foot shopping center, and 340 new apartments and town houses in the center of the community.

Nearby, on Sausalito's northern shore, are the houseboats, a unique settlement that sprang up after the war and burgeoned in the 1960s, when people broke tradition to invent their own anarchic lifestyles. They settled aboard abandoned skiffs and tugboats, moved onto old houseboats that had once drifted free in the bay, or built shacks on the hulks of old barges. Ferryboats, out of service after the Golden Gate Bridge opened, were grounded and converted to apartments and art studios. Sausalito became a mecca for people looking for low rent: philosophers, craftspeople, dropouts, and artists.

By the end of the 1960s, the houseboats had become a problem, though not to their residents, who fiercely defended their freewheeling ways. Eventually most of the boat owners bowed to the inevitable and conformed to city codes for sanitation and modern amenities. Some of the old denizens left; new ones moved in and built elegant new boats, one with a helipad on its roof.

Sausalito residents today are a remarkable mix, including San Francisco commuters, airline employees (here today, gone tomorrow), self-employed professionals who work at home, artists, retirees, and a cadre of tradespeople. A goodly percentage take active part in town affairs, which in the old days included spicy political fights with oar-wielding houseboaters or disputes with the late Sally Stanford, a notorious ex-madam who owned a waterfront restaurant and was mayor for one memorable term.

Most residents are proud of the city's history, including its days during Prohibition as an embarkation point for bootleg whiskey. One of Sausalito's most famous residents, if briefly, was the notorious criminal Pretty Boy Floyd, who drove smuggled Canadian whiskey from the beaches of West Marin to the Sausalito waterfront.

Sausalito is full of landmarks from its picturesque past, including:

• The modern house that looms over Bridgeway on the stone foundations where William Randolph Hearst once planned to build a castle. Hearst built one home, Sea View, nearby. It was later torn down.

• The two stone elephants, nicknamed Jumbo and Peewee, sitting in tiny Vina Del Mar Park in the center of town. Relics of the Pan Pacific Fair and Exposition that thrilled San Francisco in 1915, the elephants came to town by ferry in 1916.

• The sprawling industrial center at the north end of town that once housed Marinship. One cavernous old building, known as the Industrial Center Building, now houses workspace for sixty-five to seventy artists. Another houses the Bay Model, an acre-and-a-half replica of the San Francisco Bay and delta, complete with a hydraulic system that imitates the tides.

Cruising the town, you find treasures in unexpected places: the statue of a seal frolics in the water off the esplanade on Bridgeway; the venerable "no name" bar (it has no sign) hides out among the touristy storefronts, a hangout for literary locals. On Central Avenue, one of the windy streets above town, you come to the Sausalito Woman's Club designed by famous architect Julia Morgan and erected in 1913 for five thousand dollars. On nearby streets, side by side with modern houses and 1930s stuccos, are period mansions and small, picturesque churches, relics of a simpler past.

The locals are fiercely loyal to their town. They love its weather, much cooler than the towns to the north. They even love its fog, which cascades

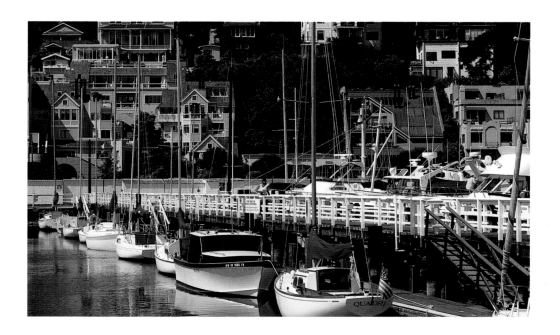

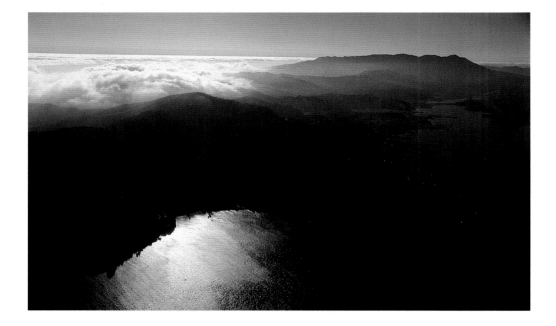

Seagulls swoop above
fishing boats off Sausalito's
Bridgeway. (Previous page)
The Marin Flea Market
is a popular weekend
destination. (Above)
The Casa Madrona Hotel
dominates the view
of downtown Bridgeway
from the Sausalito
Yacht Harbor. (Top left)
Mount Tamalpais
looms over a panorama of the
Sausalito waterfront. (Bottom left)

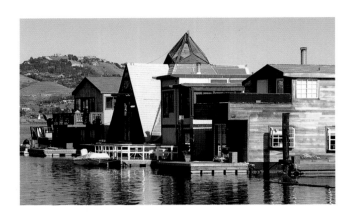

over the headlands and lies like cotton batting on the shore. They boast of its easy access to the headlands, the wide open tracts of Fort Baker, the stony, weather-crossed beach beneath the Golden Gate Bridge. They certainly wouldn't miss the town festivals.

The annual Fourth of July Parade is a well-kept secret to all but the townspeople; it ends at Dunphy Park with an all-day frolic and community picnic.

The Sausalito Art Festival on Labor Day weekend begins with a black-tie dinner for local patrons and participating artists: "it's the one event all year when you're sure to see your neighbors," said organizer Paul Anderson, owner of the town's weekly newspaper. In the ensuing three days, thousands of outsiders come to enjoy the festivities and buy the art.

The Portuguese community has its own festival, the Chamarita, every May. Townspeople have lined the streets since 1888 for the opening parade, which features drill teams, marching bands, and velvet-robed queens from Portuguese societies all over the Bay Area. The festival commemorates Queen Isabella's prayers to deliver her people from starvation in the thirteenth century.

For years, the best show in town has been the Sausalito council meetings, according to local history buff and government-watcher Dorothy Cousins, who talked with me in her hillside home overlooking the bay.

Week by week, council members mediate the battles that have kept Sausalito what it is: a charming community with a mostly open waterfront and residents who have fought to keep it that way. Today's town is the creation of its people, Cousins said. "If the townspeople hadn't spoken up, we'd have had condominiums the whole way."

Sausalito houseboats come in a variety of styles. (Top) Cartoonist Phil Frank shows off a stuffed raven, inspiration for a character in his daily comic strip "Farley" for the San Francisco Chronicle. *Frank is president of the Sausalito Historical Society. (Second from top) An artist's studio is one of many now installed in the Industrial Center Building, a relic of Sausalito's World War II shipyard. (Middle) Sausalito artist Ann Hallatt shows off one of her masks. (Bottom) A schooner heads into Sausalito on a cold winter's day. The Sausalito Hotel appears beneath the bowsprit. (Facing page)*

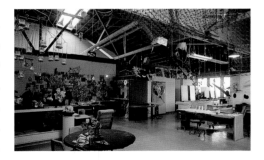

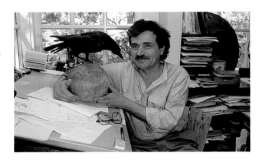

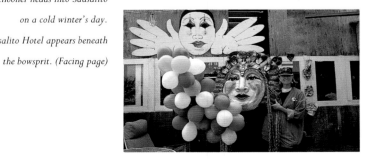

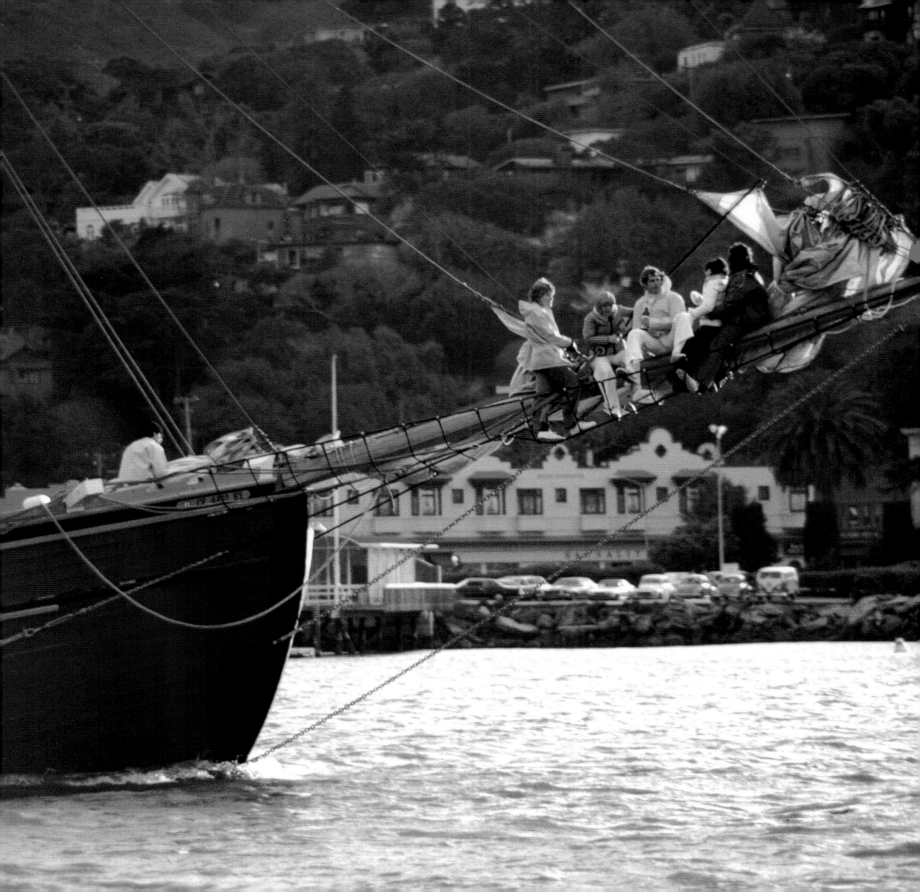

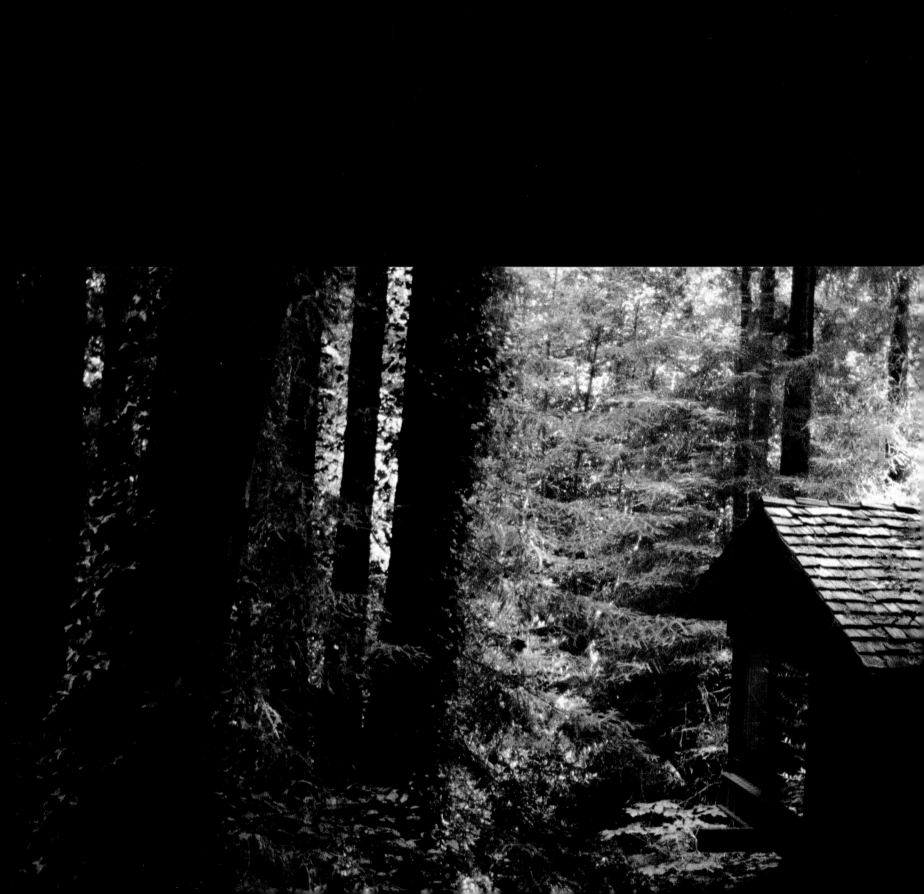

MILL VALLEY | MOUNT TAMALPAIS

When a noted Bay Area architect decided to retire a few years ago, he went looking for "a little village" to settle in. He wanted "a place where I could walk to town for coffee or the paper, and would know at least one person on every corner." He chose Mill Valley. Indeed, downtown Mill Valley has all the characteristics of a little village— winding streets, shade trees, park benches, and plenty of places to hang out. A bookstore-coffee shop anchors the town plaza.

Hillsides bank the plaza on three sides. A delightful old redwood building and its gardens, the Outdoor Art Club, form an improbable oasis at one of the main intersections. Over every street hangs the siren presence of Mount Tamalpais—Marin's mountain, green and eternal.

It is a downtown of ineffable charm; because it lies at the foot of a mountain, it has been compared to a village in the Alps. Belying the small-town look, however, are a raft of boutiques, art stores, and stylish restaurants. The village grocery store, the Mill Valley Market, is famous for its selection of all things gourmet—110 different mustards, 143 kinds of salad dressing, eight aisles of notable wines.

When Cyra McFadden wrote her famous book *The Serial,* a satire of Marin in the 1970s, she sent her heroine to the Mill Valley Market to buy walnut oil and long-stemmed strawberries and described lady tennis players strolling the aisles in "impeccable crotch-length whites, their deeply tanned legs flashing, little half-moons of exposed white buttocks glimmering as they leaned into the dairy cases for kefir."

While maintaining a down-home veneer, Mill Valley has a sophistication that stems from its proximity to San Francisco, only ten miles away, and from the people who have chosen to live here—an eclectic and accomplished crew, from rock stars to artists, nationally known authors to top-drawer business executives and political radicals, all of whom came for the pleasure of normalcy and anonymity and to live in the same-relaxed way as their neighbors.

Hollywood actor Peter Coyote said "This is my turf—a place where I can get good meat from Kean's, impeccable service from Dimitroff the framer, and careful attention to my car from the Oliveras at the gas station." He loves his home on a dead-end Mill Valley street, he said; "there are deer in my yard every day."

On more than one occasion, lifelong resident Scott Mills has told me that Mill Valley, as much as anything, is the people. "They came here because they could live the way they wanted to, and they pretty much keep to themselves. They aren't at the market, parading in front of the meat counter every day."

The look of the downtown is only part of the Mill Valley story. Perhaps even more characteristic are the streets that wind from the town's main thoroughfares—Blithedale, Throckmorton, Miller—into the redwood canyons and steep hillsides that gird the village itself. These streets are an indecipherable maze to out-of-town drivers, but they are a source of wonderment, too, shaded as they are by towering trees, bordered by banks of rampant greenery, flanked by massive brownshingled houses with pine needles in their yards and moss on their roofs.

Residents who live in these canyons probably don't stroll downtown for their daily paper. Most of the streets have no sidewalks, and many are so narrow two cars can't pass. Still, the town has a rare sense of community: Tamalpais High School, which began in a barnlike building in 1908, has educated most of the town's teen-agers ever since; a fall art festival embraces every artist in town and fills every downtown sidewalk; there are an active women's club, a chamber of commerce, and a historical society with its own archival space and volunteer staff in the library.

A town treasure is the Blithedale Canyon estate of Ralston White, one of the town's earliest settlers. The majestic old homestead, swathed in wisteria and breasting a heart-shaped lawn, has been made into a conference center, operated by the United Church of Christ.

Mill Valley history began with the arrival of a young Irishman named John Reed, who in 1834 acquired a vast land grant in the area and two years later built a sawmill on Cascade Creek to cut wood for his house. The restored mill, the structure that gave Mill Valley its name and perhaps the first sawmill in all California, still stands among the mute redwoods in Old Mill Park, a few blocks from the city square.

Reed shared his land with the remnants of an Indian population that had in large part been destroyed by disease brought by the white men who settled the missions. Relics of the Miwok Indians are still found in parts of Mill Valley—in the lowlands near Alto, a modest section of town next to Highway 101, and on the shoulder of DaSilva Island, across the highway at the edge of the bay.

After Reed's death the land was used for dairy ranches, many of them leased by Portuguese immigrants. When a railroad was built from Sausalito to the north, an enterprising doctor built a resort hotel not far from the train stop at Strawberry. The creek was dammed for swimming; there was fishing, hunting, and horseback riding on the surrounding hills; there were lantern-lit parties in the evenings. Families came from all over the Bay Area to spend summers in Mill Valley.

In the 1880s, a group of businessmen formed the Tamalpais Land and Water Company and set about designing a town, with spots for churches, schools, and parks. On May 31, 1890, a land auction was held near Reed's old sawmill, and more than two thousand acres were sold.

The new property owners built permanent homes or summer cottages; some just tented on their property. Mill Valley was on its way to becoming a town. A spur of the railroad was extended into the town from Almonte. Churches were built. A one-room schoolhouse (Summit School) was opened in 1892. Retail shops grew up near the railroad station where the Depot bookstore now stands.

In 1896, the Mount Tamalpais Scenic Railway, aptly nicknamed The Crookedest Railway in the World, was constructed from the middle of town to the top of the mountain; a gravity-car extension into Muir Woods was added in 1907. Tourists swarmed to the area for Sunday excursions at two miles an hour over eight miles of track, with stopoffs at one of three inns—the Muir Inn, the Tamalpais Tavern, or the still extant West Point Inn, now a stop-off for hikers. The railroad died in 1930, when autos could reach the top of the mountain on a brand-new road.

In 1900, 168 male voters decided to incorporate Mill Valley as a town. Two town traditions sprang up shortly afterward.

The Outdoor Art Club was founded in 1902 by a group of civic-minded women whose avowed purpose was to preserve the beauties of Mill Valley, a battle they're fighting still. Bernard Maybeck, a famous architect of the period, designed the clubhouse that today is the site of club meetings, weddings, festivals, and teas.

The Dipsea Race was launched in 1905 by the San Francisco Olympic Club, and it has been held almost every year since. The race, seven tortuous miles from the town square over Mount Tamalpais to Stinson Beach, now attracts hordes of would-be entrants but has had to be limited to fifteen hundred.

A landmark date in the history of the flowering city was the 1929 fire, which began on the middle ridge of the mountain and raced down the wooded canyons, gobbling up two hundred homes. A last-minute shift in the wind kept the downtown from being devoured.

The opening of the Golden Gate Bridge and the advent of World War II made giant changes in the city, which somehow has retained its central core while it has spread, amoebalike, to the outlying areas. Townspeople have fought hard to retain the sanctity of the ridgetops, although here and there pricey mansions have appeared, and once-bald hills have become densely cultivated subdivisions like Strawberry, Scott Highlands, and Enchanted Knolls. Over the years, the town has grown up the mountainside, and westward into Tennessee Valley, toward the sea.

Some townspeople mourn that Mill Valley's charms are no longer a secret. How could they be, since Rita Abrams wrote a bestselling song about it, Cyra

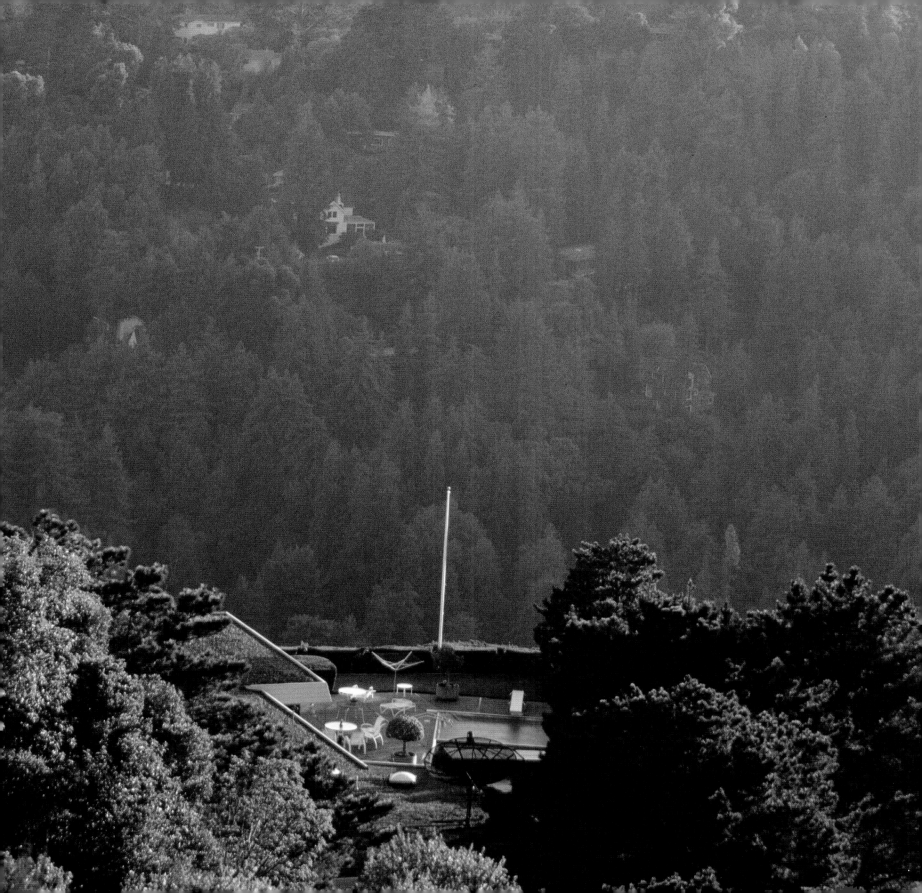

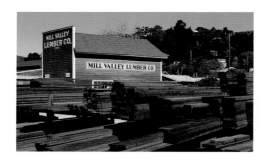

A private home sits in a shady redwood
grove near Old Mill Park. (Page 20)
A sweeping view minutes
from downtown
Mill Valley. (Previous page)
In Mill Valley, a flower stand,
the 2 A.M. Club, and one of the town's
oldest businesses. (Top, middle, bottom)
A private stairway beckons
from a busy Mill Valley street.
The El Paseo arcade of shops
begins at left. (Opposite)

McFadden blitzed it in her book, and a world-famous film festival attracts movie buffs and Hollywood stars to town every autumn. And yet Mill Valley remains Mill Valley, a place where every home is a stone's throw from a patch of woods, and every street has a view of the mountain. It is a village still, where one can walk the streets with lifted heart, browse in amiable leisure, and greet a friend on every corner.

MOUNT TAMALPAIS

Mount Tamalpais is the centerpiece of Marin County—its symbol, its sentinel, its most beloved landmark. "Those of us who run on the mountain love it with a passion that is almost religious," said George Frazier, a Marin newspaperman and member of the Tamalpa Runners. "I'd rather be there than in Switzerland."

As mountains go, Mount Tamalpais isn't much—just half a mile high and softly sloped, a gentle, suburban-size mountain. Its shape long ago suggested to someone the outline of a sleeping maiden, an image that found its way into at least two poems in the early part of this century and into a play called *Tamalpa,* performed several times in the mountain's outdoor theater. The title character was an Indian princess, betrayed by love, whose bier was at the top of the mountain.

Local lore has long linked the mountain with the Miwok Indians who roamed the coastal lands for twenty-five thousand years, although no one knows for certain whether any Miwoks ever climbed to its summit. But the Miwok story of creation, which was transcribed by C. Hart Merriam at the turn of the century, suggests that the Indians believed the mountain was the domain of their god, Coyote. Lincoln Fairley, chronicler of mountain history, wrote that "There can be little doubt the Indians looked on our mountain with awe and reverence. So do we."

Travelers returning to Marin from California's hinterlands see the mountain and know they are home. At dawn, sometimes, it takes on a rosy glow; on a gray day it is a black silhouette, but always its slumbrous outlines bring a pang of joy and identification. Artists have painted it from every angle and in all its glorious moods, covered with wildflowers or laced with wisps of fog, like a brush painting from Japan. Occasionally, when heavy fog rolls in from the Golden Gate, the mountain disappears altogether.

Rob Nilsson, who has been hiking and running on Mount Tamalpais since age fourteen, made a movie on the mountain called *On The Edge.* He described "one of the most thrilling runs I ever took." He started from Lytton Square in downtown Mill Valley. "It was overcast all the way to the railroad grade, and suddenly I came out of the overcast into the sun. When I began to approach the peak, it grew overcast again, and it started to snow. I ran across the meadow in six inches of snow. Down below I could see Greenbrae and San Rafael in pure sunlight."

While the mountain is a dominant presence in residents' everyday lives, it is also a mecca for hikers, picnickers, runners, and wedding celebrants. Many use the mountain for private rituals, from watching the Easter sunrise to scattering the ashes of departed loved ones. For years, Redwood High School held its graduations in the outdoor theater. Each Labor Day the Tamalpa Runners, hundreds strong, run to the top.

People have been "going to the mountaintop" for generations, enthralled by the peacefulness of it, the giant trees, the five reservoir lakes, the fairytale views. Each trail, campsite, or knoll has its own unique outlook, and from the very top, from the fire lookout or the Verna Dunshee trail, you can see it all: San Francisco's magic skyline, the shimmering boat-filled bay, the mountains beyond the East Bay hills, and—stretching endlessly westward—the vast, romantic ocean.

Almost as soon as white men arrived in the bay, the abundant timber of the lower slopes was harvested, first for use on whaling ships as firewood and later

to supply lumber to build the San Francisco Presidio. Marin land-grant ranchos used the meadowlands to graze longhorn cattle. Hunting for deer was an early commercial practice, and West Marin historian Jack Mason claimed that in the 1840s grizzly bears were shot on the mountain to provide steaks for San Francisco. Copper and gold mining was even tried, though to little commercial profit.

All those uses have become part of history, thanks to changing times and the zeal of preservationists. Dairy farmers, who succeeded the cattle ranchers, lost their last grazing leases in 1969. Logging, which prospered throughout the nineteenth century, was gradually phased out, but not before all the first-growth timber on Mount Tamalpais (except in Muir Woods) had been removed. Wild game on the mountain—elk, brown bears, bobcats, and mountain lions—had been greatly diminished by 1917, when the whole area was finally designated a game refuge, over the vociferous pleas of many hunting clubs that had established domain on the mountain. Mining disappeared of its own volition, leaving behind a few telltale depressions in the land, a few tailings.

Today the mountain is entirely in public hands. In 1930, 692 acres were designated the Mount Tamalpais State Park; today the park covers 6,000 acres and remaining areas of the mountain are in permanent open space, as watershed for the Marin Municipal Water District or as part of the Golden Gate National Recreation Area, which extends from the Golden Gate Bridge to the Point Reyes peninsula.

The land is managed carefully for public benefit, a task not as simple as it sounds. The interests of hikers sometimes collide with the habits of horsemen; in recent years, mountain bikers have been moved off the most populous hiking paths and restricted to trails of their own.

The main users of the mountain are runners and hikers and tourists. More than two hundred miles of trails lace the state park, the watershed, the

Golden Gate National Recreation Area, and Muir Woods. On a spring weekend, the trails are alive with strollers and joggers, amblers and serious striders, out for the pure air and exercise and enjoying the carpets of wildflowers. In an oral history, the late Alice Kent described the profusion of poppies and lupine on the slopes above Stinson Beach as "sheets of gold and sheets of blue, acres and acres, and it was that way all down the coast."

Nature has blessed the mountain with a profusion of flora and fauna, from seven or eight hundred species of plants to more deer than the authorities can easily control. Hikers frequently report foxes, skunks, and raccoons; there have been occasional sightings of bobcats. The west slope is crammed with Douglas firs and redwoods, the eastern side with chapparal, oaks, and bays, and when spring comes, the meadows are covered with lupine and poppies and monkeyflowers and species mere mortals can't name.

Not all the wonders are natural: on the watershed are five man-made lakes, Phoenix, Lagunitas, Bon Tempe, Alpine, and Kent, storing water for central and southern Marin. All are accessible to hikers, though Bon Tempe and Lagunitas have the best roads for walking. All but Phoenix are stocked with fish; rainbow trout are most abundant in Bon Tempe.

Lately, park rangers and water district watchdogs have been locked in battle with a proliferating population of feral pigs, whose presence on the mountain has endangered plant life and alarmed hikers. Plant lovers, particularly members of the Marin Native Plant Society, have waged what appears to be a losing fight against another invader—three species of broom, introduced from Europe more than a century ago—which threaten to overwhelm the native plants.

Most people are happily unaware of such troubles and focus instead on the treasures. What visitor has not looked forward to stopping for a meal or a beer at the Mountain Home Inn, a Mount Tam rendezvous since 1912. What hiker has not con-

spired to have a cookout or an overnight at West Point, once an inn, later a private club, and now a public stop-over for hikers.

And what resident has not resolved someday to take in a Mountain Play, one of the last public events allowed in the outdoor Samuel Cushing Amphitheater and a summer institution since 1913.

The theater was built by the Civilian Conservation Corps during the Depression years of the 1930s, following an earlier plan drawn up by the Mountain Play Association. Forty rows of stone seats were set into a natural bowl in the mountain, facing a grassy stage and a panoramic view of San Francisco Bay and the city beyond. Here, thousands gather on weekends in May and June to see familiar musicals like *Oklahoma, The King and I, Brigadoon,* and *The Sound of Music,* adapted to the mountain setting. These Broadway musicals are the glitzy grandchildren of earlier dramatic productions like *Peer Gynt, Rip Van Winkle,* Shakespeare's plays, and *Tamalpa.*

Other organizations, including jazz bands, symphony orchestras, and convention promoters, have sought to book the mountain theater for their productions, but fire danger, traffic problems, and worry about the damage that human crowds can inflict have led to a virtual ban on other uses. On nonplay days, the theater now serves as a stopping-off place for hikers content to contemplate the view or picnic in peaceful surroundings.

Protection-minded residents and park rangers would be horrified today if the Mount Tamalpais Scenic Railway were still running. Built in 1896, its main line extended uphill from the center of Mill Valley to the top of the mountain and had a spur into Muir Woods. At the top the Tamalpais Tavern was a first-class hotel, with dining room and a 150-degree view of the ocean, Marin, and San Francisco.

The 1929 fire that began on the middle ridge of the mountain and burned two hundred homes was one factor in closing the railroad—that, and the grow-

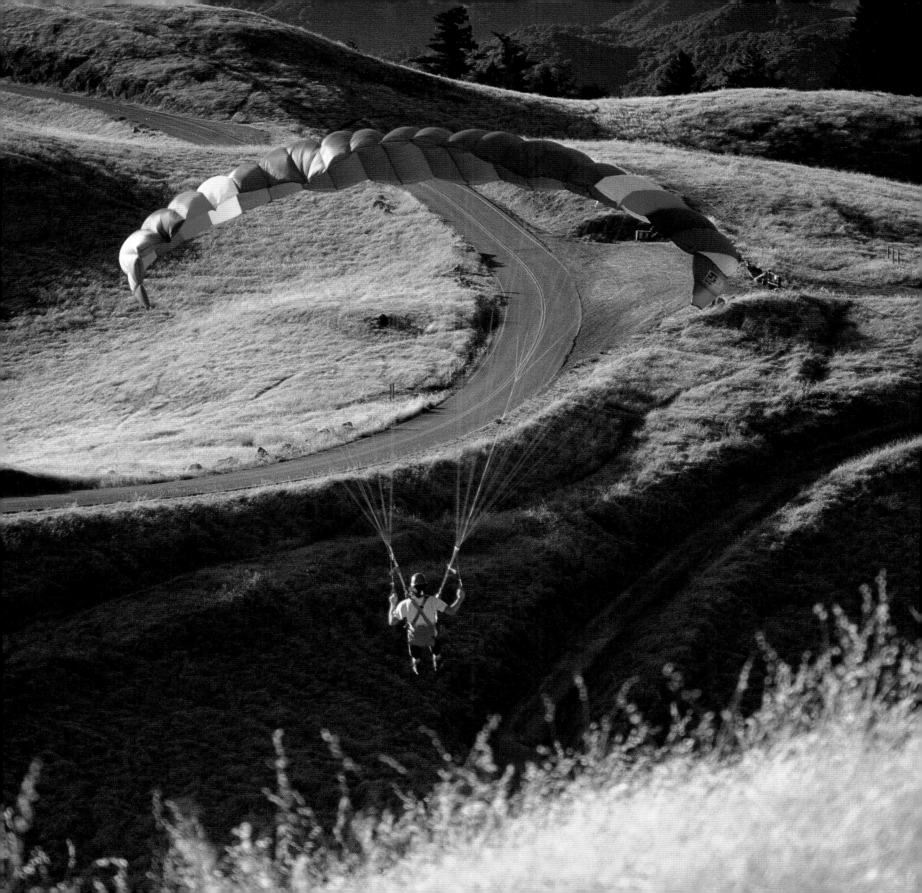

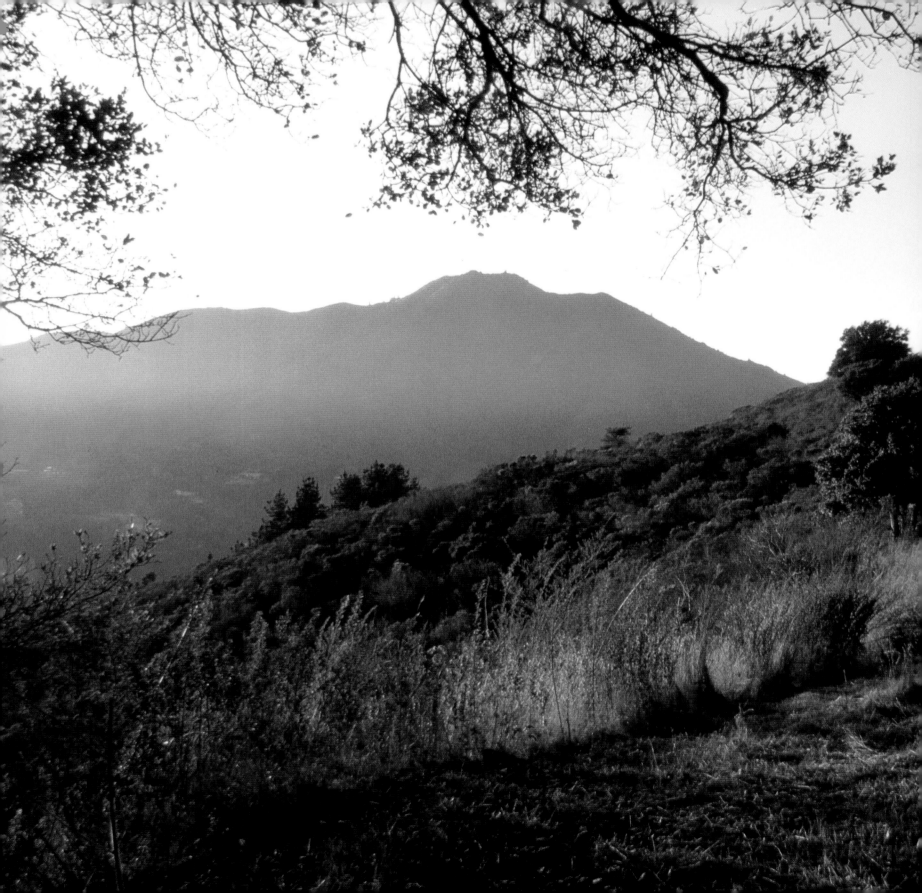

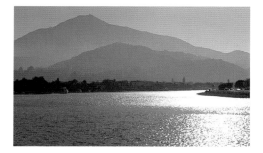

A parachutist

on Mount Tamalpais. (Previous page)

A trail north of Mill Valley

looking toward Mount Tamalpais. (Left)

Mount Tamalpais:

as backdrop, to homes

along Corte Madera Creek

and to San Pablo Bay,

and as silhouette. (Top, middle, bottom)

ing popularity of automobiles, and the scenic new road they could drive to the top of the mountain. A railroad would be unheard of today, in the climate of conservationism that has allowed natural forces, where possible, to reclaim the mountain.

George Frazier, the Tamalpa club runner, described the spiritual beauty of a run on the trails. "There's one little knoll above the Mountain Theater. It doesn't have a name. As people shout 'author, author' at the conclusion of a brilliant play, one runner on that knoll once cried 'Maker, Maker.' Now we call the knoll Maker. When we run on the mountain, we have a sense of awe."

THE DIPSEA RACE

One of the toughest and most honored footraces in the United States is Mill Valley's annual madness, the Dipsea Race. Sportswriters call the runners "Dipsea Maniacs."

Fifteen hundred men, women, and children enter each year, lured from half the states of the union. A large number are Dipsea cultists, local men and women who prepare for months and dream for years of winning.

The Dipsea Race is 7.1 miles long, from Lytton Square in Mill Valley over Mount Tamalpais to Stinson Beach. It starts with a stairway of 671 steps and it continues through epic stretches with names like Suicide, Cardiac, and Insult. Runners may end up scraped and bloodied, but they wear their wounds with pride: the harder race, the greater the glory.

The Dipsea Race is the second oldest race in the country, behind the Boston Marathon. It has been run almost continually since 1905, with time out in 1932-33 and 1942-45. The distance has fluctuated over the years, from 6.7 to 8.16 miles, but at any length it's no race for softies. Many first-time entrants swear never to run it again but keep coming back for years. Some runners are so addicted they take part in an unofficial race for masochists a few weeks later: from Mill Valley to Stinson and *back*, the Double Dipsea.

Here's how veteran runner and perennial contender Eve Pell described the experience: "You go over Cardiac, and there's the descent to the sea, and it's just so beautiful. I love the wildness of it—in what other race can you run full-speed and jump into a ravine, hoping you'll land on your feet."

The race attracts entrants at all levels through an elaborate system of handicapping: women have won, and so has an eleven-year-old child.

Nonrunners who are Dipsea fans stake out viewing places along the trail—at the bottom of the stairs in Old Mill Park, at the top of the stairs on Sequoia Road, at Windy Gap on Panoramic Highway, in Muir Woods, on Cardiac Hill, by the stile above Stinson Beach, and at the finish line in Stinson Beach State Park.

Starting time is nine A.M. in Lytton Square, one early Sunday each June. Be there: you have to see it to believe it.

MUIR WOODS

Kings and queens and rock stars have come here; so have Richard Nixon, the Shah of Iran, and the Bolshoi Ballet. Muir Woods is a mecca for celebrities and Joe Tourist alike. More than 1.6 million people visit every year.

Muir Woods is the forest primeval, an untouched canyon full of towering redwood trees two hundred feet tall and a thousand years old. It is a marvel of the ages, a dark and silent place extending eons back in time. Visitors routinely try to express their awe in the book set out for their signatures, but few can find adequate words.

Muir Woods National Monument was a gift to the nation from a Marin congressman named William Kent, whose family helped settle Kentfield. Kent had purchased the land known as Redwood Canyon for forty-five thousand dollars. When his wife, Elizabeth, objected to spending so much money, his argument was that "if we lost all the money we have and saved the trees, it would be worthwhile, wouldn't it?"

Before Kent's purchase in about 1904, the canyon had been a popular destination for hikers and the site of a huntsmen's club. In 1892, the Bohemian Club held its "High Jinks" there, but decided against buying the site because, someone said, the nights "were cold enough to freeze the male evidence off a brass monkey."

After Kent bought it, the North Coast Water Company proposed to condemn the land, cut the trees, and use the area for a reservoir. Kent, who had already tried to give the land to the county and the state, turned to the federal government. Under a statute allowing small gifts of land as national monuments, he deeded his 295 acres to the nation and the redwoods were saved.

Kent asked that the monument be named for John Muir, the famous naturalist, who called the woods "the best tree-lovers monument that could be found in all the forests of the world."

The redwoods in Muir Woods are *Sequoia sempervirens,* and they can live for two thousand years. Park rangers believe some Muir Woods trees are as much as a thousand years old. Huge, ancient, gigantic, they are silent sentinels of an unrecorded past.

Now five hundred and eighty acres in size, thanks to subsequent donations of land by Kent and the Mount Tamalpais Railway (in which he had a major interest), Muir Woods attracts nature lovers year-round. Steelhead spawn in Redwood Creek every fall, and in spring the paths are bright with purple and white trillium, fritillarias, and fetid adder's tongue. Later, azaleas bloom.

In addition to the redwoods, the canyon is replete with bay, oak, buckeye, and nutmeg trees. The back woods are alive with raccoons, chipmunks, and deer.

Said John Muir: "Saving these woods from the axe and saw, from the money changers and water changers is in many ways the most notable service to God and man I have heard of since my forest wanderings began."

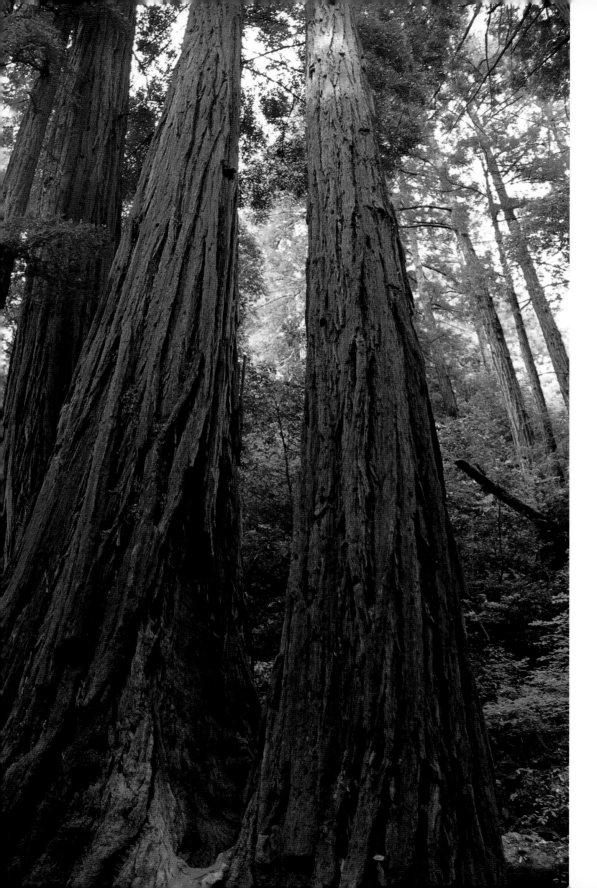

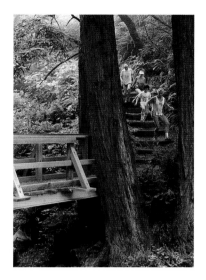

Towering redwoods reach
toward sunlight
in Muir Woods. (Left)
Dipsea racers run
down stairs to the footbridge
en route to the Stinson Beach
finish line. (Right)

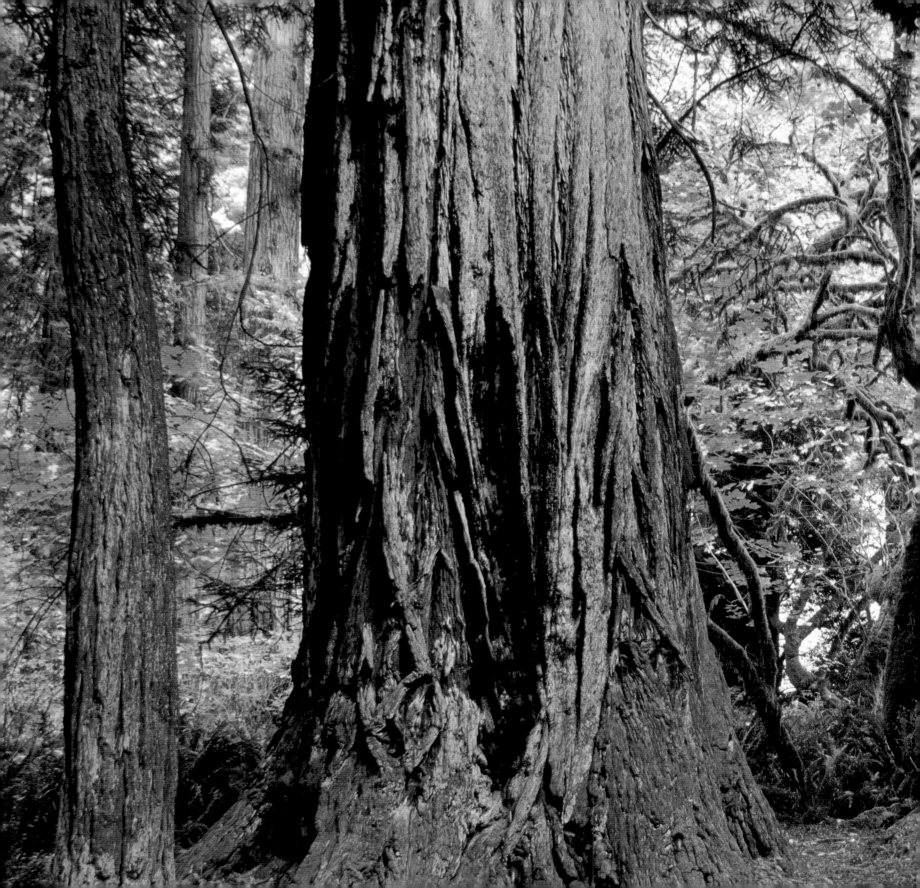

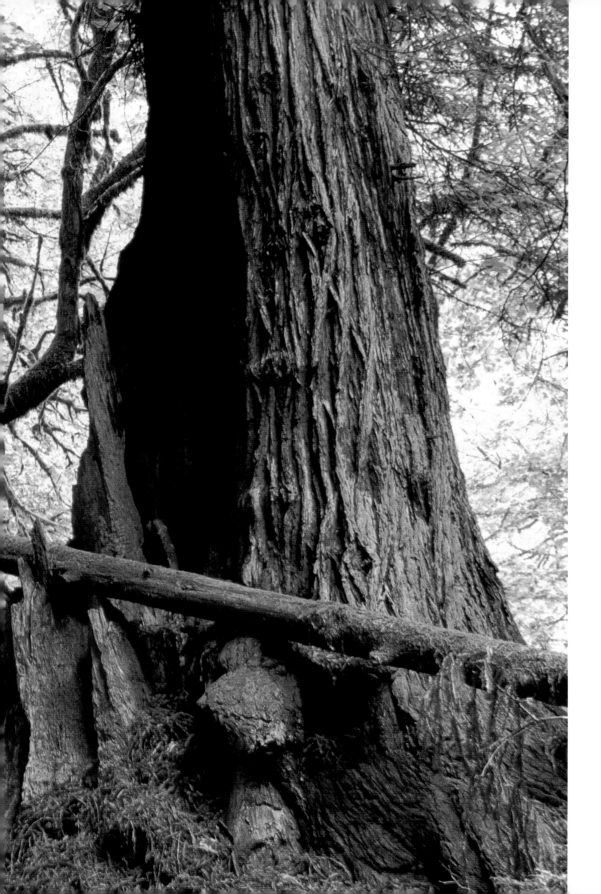

Huge trees in Muir Woods:

some are a thousand years old. (Left)

On Mount Tamalpais:

a wisp of fog, seen from above

Phoenix Lake;

a view spot northwest of Pantoll,

popular for photographing

car commercials;

and weeds through a rare blanket

of snow. (Top, middle, bottom)

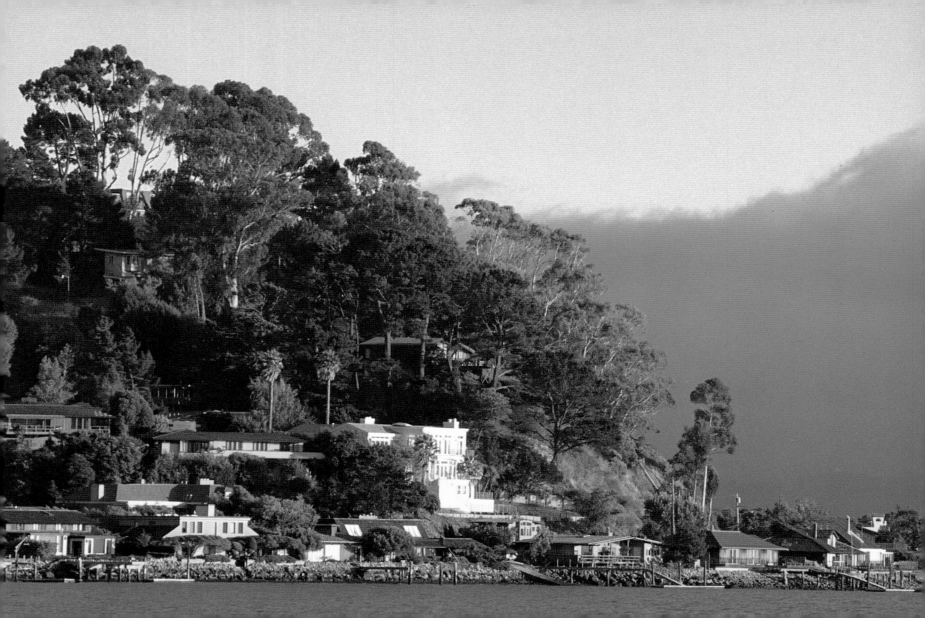

Old-timers remember when the Tiburon peninsula had more cows than people. Dairy ranches stretched along Tiburon Boulevard, from the Alto area—Highway 101 junction where it began to the two tiny villages where it ended.

TIBURON | BELVEDERE

The cows have long since disappeared. Old-timers blink at what has replaced them: a stunningly beautiful community of showplace homes and privileged humans. Today the peninsula towns, Belvedere and Tiburon, are among the fanciest addresses in the state.

Belvedere comes from the Italian for "beautiful view," and views are what the peninsula is about. Every home was built to have one—of cozy Belvedere cove, of Mediterranean Sausalito, of parklike Angel Island, or even a view of the whole schmeer: San Francisco and the busy, boat-filled bay.

Fifty years ago, it wasn't like this. The west side of Belvedere was nude of houses; the hills behind Tiburon were bare, except for St. Hilary's Church. Aside from a few churches and two pint-sized schools, the best-known institutions on the peninsula were the railroad trains and Sam's seafood cafe and bar.

Today downtown Tiburon is a both-sides-of-the-street lineup of restaurants, souvenir shops, and pricey boutiques. Baronial homes have sprung up on its hills, and the modest homes that once belonged to railroad workers are notable versions of the remodeler's art. Belvedere Island is filled with homes from top to bottom, as are the fingerling streets of Belvedere Lagoon, once a tidal mudflat and now an enviable community with a lifestyle of its own.

In Tiburon's days as home base for a railroad, there was a distinct difference between the peninsula towns: Belvedere was a refuge for the rich; Tiburon was the other side of the tracks. The towns have become much alike, but they grew up differently.

In the beginning, the peninsula was home to at least fifty Indian villages. Their presence is still patent in shell mounds, an occasional find of mortars and cooking stones, and petroglyphs on the rock face of Ring Mountain.

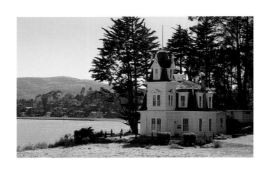

Some of the Indians worked for the the peninsula's first white settler, John Reed, who established his rancho on the lands where Mill Valley, Belvedere, Tiburon, San Quentin, and Corte Madera now lie. He brought cattle from England to swell his herds; Belvedere Island was the pasture where they were fattened for slaughter. Elsewhere on the peninsula he established salt yards, a brickyard, and a stone quarry.

When Reed died at age thirty-seven—he bled to death during treatment for sunstroke—his lands were divided among his three surviving children, John, Maria Inez, and Hilarita, the last named for his wife Hilaria, daughter of the onetime commandante of the San Francisco Presidio.

Hilarita (whose name survives in a Tiburon low-cost housing project) inherited the lower end of the peninsula and Strawberry Point. She and her husband, Dr. Benjamin Lyford, built a handsome, turreted home on the Strawberry shores, which years later was barged to a site on Tiburon Boulevard and now serves as headquarters for the Richardson Bay Audubon Center & Sanctuary.

The Lyfords and John Reed, the son, operated four peninsula dairies. Lyford had been a Civil War embalming surgeon, and he had strong ideas about sanitation and morality: in 1886, he laid out an idealized resort town on Tiburon Point that he named Hygeia, for the Greek goddess of health. The town was never built, but you can still see the tower of its stone entrance gate on a steep rise of the shore along Paradise Drive.

Others tried and failed to establish settlements on the peninsula, apparently considered too out-of-the-way by those who were rapidly forming little towns elsewhere in Marin. Instead, the area became a site for several industries (as well as the dairies): brickworks, an oyster farm, two powder companies, a ship salvaging yard, and three codfishing plants.

It is hard to imagine these now-elegant shores strewn with racks of drying codfish. But beginning in 1864, huge sailing ships brought their catch from the great cod banks of the northern Pacific to the Tiburon shore. A merchant named Israel Kashow employed one hundred Chinese in a codfishery on Belvedere's Beach Road. In 1877, another codfishery was established on the west side of the island, and a third operated on the east shore of Tiburon, processing dried flaked fish and thousands of gallons of cod liver oil. The latter two fisheries merged in 1904 and continued operating as the Union Fish Company until 1937. The old buildings on the Belvedere shore later housed a colony of artists, until they were torn down to make way for new homes.

On the remote east shore of Tiburon, still wooded today, a long wharf was built in 1877 for cod-fishing boats to offload their catch. In 1904, a U.S. Navy coaling station was established on the site, eventually to be supplanted by a merchant marine training station and an industrial cable company. In 1940, perhaps anticipating a war, the Navy established a net depot there, to make and maintain steel antisubmarine nets for bases around the Pacific. One net guarded the entrance to San Francisco Bay.

Nothing transformed the peninsula quite like the coming of the broad-gauge railroad in the 1880s. Peter Donahue, who owned the Sonoma County Railroad, wanted to run his line to a point in Marin to hook up with ferries carrying freight and passengers to San Francisco. Sausalito had already been taken as a jumping-off place by the narrow-gauge North Pacific Coast line, so Donahue opted for Tiburon Point. In doing so, he abandoned his depot (called Donahue) in Petaluma, and moved its buildings—shops, an engine house, and the forty-room Sonoma House hotel—by barge and flatcar to the Tiburon shore.

Peter Donahue built the first ferry, the *James M. Donahue,* first of a long line of ferries that still carry passengers to San Francisco, six miles away. The *Donahue* was supplanted by the *Ukiah,* which carried four thousand passengers (and sixteen rail cars on its lower deck).

The railroad created the town. Workers settled there in modest cottages, and on the block-long Main Street

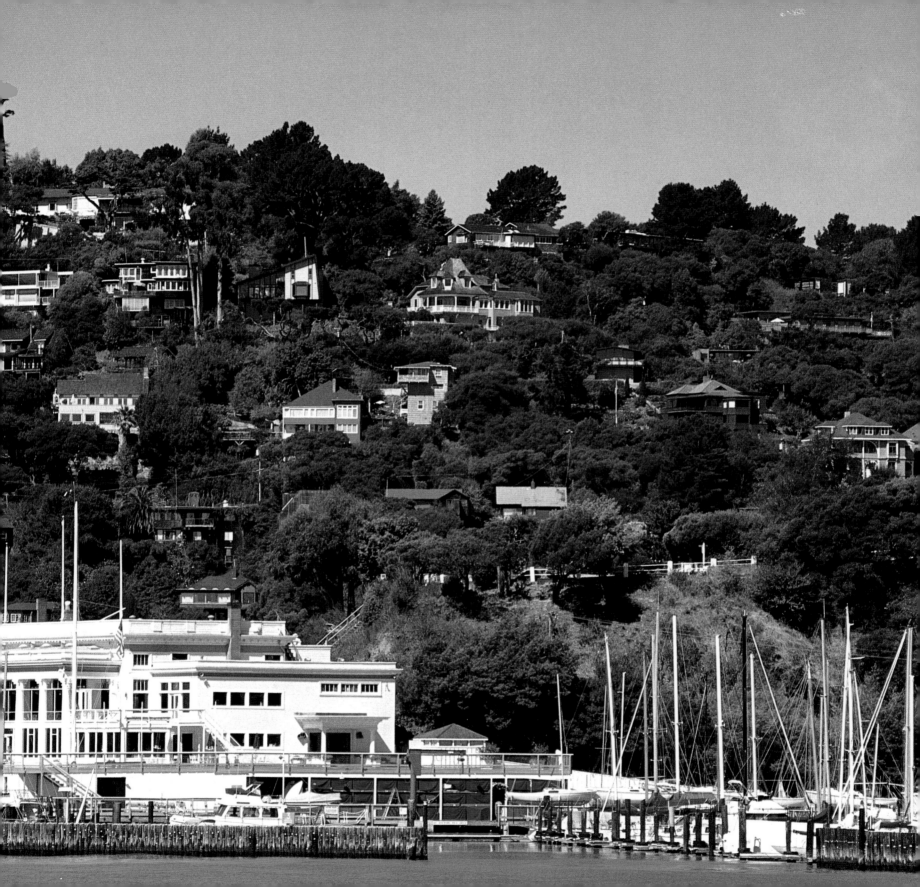

a commercial center was born, with grocery stores, stables, dry goods stores, and saloons. The broad flatland now occupied by the high-priced townhouses of Tiburon Point was crisscrossed with tracks and straddled with huge buildings, including a roundhouse, repair shops, and a sizable depot. A pier was built into the bay, to let cars carrying lumber and other freight roll directly onto the boats.

Belvedere came later; in 1890, San Francisco businessmen acquired title to the island from the heirs of John Reed. They formed the Belvedere Land Company and began selling lots, mostly to wealthy San Franciscans, who built the first elegant homes as summer retreats.

These earliest settlers were joined by a colony of another sort—the houseboaters, who floated flat-bottomed arks in Belvedere Cove from April till October, then had them towed into the lagoon-cum-mudflats behind Beach Road for the winter. The boats offered all the charms of life on the water with all the comforts of home. Many had multiple bedrooms and white-railinged decks, the better to entertain a flock of guests.

A highlight of the houseboat season was the Nights in Venice celebration, when the arks held open house. Concerts were held, and decorated boats paraded by torchlight.

Ark life ended when the drawbridge that then separated Belvedere Cove from the lagoon became a fixed concrete causeway. Many of the boats were towed to other locations; some were hauled onto dry land to become shops and rental cottages. You can still see one of them at the Hyde Street Pier in San Francisco, an exhibit of the Maritime Museum.

The towns evolved. The cove side of Belvedere island rapidly filled with homes; a golf course was built on its crown. Main Street Tiburon was twice rebuilt after devastating fires. A huge hotel on Belvedere Cove was replaced by the San Francisco Yacht Club. Tiburon, during Prohibition, became a haven for bootleggers. The railroad gradually closed down, first to passengers, then to freight. The last locomotive wheeled out of town in 1967.

After World War II, newcomers swarmed to the area and the housing boom began. The once-open lagoon area had silted in after the causeway was built. Home sites there were rapidly filled with houses, the Boardwalk shopping center sprang up, and the Belvedere Land Company dredged the remaining lagoon for the present development of ranch-style homes, most with boat docks (and boats) of their own.

A strip of handsome homes was built on filled land skirting Belvedere's west shore; dozens more were fitted among the eucalyptus trees on the steep west side of the island, across from Sausalito. Today Belvedere is a trove of different architectures, ranging from the massive Queen Anne and Mission Revival homes of the 1890s to more modern Japanese-style and Mediterranean villas and spectacular cantilevered structures that seem to float on the water.

Tiburon's architecture is another mix altogether. You find small cottages downtown, most of them handsomely remodeled, modern showplaces on view sites in the hills, and small marvels of engineering that jut over the water on Paradise Drive.

These days the comparatively modest homes fetch prices in the neighborhood of one million dollars. Old-timers are shocked, but it's all in your viewpoint.

With seventeen miles of waterfront, the viewpoints are plentiful. Residents pay to have them, and tourists congregate to see them. Even on a weekday, downtown Tiburon is crammed with browsers. On a weekend, cars crawl at a snail's pace around Belvedere Island. Despite the constant presence of gawkers, and the almost otherworldly beauty of the area, residential life goes on.

Two yacht clubs—the San Francisco and the Corinthian, on nearby Corinthian Island—shelter hundreds of sailboats for local yachtsmen: opening day of the yachting season is one of the peninsula's prize festivals, when parading vessels transform the bay with their white wakes and colorful sails.

Residents enjoy private tennis clubs and public courts, and they form a steady stream of joggers and pleasure-walkers along the bike path that stretches from Strawberry to the bay. The peninsula is rich in community parks, from cozy Belvedere town park to sprawling Paradise Park on the east shore of Tiburon.

Near the Strawberry Shopping Center, part of the peninsula but outside the Tiburon city limits, is the Golden Gate Baptist Seminary, which opened its doors in 1959. Its hillside site was once seriously considered as the world headquarters for the United Nations. Behind the seminary, along Richardson Bay, is Strawberry Point, where oglers can get their fill of enormous haute-design homes.

Blackie's Pasture is a landmark piece of open space at the bend in Tiburon Boulevard known as Trestle Glen, for the long-gone railroad trestle that crossed here. This spot was known for years as the home of a remarkably sway-backed horse named Blackie. When the horse died, townspeople erected a statue and a permanent park in his name.

Luckily the whole peninsula has been blessed with preservationists. Without them, the long stretches of open waterfront would never have survived. Townspeople circulated petitions and raised money to head off one developer's plan to fill in portions of Richardson Bay and build two thousand new homes. Residents bought the tidelands; the Richardson Bay Audubon Center & Sanctuary was born.

A citizen campaign likewise saved Ring Mountain, on the north side of the Tiburon peninsula, where thirty-four hundred housing units were planned. That campaign was helped by the presence of irreplaceable Indian petroglyphs and sighting of the Tiburon mariposa lily, which grows nowhere else.

Although the Tiburon Naval Net Depot has disappeared from Tiburon's east shore, its lands are still in public hands. The Tiburon Marine Laboratory uses old depot buildings to conduct research on sea life and minerals, and the Romberg Environmental Center of San Francisco State University does research on the health of the bay. Surplus lands around the net depot have become the Uplands Nature Preserve.

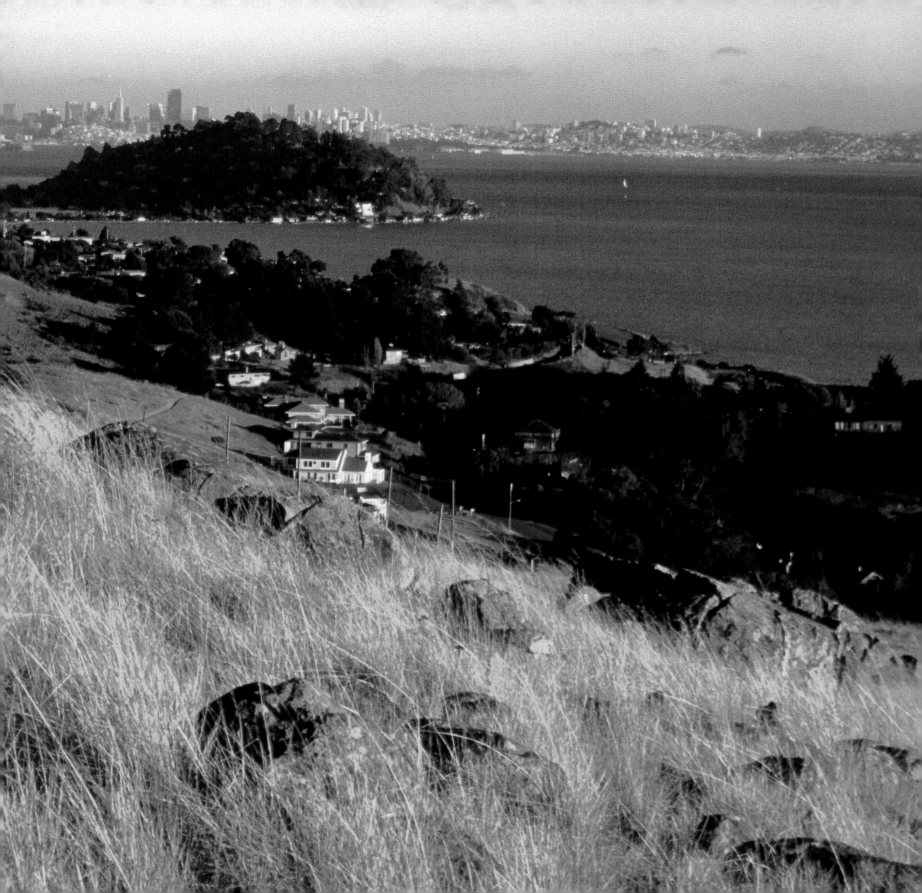

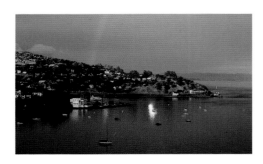

Ring Mountain affords a glorious view
of Tiburon, Belvedere,
and San Francisco. (Previous page)
Competition is fierce
in the Big Boat Series race off the
Belvedere shore. (Top)
A rainbow arches over Belvedere
and Tiburon after
a late-afternoon storm. (Bottom)
Views of the water dominate
in Tiburon (foreground) and on
Belvedere island.
The Golden Gate Bridge
stands in the background. (Opposite)

The Belvedere-Tiburon Landmark Society has helped save other treasures that might have been lost: a native plant sanctuary in two acres around Old St. Hilary's Church; and the China Cabin, once the social cabin of the old steamship *China,* which plied the waters between San Francisco and the Orient from 1866 to 1886. Now beautifully restored, it is a permanent structure on Belvedere's Beach Road.

The Tiburon peninsula isn't cow country any more, but it's not just a showplace, either. Beneath their affluence, Belvedere and Tiburon have the civic pride and problems of small towns the world over.

CORINTHIAN ISLAND

It's a tight little island. It has fifty-eight houses on fifteen tree-spangled acres, most of them canted straight up.

Its three narrow streets are all one-way, just wide enough to allow for one car. The one hundred forty-five residents—unless they own an outdoor elevator—must puff up and down as many as ninety stairs to reach their front doors. In most cases, precipitous lots have made two- or three-story houses a necessity—with plenty more stairs inside. So why would anyone want to live on Corinthian Island, a little hillock that lies two-thirds in Belvedere, one-third in Tiburon on the shores of Belvedere Cove?

"It's like living on the Amalfi coast of Italy," said longtime resident Joan Bekins, whose house sits on a steep hillside next to the cove. "The beauty is quite breathtaking."

Other waterside residents praise the togetherness they feel as they face winter winds and high tides: "We tie down our boats together, and keep an eye on each other's docks." One old-timer was lyrical about the weather: "The fog can come swirling through the Golden Gate, and we're still basking in sunshine."

Corinthian Island—once named Valentine Island for its original owner Thomas Valentine, and more recently known, with pursed lips, as Vinegar Hill—is home to a mix of old-timers who say they could never afford to buy there now and newcomers who don't even blink at the high cost of Marin real estate.

Until a few decades ago, Corinthian Island was considered a poor relation to Belvedere, its flossier neighbor across the cove. Probably the first structure on the island, erected in 1886, was the unpretentious wooden shack that housed a duck club, the forerunner of today's imposing white behemoth, the Corinthian Yacht Club. Some of the first homes were weekend cottages for visitors from San Francisco, a few were onetime arks hauled up the hill, and others belonged to workers from the Tiburon rail yard. Most of today's homes, by contrast, are showplaces.

The island was once joined to the "mainland" of Belvedere by a causeway. Early-day pictures show an open drawbridge at the foot of the island, between the cove and the expanse of water where the Belvedere Lagoon and filled flatlands now lie.

The Corinthian Island Company was formed by the men who purchased the island in 1907 from Thomas Valentine's widow. Lots were offered for prices ranging from three hundred to twenty-five hundred dollars; some were only twenty-five feet wide. In 1913, women of the island Improvement Association commissioned the two stone pillars that still guard the single entrance road.

For all its present-day glories, life on Corinthian is not all roses. "Living so close," one resident confided, "people do tend to get on each other's nerves."

The disputes have been many, over misplaced fences, hedges that overreach, people parking in others' hard-won private spaces. Traffic is always a problem; when the mail truck arrives, residents have to stop-and-go in its wake.

In 1970, Tom Belton ran for president of the Corinthian Island Association with the promise he would never hold a meeting. According to the Landmark Society book *Belvedere: A Pictorial History,* he won, "and has kept his word for twenty years."

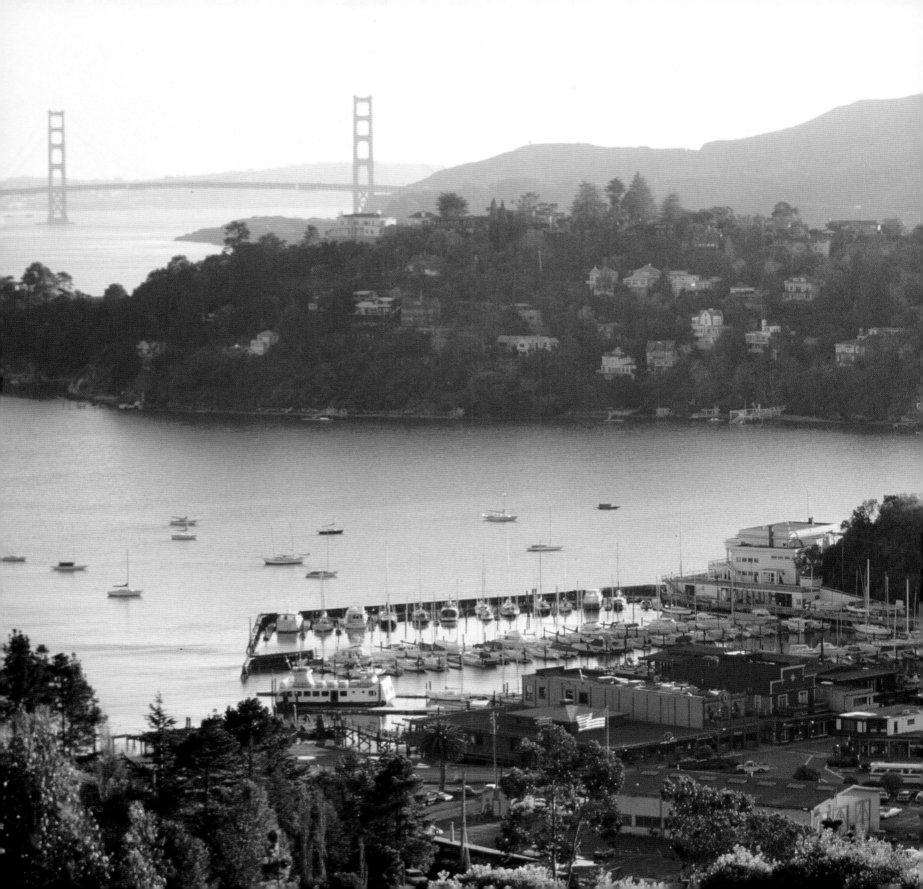

Larkspur and Corte Madera? To many people, the so-called Twin Cities are road signs, places you pass on your way to somewhere else.

Corte Madera and Larkspur lie in the lowland basin between southern Marin and San Rafael, the county

LARKSPUR | CORTE MADERA | GREENBRAE

seat. Although the towns straddle Highway 101, most drivers barrel on by unaware that they're missing something. That's OK with the residents: they've had their hands full in recent years, trying to preserve their smalltown ambience. The makers of a 1985 videotape of Larkspur history proudly subtitled it *The Saving Of A Small Town,* and save it they apparently did. Larkspur's downtown area has been listed in the National Register of Historic Places as an irreplaceable American "home town." Corte Madera has been a pioneer in the art of land preservation, using the resources of the state, the county, and local citizens to save its ridges and wetlands.

Though they are called the Twin Cities and share a police force, the towns are insistently separate. "Larkspur has been much more progrowth than we are," according to Corte Madera's former mayor Jana Haehl, who worked for years to control the size and environmental impact of the new Village shopping center. Larkspur preservationists might bristle to hear it.

In fact, both towns are almost "built out" now, their buildable lots filled with an astonishing variety of neighborhoods and a head-turning mix of architectural styles. Such variety makes it impossible to give one-word descriptions of the towns, although both have their share of canyons reaching into the foothills of Mount Tamalpais, which forms one serene backdrop for both. Larkspur has its Baltimore Canyon and Murray Park; Corte Madera has Christmas Tree Hill, where homes of every size and description cling tenaciously to the steep, wooded slope.

Walking trails begin in these canyons, making Sunday hikes one of the facts of local life. The meadows are full of lady slippers and trillium, the woods rich with redwoods, bays, and broadleaf maples. On the dark, redwood-arched trails, you feel a thousand miles from civilization; from the ridgetops, you connect to the whole Bay Area, available in one comprehensive view.

The canyons are only part of the Larkspur–Corte Madera story. Larkspur has two boardwalk communities and a slew of apartment complexes; Corte Madera has two regional shopping centers and a subdivision skirting the bay; both have upscale neighborhoods and economy subdivisions, although in Marin's present real estate market, no house is truly cheap.

Both towns were once open fields inhabited by Miwok Indians: most of the structures from Larkspur Plaza to the old Larkspur–Corte Madera School were built on a giant midden. Both were part of one of the original Mexican land grants, Corte Madera del Presidio, given to Irish settler John Reed in 1836 and first exploited to supply lumber to build the San Francisco Presidio. Covering nine square miles that stretched from Raccoon Straits to Larkspur's Baltimore Canyon and the current downtown Mill Valley, Reed's land was rich in timber, wild game, and meadowlands, well suited for orchards and cattle.

In 1846, whaling ships used Corte Madera Creek (which is in Larkspur, not Corte Madera) as anchorage, and steamboats plied the creek carrying lumber, hides, beef, and produce from the Marin countryside to the city across the bay. In 1847, a government sawmill was built on the site of downtown Larkspur; not long afterward the Company built one, too. Barges carried timber down Corte Madera Creek to San Francisco. By 1860, all the majestic old redwoods had been harvested and a new generation of settlers used the denuded hills for ranching and dairying.

Streets and settlements in the two cities still bear the names of their earliest residents—King, Murray, Chapman, Escalle. An early settler in Corte Madera was Frank Pixley, onetime California attorney general and editor of the San Francisco *Argonaut,* a literary magazine. He bought a grand 160-acre estate called Owl's Wood, which his widow Amelia later split with her sister-in-law, Emily. When Larkspur was incorporated in 1908, the town boundary coincided with the line dividing the estate. Amelia later sold her half, the part in Larkspur; the buyer subdivided the land into a tract called Chevy Chase.

Corte Madera grew much more slowly than Larkspur, which had an early reputation for roistering and a nickname to match — "Jagtown." (The name Larkspur was acquired later, when the wife of a major subdivider, Charles Wright, named the area for the lupine she found there, identifying it mistakenly.)

Three hotels were built in the town. The Bon Air, on the present Marin General Hospital site, was where city bigwigs brought their girlfriends. Wright's Hotel at the top of Sycamore was a resort for families. And the Larkspur Hotel, built for itinerant workers, now houses the upscale Left Bank restaurant.

There was no Highway 101 when these towns were aborning, but what was Marin's main road of those days cut right through Larkspur and Corte Madera, as did the railroad that came to town in the 1870s. In both towns, the old rail depots survived for decades after passenger service ceased in the 1940s. Larkspur's depot is still there.

By the turn of the century, both towns had attracted a number of San Francisco families who came for the summer. Vacationers built bungalows; some stayed on. Baltimore Canyon and Christmas Tree Hill were both subdivided into tiny (twenty-five by twenty-five foot) lots for tent sites, where families came for weekends. After the 1906 earthquake in San Francisco, many used their tent sites to build permanent homes. Some of the tiny cabins remain. In later years, oversized houses have been built on the same undersized lots.

One of Larkspur's best-known settlers in the 1890s was Jean Escalle, a young Frenchman, who planted the hillsides of northern Larkspur with wine grapes and built a two-story brick and white winery, whence he made deliveries around town two or three times a week in a cart drawn by a horse named Pedro. You can still see the winery at the north end of town. A more visible "landmark" is the lovely yellow-and-white Murphy mansion, built in 1888 and now home of a nationally famous restaurant, the Lark Creek Inn.

By the 1890s several grand Victorians had been built, a heartening number of which remain, cheek-by-jowl with modest bungalows, Craftsman-style homes, 1930s stuccos, and modern homes of natural redwood. "Larkspur is a real social and economic mix," said Helen Heitkamp, a planning commissioner and member of the Larkspur Heritage Preservation Board who gave me a tour of city byways and elder structures.

In the ensuing years, more and more residents were attracted to the area, lured by the near-perfect weather and the natural attributes of hills and bay. (Before the lowlands were filled for subdivisions, the bay was much nearer.) A Corte Madera history compiled by the Heritage and History Group describes balmy evenings on porches lit with colored paper lanterns, and of singing to the music of banjos. "There were house parties, masquerades, dances, ball games, and afternoon picnics on canoes on the creek."

In Corte Madera an Improvement Club was formed; fund-raisers were held to buy street lights and pave the roads. In 1917, Corte Madera became a town.

In 1913, Larkspur's volunteer fire department, needing money, launched a series of weekend dances, which by the 1930s were held under the redwoods on an outdoor dance floor called the Rose Bowl; two thousand people, many from San Francisco, came to dance each weekend, putting the little town on the map.

The Rose Bowl has been gone for decades, but another Twin Cities event continues to pull 'em in: the annual Fourth of July parade, which begins at Redwood High School and clops and prances and marches through downtown Larkspur and Corte Madera Village Square to the Town Park, next to city hall. Local bigwigs drive by in convertibles and vintage cars; they are joined by jazz bands,

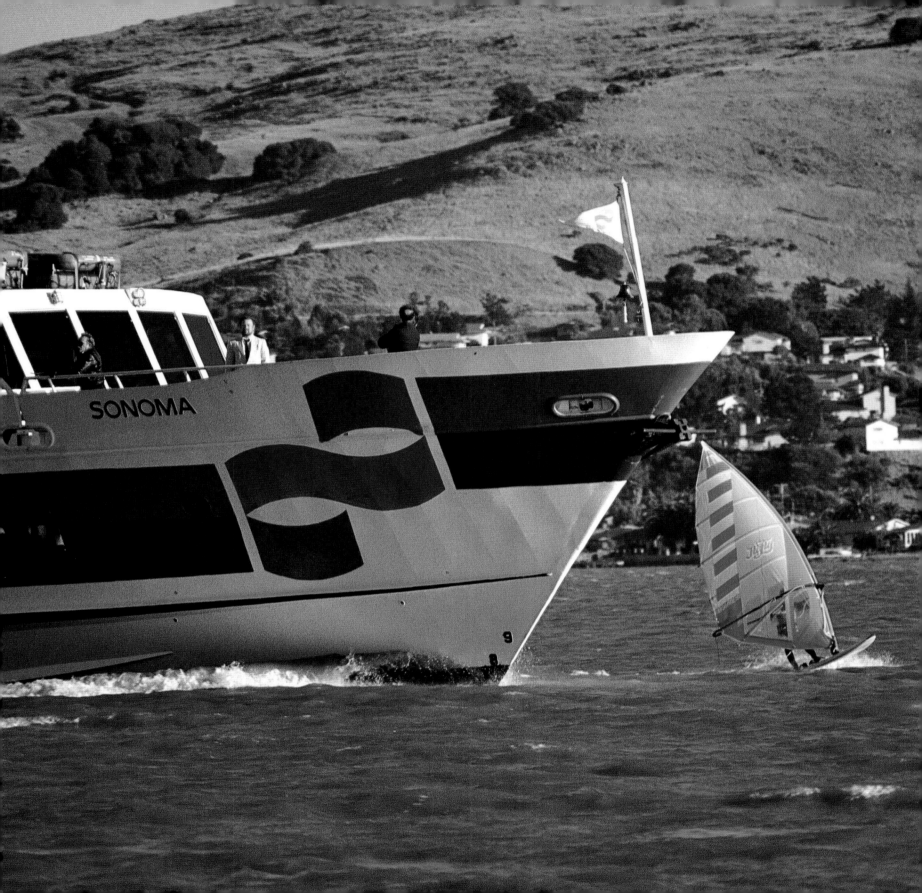

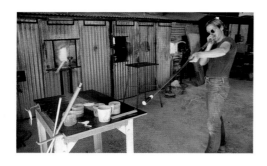

Pleasure boats dot the waters

of Corte Madera Creek in the shadow

of Mount Tamalpais. (Page 42)

A windsurfer zips across

the bow of the Larkspur ferry as it passes

the Paradise Drive area

near Tiburon. (Previous page)

A worker prepares to blow molten glass

at the Maslach Art Glass

factory in Greenbrae. (Top)

Lark Creek Inn, once an auto

showroom, is now a famous

restaurant. (Bottom)

The drawbridge of a defunct

railroad yawns

over Corte Madera Creek.

The Greenbrae Boardwalk

is at right, San Quentin Prison

at rear. (Opposite)

horsemen, unicyclists, drill teams, and (one year) local housewives dressed in brown paper bags.

The towns changed substantially during World War II and right afterward. Corte Madera built a number of new subdivisions, and eventually jumped across Highway 101, which had been built in the late 1920s. The town soon sprawled all the way to the bay and up the Alto hills that border Mill Valley and to the foot of Ring Mountain. Larkspur, too, grew by leaps and bounds. In the late 1940s a grand new subdivision called Greenbrae was built north of Corte Madera Creek, and twenty-five years later Larkspur Landing was added—a complex of apartment buildings, offices, shopping mall, and ferry terminal, where sleek white boats carry sight-seers and commuters to San Francisco and back. Larkspur Landing is on the road to San Quentin Prison, which is not a part of the town, and lies opposite the Greenbrae Boardwalk, which is.

Greenbrae Boardwalk and its counterpart, Board-walk Number One close to downtown Larkspur, are among California's last ark communities. The former reaches out into the bay, the latter fronts on Corte Madera Creek. Reachable only by boat or over weathered plank walkways, the two com-munities offer a reclusive back-to-nature lifestyle; both combine onetime free-floating houseboats with newer houses built on piles. Boardwalk Number One was once a haven for bootleggers.

Today the "real" Larkspur and Corte Madera are hard to define, so spread out and diverse have the towns become. To outsiders, Corte Madera is best known for its shopping centers, including the up-scale Village center east of the highway. Larkspur is known for the creek, Marin General Hospital, Redwood High School, the hilltop Tamalpais re-tirement center, and three sizable apartment com-plexes: Skylark, Bon Air, and Lincoln Village at Larkspur Landing.

But to the townspeople, the towns' charms are found in the byways, the sometimes hidden neigh-borhoods that bespeak a rich history. Explore the

canyons, walk the stone steps that link one tier of town to another, take a hike into the mountain wilderness at the end of the road. Or stroll the downtowns: almost all the buildings important in Corte Madera's past still stand in the square.

At core Larkspur and Corte Madera are still small towns, with the intimacy gained from generations of living and working together. "Larkspur is the people," said Heitkamp. "We may have a few freaks, and we do have a town drunk, but nobody worries."

Some of the old homes are being torn down to be replaced by new ones. A few are outsize, even baronial, but most of them are happily in keeping with the scale and image of the towns in which they reside, unpretentious, welcoming, part of some-thing bigger and more precious than themselves.

SAN QUENTIN PRISON

It's a nice place to visit, but you wouldn't want to live here. San Quentin Prison sits on one of the most glorious pieces of real estate in Marin County, on a point of land at the top of San Francisco Bay. The Larkspur Ferry sails by on one side; the Richmond Bridge takes off on the other. The great yellow prison, with its steel gates and gun towers, looks across the water at one of the most coveted views in the world: the city, the East Bay, and Alcatraz island.

Living here, of course, is no treat for the inmates. Although it contains the largest cell block in the world, the prison has long been overcrowded. The current population of fifty-five hundred, said Assistant Warden Dick Nelson, is 190 percent of capacity: "The men are double-bunked and double-celled." As of mid-1996, more than three hundred men were on Death Row, waiting for executions that had been delayed for years.

San Quentin has been an incongruous part of the Marin landscape for most of a century and a half. People driving Highway 101 are surprised to see such a grim institution so close to its charming neighbors, the Greenbrae Boardwalk and the con-dos and specialty shops at Larkspur Landing. Off-

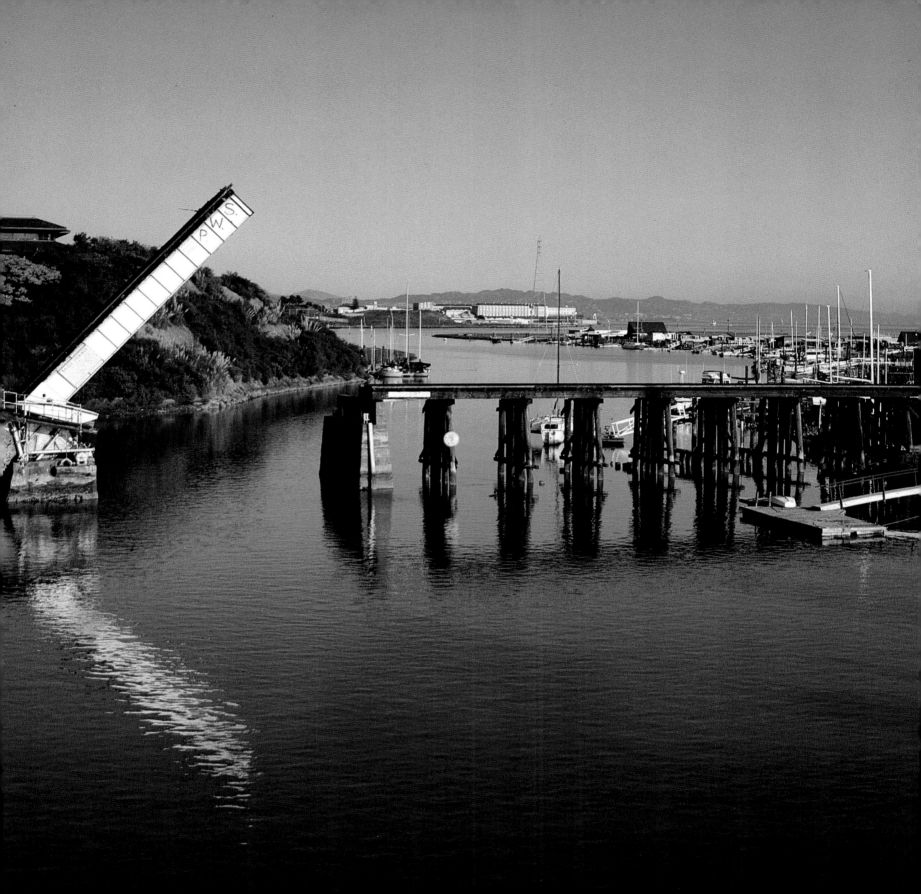

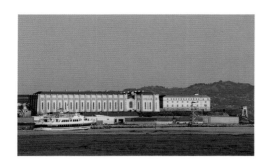

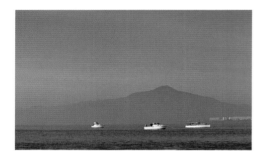

The Larkspur ferry cruises
by San Quentin Prison
in the late afternoon. (Above)
Fishing boats enjoy a cloudless
day on the bay. (Bottom)
Escalle's was a famous
winery in early-day Larkspur.
(Opposite)

shore, windsurfers wheel and dart on their brightly sailed boards. Such a benign setting, it seems, for a place with so brutal a past.

San Quentin was built at the height of the Gold Rush. Thieves and scoundrels were running rampant in the frontier streets of San Francisco; the brand-new California legislature needed a place to set up a prison. In 1852, the state paid Benjamin Buckalew ten thousand dollars for twenty acres at San Quentin Point.

At first, the prison was offshore. The Sheriff of San Francisco had purchased a 268-ton wooden vessel, the *Waban,* and anchored it in Raccoon Strait as a place to keep his prisoners. In 1852, the convicts began building the prison. By 1853, one hundred and fifty of them lived onshore, although women prisoners still lived on the ship. The state took over operation of the prison in 1858. A hospital was built, and a school for inmates. Striped uniforms were introduced to distinguish prisoners from guards.

In 1892, San Quentin's first execution was held. Death was by hanging—until 1937 when the gas chamber was built. Four hundred and twelve people (three of them women) had been put to death at San Quentin by mid-1996.

One of the most famous to be executed was Caryl Chessman, the "Red Light Bandit" whose case made headlines in the 1960s. Other inmates were even more notorious: Charles Manson, head of a murderous cult, and Sirhan Sirhan, who killed Robert Kennedy. Tom Mooney, another cause célèbre, was sentenced to die in San Quentin for the San Francisco Preparedness Day bombing of 1917; his sentence was commuted, and he folded sacks in the prison jute mill until 1939, when he was pardoned.

San Quentin lore is replete with escapes or attempted escapes. In 1935, four life-termers entered the warden's home and kidnapped three members of the parole board and the warden's secretary during lunch. A two-hour chase through the Marin countryside ended in Valley Ford where the ring-

leader was shot to death by the district attorney.

In 1978, three convicts made a boat in the prison furniture factory warehouse, painted it blue, and wrote "Rub A Dub Dub" and "Marin Yacht Club" on it in red. As they paddled the craft past the prison toward Corte Madera Creek, guards waved them on. Did they need any help, the guards asked the convicts—the boat seemed so low in the water. The escape succeeded at the time, but all three were recaptured within a year.

In the 1940s, Clinton Duffy became the youngest prison warden in the country. The convicts trusted him: he was the first warden to walk alone (and safely) through the prison yard. He became famous nationwide, admired for his humane attitudes toward prisoners and his opposition to the death penalty he was required to carry out. Duffy retired in 1951.

There were often disturbances in the prison—riots, knifings, assaults. In 1971, in an escape attempt, six people were killed, including one of the so-called Soledad Brothers, George Jackson, who carried a smuggled gun.

"The prison population always mirrored what was going on outside," said Nelson, the affable assistant warden who took me on a tour of the prison premises. "The Black Panthers, the antiwar demonstrators of the 1960s and '70s, the street gangs today. Tom Mooney came from the labor movement of the 1900s. In every movement there's a criminal element that oversteps the bounds."

Until fairly recently, San Quentin was one of America's grimmest prisons, home to murderers, armed robbers, and rapists. Today it is a minimum-to medium-security prison, and most inmates serve relatively short sentences. Many work making furniture or detergent, the prison's two main industries. Some go to school; the prison operates everything from remedial classes to college courses. Some even work outside the prison, on state roads and in state parks.

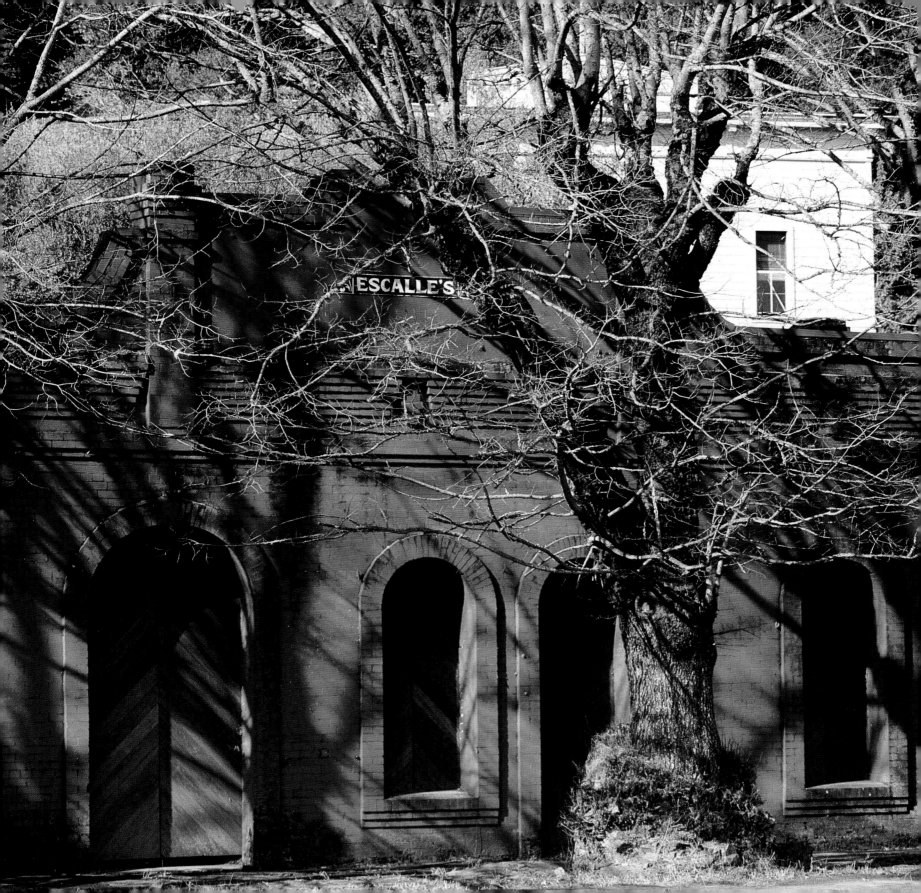

San Rafael began in 1817 as Mission San Rafael Archangel. It spread out from there. Now San Rafael is so many things, it's hard to define.

It's staid old Fourth Street, where the storefronts still look like an old western town. It's the Dominican

SAN RAFAEL

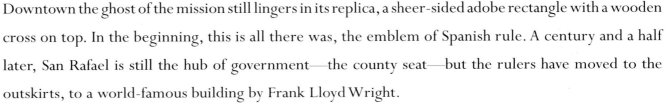

area, where the affluent live in period mansions under century-old trees. It's the teeming Canal District, where Mexican, African, Vietnamese, and Haitian refugees live sometimes ten per apartment, and struggle to find the American dream. It is all these, and a dozen neighborhoods more.

Downtown the ghost of the mission still lingers in its replica, a sheer-sided adobe rectangle with a wooden cross on top. In the beginning, this is all there was, the emblem of Spanish rule. A century and a half later, San Rafael is still the hub of government—the county seat—but the rulers have moved to the outskirts, to a world-famous building by Frank Lloyd Wright.

The city has sprawled far from its original boundaries, into vast new developments to the north and east, but it somehow remains a community. San Rafael residents boast of its marvelous schools and handsome churches, its multiple parks and long, scenic shoreline. Even in hectic times, they turn up at council meetings to argue its future or protect its past. Despite its population of fifty thousand, it still has a small-town flavor.

Fourth Street, San Rafael's main stem, still has the look of the village that it was when the sidewalks were wood and cattle periodically filled the streets. Amid the modern storefronts you find many façades from the 1890s; Victorian dormers hang over the sidewalks.

New owners have restored some of the turreted showplaces of San Rafael's early days, stuck here and there on the hills or side streets. Descendants of the original owners still live in charming working-class homes in Gerstle Park. At China Camp, on San Pablo Bay, the Quan family has preserved a few shacks from a nineteenth-century Chinatown. The mission, though, is where the town began.

More than two hundred years ago the Spanish conquerors of Mexico, grown rich on Aztec silver, spread their tentacles northward, looking for new treasures and new converts to the Christian faith. Military

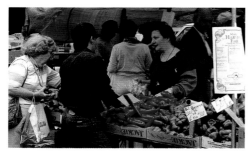

St. Raphael's Church

dominates the view

from A street. (Previous page)

San Rafael's Panama Hotel

offers a bed and breakfast;

the Farmer's Market

offers produce. (Top, bottom)

Moonrise accents

St. Vincent's Chapel. (Opposite)

expeditions came searching for harbors; religious expeditions under Father Junipero Serra came on horseback to establish missions in a string from San Diego to the north.

The San Rafael mission was given purposes beyond conversion of the natives. It was to be an offshoot of the Mission Dolores in San Francisco, to serve as a sanatorium for Indians who had grown sick in the fog and cold. But more importantly, it was intended as a hands-off warning to the Russians who had established a settlement at Fort Ross on the Sonoma Coast and were threatening to move south.

By the time San Rafael was founded, Father Serra was dead, but Father Prefect Vicente Francisco de Sarria, three other friars, and an escort of soldiers established Mission San Rafael Arcangel on December 14, 1817, in a sunny valley the Indians called Nanaguani. Father Gil y Taboado was put in charge of the mission, whose residents included 230 ailing Indians from San Francisco and—by the end of the first year—386 newly baptized Miwoks from the lands nearby.

Soon the Indians had cultivated the surrounding fields in wheat, barley, corn, beans, and peas, and mission herds had grown to thousands of sheep and cattle and 450 horses. Workshops were built to tan leather, make harnesses, and forge tools. By 1828, along with the friars and soldiers, more than a thousand Indians worked the mission lands.

In his book *San Rafael, Marin's Mission City,* historian Frank Keegan says treatment of the Indians at San Rafael was no better or worse than their treatment at other missions: they were uprooted from the life they knew, summoned to work by the sound of a church bell, placed in stocks or roundly flogged if they failed to follow the white man's orders. But it was not deliberate mistreatment that caused their ruin. It was the white man's diseases, brought by the Spanish, and "dislocation from the land, divorced from life among the plants and animals, and their social disintegration" that ended the

Miwok civilization. By midcentury, most of the Indians had died.

The mission's brief history had moments of unrest and violence. In 1824, San Rafael's Indians rose against their new masters but were put down by soldiers from the San Francisco Presidio; during the hostilities, two Indians with familiar names— Chief Marin and Quintin—fled to the Marin Islands off the San Rafael shore. Marin escaped. Quintin was captured and imprisoned, but his name lives on at San Quentin Point, where the famous state prison now stands.

In 1821, the colonists in Mexico overthrew Spanish rule, and California became a Mexican fiefdom. The mission friars saw the new Mexican constitution as a threat to their clerical authority, and in the ensuing struggle for dominance, the Mexican Congress passed a bill secularizing the missions, taking them away from church rule. In 1834, the Mexican governors began dividing the mission lands. Mission San Rafael was distributed in land grants.

John Reed, one of Marin's first settlers, was entrusted with the mission breakup. A year later, in 1837, he relinquished his post to Don Timoteo Murphy, a huge man (more than six feet tall, three hundred pounds) who served many years as *alcalde,* or mayor, for the region and was known for his kindness to the Indians. Murphy himself received a land grant in 1844—twenty-two thousand acres that included northeastern San Rafael proper, Northgate, Marinwood, Terra Linda, and China Camp.

In those days, at least in Marin, the dons were the real power, supreme local agents of distant Mexican rule. Don Timoteo and other landowners set the tone of an era when elegant ranchos were built, and lavish parties brought stylish company from far and near.

Into this idyllic existence came the Bear Flag Revolt. Yankee settlers were beginning to see California as a challenging frontier and the rightful

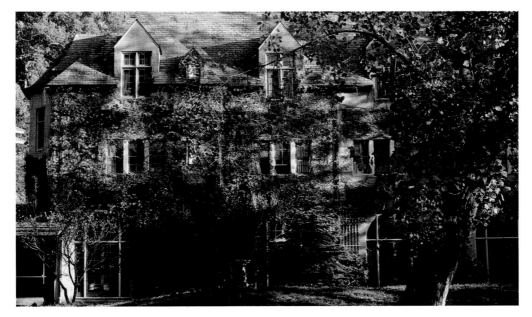

Vines show fall colors on a dormitory at Dominican College. (Top) The Marin Civic Center (with the Hall of Justice in foreground) is one of Frank Lloyd Wright's last masterworks and his only major public building. (Bottom)

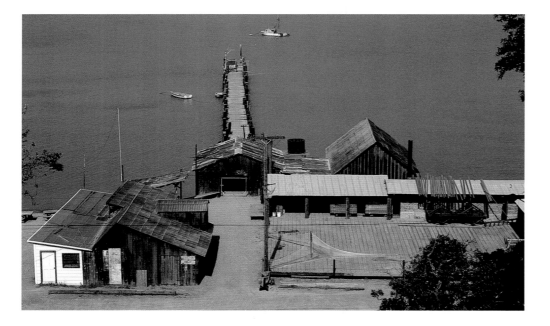

and the Boyd Park gatehouse. At the corner of Fifth Avenue and H Street stands the San Rafael Improvement Club building, a relic of San Francisco's Panama-Pacific Exposition in 1915, where it served as the RCA (Victor Talking Machine Company) Pavilion. The city of San Rafael bought the pavilion for five hundred dollars.

Beyond what seems like San Rafael proper are the sprawling neighborhoods to the north and west. Terra Linda, Marinwood, and Lucas Valley all lie west of 101, vast developments with their own character, all blessed by a backdrop of gently folding hills that for the most part are free of construction. The suburban homes of Lucas Valley give way to ranchlands as Lucas Valley Road winds west. Marinwood and Terra Linda dead-end against the hills.

East of the highway at Marinwood is an eye-stopping sight: the Renaissance-style towers of St. Vincent's Chapel, the cornerstone building of St. Vincent's School for Boys. An orphanage during the Gold Rush, the first Marin outpost of the Dominican order nuns, St. Vincent's is now a residential treatment center for emotionally disturbed wards of the state. Nuns lived in what was once a convent until 1982; a Catholic priest still lives on the grounds, and services are held each Sunday in the glorious old church.

Tradition has it that the swallows come back to St. Vincent's on St. Joseph's Day (March 19) every year. Their nests, like gray beehives, are plastered against the chapel tower. Cattle still roam on the open lands that reach from St. Vincent's to the bay.

The bay skirts San Rafael from north to south, giving a special character to each place it touches. From the north, it is accessible by car on San

Pedro Road, which departs 101 at the civic center. The road passes China Camp State Park, the luxury homes of Peacock Gap, and tree-shaded McNear's Park, with its public swimming pool, picnic areas, and pristine beach. It continues along the bay shore, where modest homes share the wide-open view with exclusive subdivisions, yacht clubs, and modern-day palaces behind iron gates.

Ultimately the bay feeds into the San Rafael Canal, where Marin's most heterogeneous community makes its home. Cheek by jowl with expensive waterside homes are apartment houses sheltering new immigrants from all over the world. Marin's least affluent people live here, in surroundings that are nonetheless charming; the community's Bahia Vista School is a multiethnic paradise and a neighborhood center, where the kids speak a dozen different languages.

In the Canal District, the accents of its many Latinos serve as reminders of the city's long-lost past.

THE CIVIC CENTER

The Frank Lloyd Wright Civic Center is one of Marin's proudest possessions and its second most popular tourist spot (after Muir Woods). Some say the elongated building looks like a space ship come to rest in the hills. Others compare it to a caterpillar, its arches like segments of a worm. Wright visualized it as "a bridge between two hills." Most call it a masterpiece, a perfect visual match for its setting.

Surely it is like no other building in Marin—a long, low-slung building with a metal spire and a turquoise roof that reaches right into the hillside. The center is in fact several buildings. There are the Administration Building, an adjoining Hall of Justice, Marin Center (including an exhibition hall and two-thousand-seat theater), and a small post

office—the only U.S. government building Wright ever designed. The Hall of Justice contains a raft of courtrooms and a jail, some of it inside the hill. All offices in the Administration Building are on the periphery, giving everyone who works there a view, and leaving room for a four-story atrium.

The unique complex, beloved now, almost didn't get built. In 1952, county supervisors recognized that government was outgrowing its offices in the white-pillared courthouse in downtown San Rafael. After lively debate about the wisdom of moving out of town, they purchased one hundred and forty acres of land near Terra Linda for a new civic center. In 1956, they began looking for an architect.

Hiring Wright was wildly controversial. Opponents wanted someone local (and cheaper), but a contract was signed in 1957. Wright unveiled his design to a jam-packed meeting at San Rafael High School the following year. Reaction, according to the county newspaper, was "either enthusiastic or insulting."

The controversy went on for years. At one point a new, divided board voted three to two to stop work on the building. The resultant outcry was such that one supervisor was recalled; the vote was immediately reversed. By the time the Administration Building was complete, in 1962, Wright had died.

The Civic Center, one of Wright's last creations, has endured. Today it is known as "Big Pink," where government holds forth to the rage and/or comfort of the whole population. World-famous entertainers perform at the auditorium. A county fair is held each July on the center grounds, and nature lovers come all year long to picnic on the rolling lawns or feed ducks in the center lagoon.

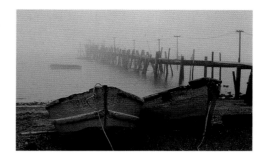

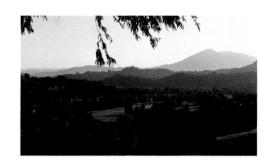

Marshlands and two duck blinds reach into San Pablo Bay near China Camp. (Opposite top) A shrimp boat moors off the pier at China Camp, with the settlement's restaurant-bar at left. (Opposite bottom) Mists give an otherworldly look to the pier at China Camp. (Top) Eucalyptus leaves frame an overview of Peacock Gap homes and golf course. Mount Tamalpais looms at right. (Bottom)

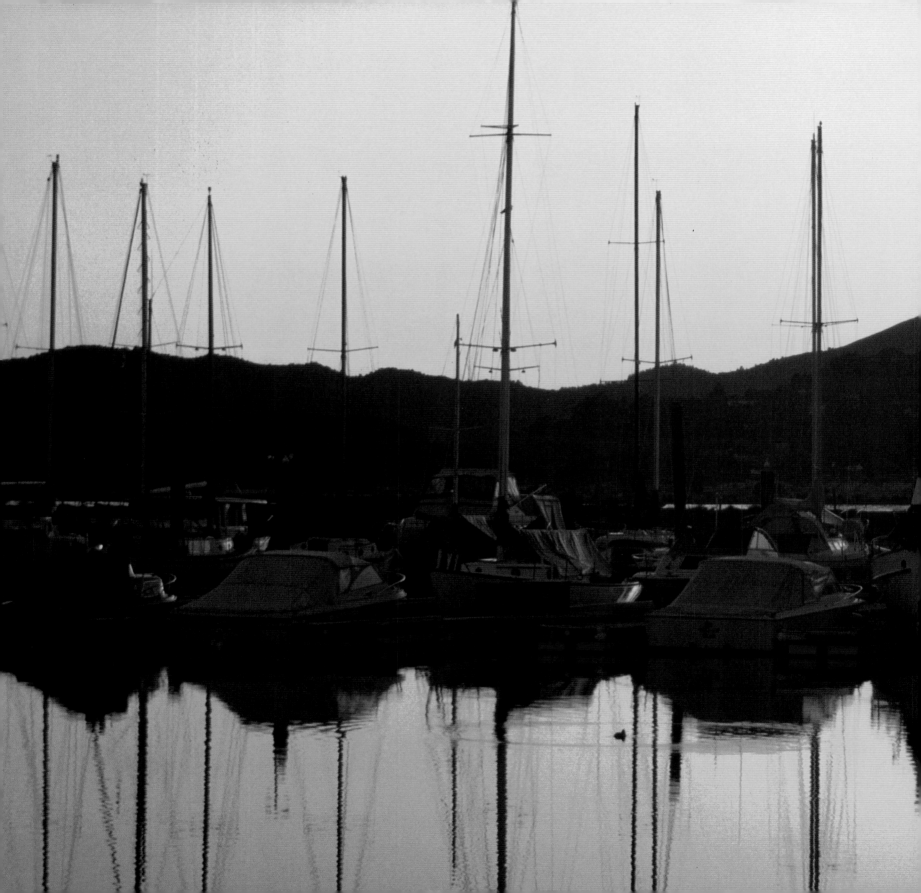

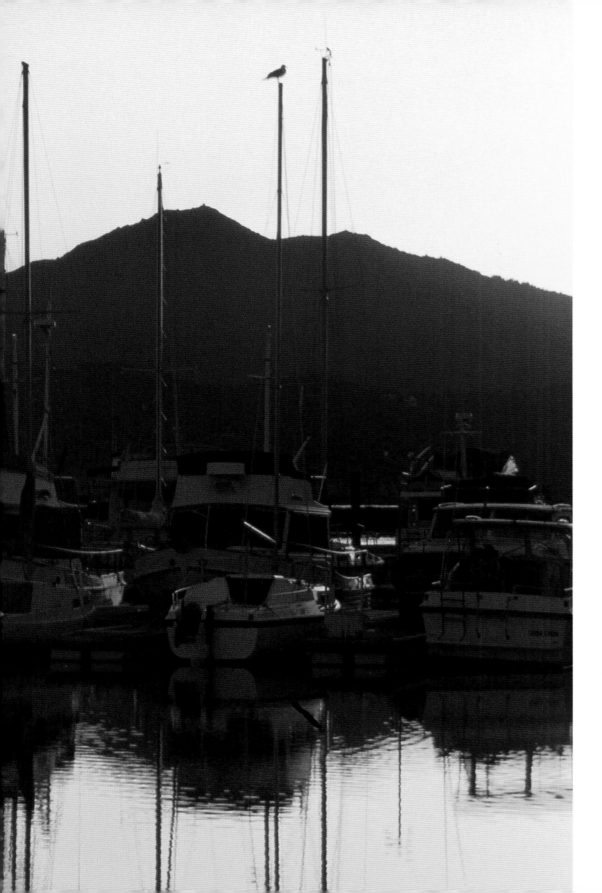

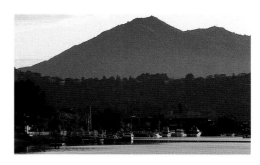

A seagull perches on a mast during
early evening at Loch Lomond
Yacht Harbor. (Left)
Sunrise transforms the view
of oak trees, pasturelands, and hills
near St. Vincent's
in San Rafael. (Top)
Private yachts ride at anchor
in San Rafael Canal. (Bottom)

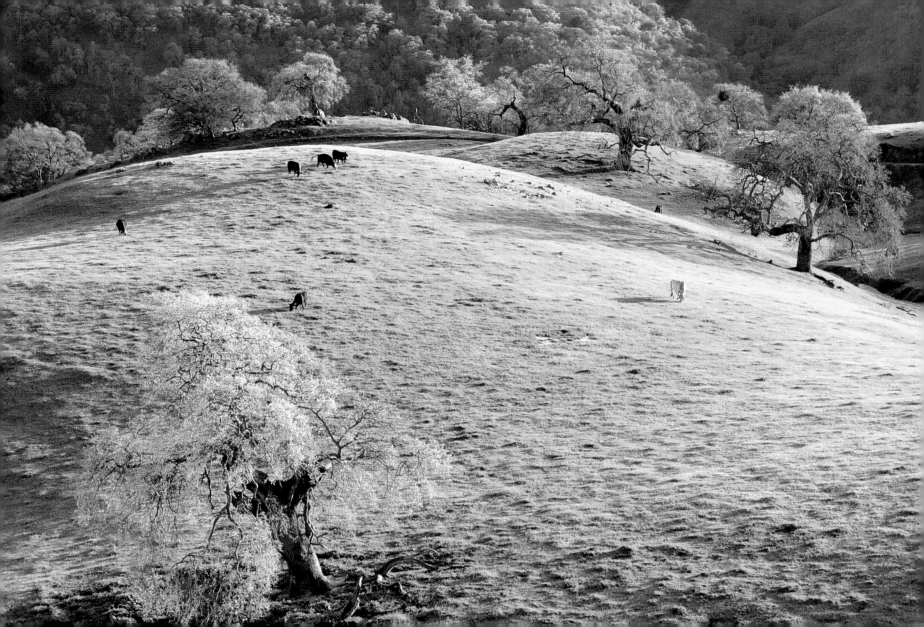

For years, Novato was Marin's poor relation; like Rodney Dangerfield, it got no respect. Novato was still cow country when the rest of Marin became famous for trendy people and expensive homes. Southern Marin had the theaters, the college, the civic center, the stores. Novato had practically nothing.

NOVATO

In the 1990s, all that has changed. Today Novato is making a bid to become Marin's biggest city, and its wide-open landscape has filled up with condos, subdivisions, minimalls, and estates. Old Town, which had been a sleepy downtown center, booms with restaurants and specialty shops. Novato even has its own college. It has grown so fast that residents worry about when to stop. Fights break out over each new plan for development.

Novatans like their city as it is—a congenial, down-home mixture of distinct neighborhoods, from the waterfront communities of Bel Marin Keys and Bahia to the horse farms along Atherton Avenue and Vineyard Road and the mansions of Wild Horse, Pacheco, and Verissimo Valleys. Still, Novato is somehow apart. It has its own water district; until recent years, it had its own phone book.

"I bring people up here and they're amazed at how nice it is," said Susan Stompe, devoted conservationist and former mayor. "Mount Burdell is as beautiful as Mount Tam, and it doesn't have one tenth of the traffic."

Like Topsy, the city "just growed," starting as dairies and fruit orchards and subdividing into smaller communities as the Bay Area expanded. The commissioning of Hamilton Field as a U.S. Army air base in 1935 jump-started the area and influenced much of what came afterward; the base, now idle, is about to become a multifaceted residential development.

Even as Novato grew—it became a city in 1960—it had few of the amenities of its cousins to the south. "You had to go to San Rafael for most of your shopping," said Diane Ryken, a longtime resident and recent "Novato Citizen of the Year." "All the government services were in southern Marin."

As a result, Novato formed several charitable agencies to take care of its own, among them a Human Needs Center, a youth center, a child care project, and an association for affordable housing.

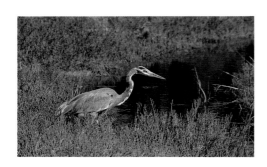

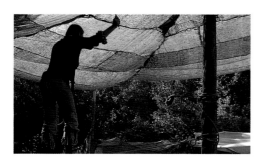

"Novato's a very friendly place to live," said Dietrich Stroeh, an engineer who has been here since boyhood. "Neighbor helps neighbor. When a park needs to be built, volunteers do it. I've laid an awful lot of sod in this town."

Small businesses have sprung up all along the downtown streets, and in an industrial park to the east of town; recently, a regional shopping mall on Highway 101 has brought crowds to a complex of discount stores and an eight-plex movie theater. Indian Valley College, in the oak-covered hills at the far end of Ignacio, brings students from all parts of Marin. Plans are on the drawing board for a national research center on the problems of aging; if the plans come to pass, Novato will have a new attraction—a building complex designed by world-famous architect I. M. Pei.

So far, growth hasn't destroyed the still-rural feel of Novato. There are still wide-open swatches of tide flats and farms and the surrounding hills are largely untouched. Mount Burdell itself is almost all public land, crisscrossed by trails but off limits to cars. There's an airport on the outskirts of town, but it's small, and barely noticeable in the diked lowlands by San Pablo Bay.

The city lies between the bay on one side, Mount Burdell and Big Rock Ridge on the other; Highway 101 runs right through it. To the east are Black Point, Bahia, Bel Marin Keys, and the horsy stretches along Atherton Avenue and School Road. West is Ignacio, Old Town, San Marin, and Olompali. Beyond are the hills and back roads where real "country" begins.

A century and a half ago, all Novato was "country." Three hundred Indians lived in a village at Olompali; Mexican soldiers, trappers, and padres crossed the emptiness between Mission San Rafael Arcangel and the fort at Sonoma. Kit Carson first came here in 1829. So did a fur trapper named James Pattie, who wrote of the great many fruit trees he found.

When the missions were secularized, the lands were divided into ranchos. Olompali, in the north, was awarded to an Indian called Camillo Ynitia; Rancho de Novato went to a Fernando Feliz, and the southern territory, now called Ignacio, was given to Don Ygnacio Pacheco.

Pacheco raised vast hordes of cattle and took pride in his horses. His adobe hacienda was famous for barbecues and fiestas; visitors came from all over the Bay Area and stayed for weeks of celebration. The hacienda remained until 1916 on the present site of Galli Square and Dalecio's restaurant. In 1881, Pacheco's son, Gumescindo, built a home that still sits in stately splendor beside Highway 101. Pacheco descendants have planted cabernet sauvignon grapes and run a winery there.

Fernando Feliz didn't hold on to his rancho very long. It passed through several hands before being sold to two New Englanders, J. B. Sweetser and Francis De Long. They planted hundreds of acres with fruit: 20,000 apple trees, 3,600 pear trees, 3,000 apricot trees, 8,000 grape vines, and several hundred almond, cherry, and peach trees. By the late 1860s, Novato was said to be the biggest orchard in the world. Sweetser and De Long even sold apples to Australia. What apples they couldn't sell they turned into vinegar.

By the 1870s, Portuguese and Italian farmers and dairy men moved into the area. The Portuguese brought with them the Chamarita, a religious festival celebrating the Holy Ghost that is still held in Novato each May.

In 1879, Sweetser and De Long dissolved their partnership, and they split up their land. In 1888, De Long subdivided eight thousand acres to begin the town of Novato. The next year he sold out to the Home and Farm Company, and more lots were auctioned off. In 1913, the Sweetser Ranch, by then owned by James Burdell, was subdivided, too.

Olompali, the northern rancho that had been awarded to the Indian Camillo Ynitia, continued for some years in Indian hands. Two adobes were

built there; parts of the second, dated 1837, still survive. During the Bear Flag Revolt, Yankee "rebels" fought a battle with Mexican forces who had taken refuge at Olompali. It was Marin's only battle in the quick-step revolt. One Mexican was killed.

Camillo Ynitia sold his land in 1852 to James Black, founder of Black Point; Black gave part of the grant to his daughter, who married Galen Burdell. The Burdells built a fine ranch house that enclosed the surviving adobe, and they planted gardens that became a north Marin showplace. The ranch house passed through several owners. During the 1960s, tenant Donald McCoy turned it into a notorious (and sometimes nudist) hippie commune called "the Chosen Family." When the mansion burned, the commune departed. In 1972, the Olompali property became a state park, where archaeologists still hunt for remains of the old Indian village and volunteers who call themselves the Olompali People work to restore its past.

Black Point was settled in 1853 by woodcutters and dairy ranchers. Hunters discovered it in the 1860s, and others came to fish in the Petaluma River. The river front was soon lined with little arks, and there was a bathing beach with bathhouses.

At one point, Black Point was a stop on the rail line from Petaluma. The Black Point Inn, before it burned down in 1979, had a long history as a roadhouse, a speakeasy, a brothel, post office, and church. Many people came through Black Point, but it was never part of the beaten path; it hid under its cover of trees, separate from the rest of Novato.

Today Black Point—a hump of land at the confluence of the river and San Pablo Bay—is a distinctly unplanned community, with a jumble of charming homes and roads that go every which way. Most of the early shacks have been displaced by custom multilevel houses, but the ambiance hasn't changed: Black Point wants to be alone.

Ironically, most people know the area because of the annual Renaissance Faire, a tradition for more than two decades (although its operators have announced they'll leave soon). For a few weeks every fall, thousands of people from all over Northern California have flocked to the Black Point flatlands to revel in Elizabethan pageantry, food, crafts, and costumes. When the fair ended each year, life went on as before.

Today, Black Point is in transition: for several years, developers have been working on plans to rim the little settlement with luxury homes and a golf course.

Black Point is considerably older than Novato's other waterfront communities. Bahia is a modern development of houses and town homes with a New England seaside look. Bel Marin Keys is a lush suburbia graced with tall trees and oleanders. Both are built beside man-made lagoons and bay estuaries where residents tie up their boats.

Novato has other distinct developments, most of them fairly new like the city. Marin Country Club has its own golf course and clubhouse; Wild Horse Valley is an enclave of luxury homes. San Marin is almost a town in itself, served by its own shopping center, fire department, and high school. Amid the larger developments are a number of pocket neighborhoods and mini-shopping centers, parks, and riding stables; on the outskirts sits Stafford Lake, a favored fishing hole and picnic spot.

Spread out as it is, Novato still has a center in the complex of historic buildings on DeLong Avenue— the city hall, community center, and history museum, painted an evocative red and white. Among the oldest buildings in town, they are the nucleus of Old Town. The city hall once was a church.

"Diversity" is Novato's strong suit, Stompe said. "There are plenty of modest homes, but more and more million-dollar mansions." Novato even has farmers: Frank Pinhiero keeps cows in his side yard, in the middle of downtown, and Will Lieb's chicken ranch is not far away.

Modern Novato grew essentially because it was affordable. Young people came here to establish their first homes. After World War II, many who

The control tower and hangar

sit silent at deactivated Hamilton

Air Force Base. (Top)

Star thistles grow wild

on an abandoned Hamilton

Field runway. (Bottom)

had served in the military chose to stay or later retired here. Today there are plenty of old-timers, but also a number of newcomers and transient professionals who work at big companies like Fireman's Fund and move on when opportunity calls. The mix of people makes town politics lively: the no-growthers versus the businessmen; conservatives versus liberals; yuppies versus the people who got here first.

In spite of debate, the city hangs together—part of Marin but somehow separate, a town intent on its own destiny, with a future that's still in the balance.

HAMILTON FIELD

Today the flight line is silent. The runways are broken and covered with weeds. Hamilton Air Force Base, where warplanes flew and presidents landed, is a ghost of its former self.

The 2,010-acre base sits on the fringe of Novato between Highway 101 and the bay, on lowlands that were diked to keep out the tides. It occupies one of the last choices pieces of undeveloped land in Marin County, but it sits on the brink of change.

After twenty years of heated debate over its use, and thanks to investment by many private and public institutions, the military base is about to be transformed into a large civilian community with a mix of high-class and low-cost housing, parks, office buildings, and retail space. It will also be home to a permanent shelter for eighty of the county's growing number of homeless people. Some of the new housing will replace the stucco bungalows that once comprised Rafael Village, built for military families outside the Hamilton gates.

In recent years signs of life at the base have been few—a commercial air show, perhaps, or army exercises that filled the sky with parachutes. A PX and commissary were open to active duty and former servicemen and their families. The field continued to provide headquarters for an army flight detachment and an arm of the Coast Guard, and one section of the base served as military housing—Spanish-style stucco houses under palm

trees and pines. But Hamilton's glory days had ended years before.

The base was a political prize during the days of the Depression; Marin welcomed it as a source of jobs. President Hoover authorized the base. The first planes arrived in 1934. From then until it was decommissioned in 1974, it was a ringside seat on history.

The first occupants of the field were men of the Seventh Bombardment Group flying twin-engine B12 bombers. When B17s arrived in 1939, Hamilton was considered too small for the larger planes, and the bomb group was transferred to Utah.

The Twentieth and Thirty-Fifth Pursuit Groups moved in, flying 170, P36, and P40 aircraft. Both left in 1942 for combat duty in World War II. By the end of the war, bombers, fighters, and reconnaissance planes had passed through Hamilton; the base had processed more than thirty-five hundred B24 crews and three thousand crews for fighters. Big bands and movie stars came to entertain. President Truman and other world leaders landed here en route to the United Nations' founding in San Francisco.

Hamilton played a tragic role at the war's beginning. Twelve B17s, en route to the Pacific from Florida, took off from Hamilton Field on the evening of December 6, 1941. When they arrived in Honolulu fourteen hours later, the attack on Pearl Harbor had begun, and the B17s were caught in the crossfire of Japanese planes and American antiaircraft guns. One of the B17s landed on a golf course. One was shot in half on a Hickam Field runway, and a crewman killed. Less than an hour before the Japanese attack, a GI operating a radar unit on the north end of Oahu had seen a cloud of blips on his screen, but his report of incoming planes—the Japanese—was ignored by a lieutenant who thought they were the B17s, en route from the States.

At war's end and for months afterward, Hamilton Field was a receiving station for thousands of hospital patients from overseas combat zones; enlisted

men's barracks were temporarily converted to hospitals. Among the arrivals were sixty-eight nurses, "Angels of Bataan," who had been prisoners of the Japanese for nearly three years.

In 1947, when the Air Force was created, Hamilton Field became Hamilton Air Force Base. It served as headquarters for the Fourth Air Force and for the Western North American Air Defense Command.

Through two more wars and the peace afterward, jet planes and "Gooney Birds" (C130 cargo planes) continued to roar off Hamilton's runways, until the base was declared surplus and the Air Force closed it, forty years after it opened. An attempt to convert the field into a civilian airport fizzled out under citizen protest.

Hamilton had one more appointment with history. In 1979 and 1980, its old buildings became a receiving station for thousands of Asian refugees waiting for resettlement all over the United States. Hundreds of Marinites greeted the refugees and gave them succor.

Now Hamilton will embark on a new chapter in its vibrant history. The military presence will fade as the land fills up with new homes and the structures of domestic commerce. At some point, even the air field will be gone, as the dikes are opened and the marshlands restored to their status quo—when the Indians lived here, before the Gooney Birds came.

Ground fog shrouds
a field outside Novato. (Opposite)

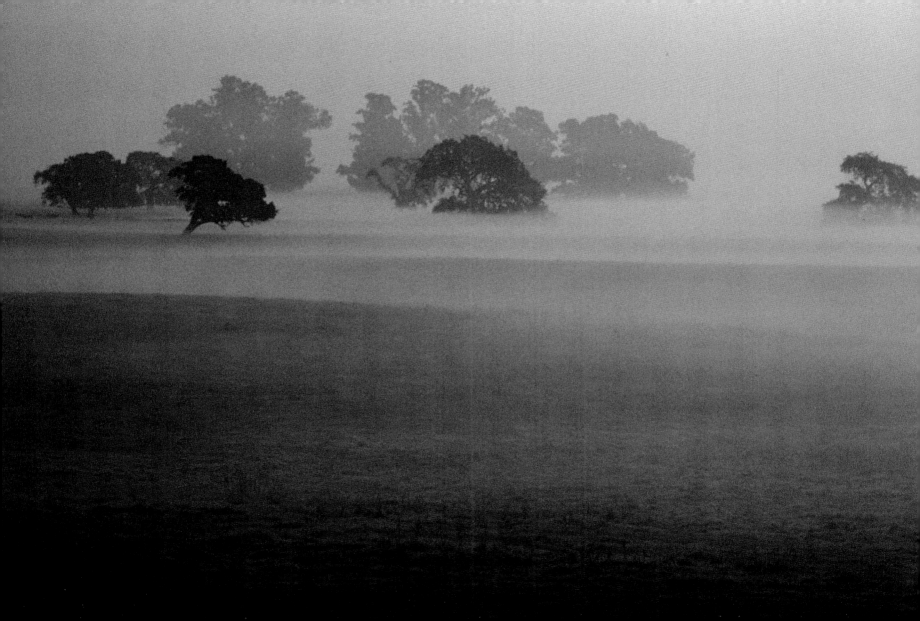

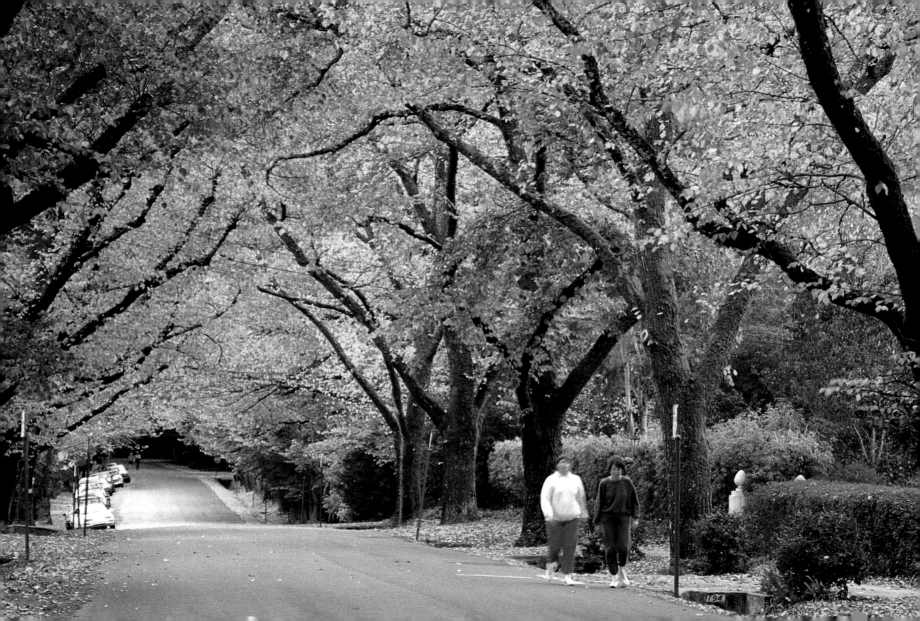

In Francis Coppola's first "Godfather" movie, there's a long shot of a boy pedaling his bike past Ross School, under the shade of the elm trees by Ross Common. The shot was meant to show the quintessential American small town, a role Ross fills to an idealized tee.

ROSS VALLEY

Ross is one of several small towns that constitute the upper Ross Valley, beginning with Kentfield in the east, through the Hub in San Anselmo, and on to Fairfax, the gateway to West Marin. Each typifies suburbia in its own way, from Ross, with some of Marin's priciest real estate, to Fairfax, with some of its humblest. Residents of each say blithely that theirs has the best climate, the finest schools, the most supportive neighborly ethos. None is lying; each town has its unique beauty, its history, its pride.

Each town also shares in modern-day concerns such as too much growth and too much traffic on the main road that holds the towns together. Sir Francis Drake Boulevard, which was built to hold fifteen thousand cars a day, by the 1990s carried sixty-five thousand.

The late Ann Walsh, onetime businesswoman and mayor of the town, described San Anselmo as a "pass-through community," because it, like the others, straddles Drake Boulevard, the main highway from urban East Marin to the rural west. Many people drive Drake Boulevard from one end of Ross Valley to the other and, though they may give a nod to Mount Baldy or an appreciative side glance at the San Francisco Theological Seminary, don't notice anything special. They're unaware that the charms of Ross Valley lie in the side streets and hidden neighborhoods, the pocket parks and vintage homes. Any driver who takes time to turn off Drake, to follow the byways wherever they lead; is invariably— and pleasantly—surprised.

Kentfield seems little more than an intersection, but look: that's the College of Marin on one corner. The two-year community college serves ten thousand degree-seeking students, and eight thousand part-timers who explore such subjects as business, math, sculpture, cosmetology, and conversational Italian. Its excellent drama department attracts theater buffs from all over.

Kentfield takes its name from the family of Albert Kent, a Chicago meat packer who settled in the area in 1872. His son William became a U.S. congressman and conservationist and donated Muir Woods as a national park. His wife Adaline gave the twenty-three acres for a community recreation center that became the College of Marin.

The Kent estate, restored to White House–like splendor by new owners, is the centerpiece of Kent Woodlands, a sylvan subdivision that adorns the eastern slopes of Mount Tamalpais. Always humming with activity, ranging from lavish moonlight dance parties to fund-raising aquacades or rallies for presidential candidates and the ACLU, the Kent estate was in the middle of this century more community resource than private home. Its new owners have somewhat renewed that tradition.

Kentfield was once the site of Ross Landing, which gave the valley its name. James Ross, a Scotsman from San Francisco, bought Rancho Punta de Quentin, a huge Mexican land grant, in 1857. He continued lumbering activities on the vast rancho, which extended from Corte Madera to Red Hill in San Anselmo, and built a wharf on the upper reaches of Corte Madera Creek, where today's Drake Boulevard meets College Avenue. There cordwood from nearby communities and lumber from the sawmill at Lagunitas were loaded on vessels bound for San Francisco and beyond.

Ross built his home in the town that bears his name, where the trees are bigger, the houses more splendid, the ambiance more Establishment than the rest of Marin. After Ross came other distinguished settlers. Today splendid old estates sit back from the winding roadways, silent tributes to stability and affluence, past and present; if the rest of Marin is bustling, Ross is not.

Satirists portray Ross as the last word in snobbery, with Ivy League mores and country club manners and ex-prom-queen housewives driving expensive foreign cars. It could as easily be portrayed as a last bastion of gracious living, where residents work together to preserve tradition. Coppola captured it as the suburban ideal. The elementary school is the town's pride and joy; the post office its social center; generations of Ross kids have played Little League ball on Ross Common.

Ross is home to The Branson School, a highly regarded prep school in an estate setting, and to the Marin Art and Garden Center, once owned by the Ross family and now a privately run community center complete with library, art gallery, kiddie playground, outdoor stage, and a barn that houses the state's oldest repertory company, the Ross Valley Players.

On its western border Ross gives way to San Anselmo, which has the busiest business district in the Ross Valley. Its county supervisor Hal Brown fondly calls it "a little nation of shops." Sandwiched between upper-crust Ross and working class Fairfax, San Anselmo has characteristics of both.

Residents of affluent Winship Park and the area around the San Francisco Theological Seminary share a common bond with those in the more modest homes at the west end of town: a love of family and a sense of community. There's a hominess about the neighborhoods. One almost expects to see a cat in each window. Citizens turn out in droves for the annual autumn wine festival and for Country Fair Day, which starts with a downtown parade, including kids on unicycles, politicians in convertibles, and firetrucks tooting their horns.

San Anselmo boasts one of the county's most successful volunteer programs—"where newcomers get involved and old-timers give back to the town," in Walsh's words. Walsh also likened the town to villages of her native Britain. It is home base for a citizen-run Campaign for a Healthier Community for Children.

The most visible landmark in town, the theological seminary, looks like a medieval fortress on a hill. Established in 1892 to train Presbyterian clergy, it attracts students from all over the United States and several foreign countries. Some of its buildings, from ivied Montgomery Chapel to the turrets and towers of Scott and Montgomery halls, have a fairytale look, and its chapels are widely used by the community for weddings, concerts, and other celebrations.

A less visible distinction is San Anselmo's reputation as the antique capital of Northern California. In a half-mile radius of downtown are one hundred and fifty antique dealers, attracting hundreds of browsers every day of the week. Their presence may account for the town's many restaurants, several of them oriented to the Ross Valley creek, which lends a bucolic flavor to the otherwise busy downtown. The creek topped its banks after memorable storms in 1925 and 1982, upending cars and destroying a number of the stores.

Past the Hub—the intersection of Sir Francis Drake Boulevard and San Rafael's "Miracle Mile"—is the highly successful Red Hill Shopping Center. Behind it, out of sight of passersby, is Sunny Hills, a residential treatment center for emotionally troubled adolescents.

Sunny Hills began more than a hundred years ago as a Presbyterian orphanage, and from its early days became the focus of charitable works. The annual Sunny Hills Grape Festival, once staged on the orphanage grounds and now held in a regional shopping center, is still one of the most successful fund-raising events in Marin, thanks to hundreds of volunteers.

The Hub in San Anselmo marks the spot where, in the 1870s, a spur track to San Rafael was added to the North Pacific Coast Railroad that ran through Ross Valley to Tomales. Long-vanished train stations still give their names to San Anselmo neighborhoods: Yolanda, Lansdale, and Bolinas Avenue.

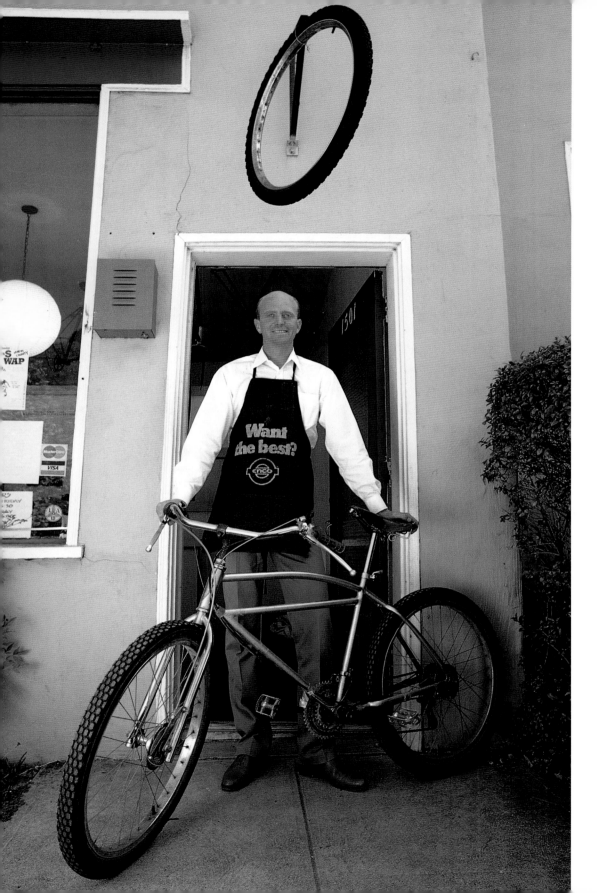

Residents stroll Lagunitas Road

in Ross on a cool

autumn day. (Previous page)

Gary Fisher, inventor

of the mountain bike,

shows off an early model

at the original shop in Landale Station,

San Anselmo, near the border

of Fairfax. (Left)

Clouds drift into a ravine

on a drizzly day near

Phoenix Lake. (Top)

A lone nasturtium blooms at the foot

of a cypress tree

in Ross Valley. (Bottom)

One of the last significant outposts of San Anselmo, just before it yields to Fairfax, is Sleepy Hollow, a residential community that actually lies in county territory but is tied to San Anselmo via Butterfield Road. Handsome ranch-style homes have been built on roads with names out of Washington Irving like Van Winkle, Ichabod, and Legend Court. At the farthest reaches of the subdivision sits San Domenico School, a private-school offshoot of Dominican College.

San Anselmo blends imperceptibly into Fairfax, which grows ever more rural, east to west. The creek in downtown San Anselmo meanders its way into Fairfax, through neighborhoods of ineffable funk and charm.

Like other towns of the Ross Valley, Fairfax grew up around the railroad line. Fairfax was originally part of a Mexican land grant to Domingo Sais, a soldier at the San Francisco Presidio. Its first settlers were ranchers. Among the most famous was Charles Snowden Fairfax, the tenth lord in a family of Scottish peers; his forebears lived next door to George Washington in Virginia. He came to California as a young man, serving in public offices around the state before settling in Fairfax in 1865. He and his wife built a home called Bird's Nest Glen, famous for lavish and bibulous entertainment. (One account describes Fairfax as "charming when he was sober, magnificent when he was drunk.")

The Fairfax estate was the site of the last political duel in the state of California. Two Democratic rivals in the State Legislature had become involved in a dispute and proposed to resolve it with guns. Fairfax served them lunch at Bird's Nest Glen, trying to head off the fight, but when lunch was done the two faced off in a meadow near the house: Daniel Showalter put a rifle bullet through the heart of Assemblyman Charles Piercy.

With the advent of the railroad, Fairfax became a resort area, like others in Marin. Vacationers from San Francisco pitched tent cabins in its wooded glens. After the turn of the century, tracts of land were divided for home sites. In 1913, developers tried to promote the sale of lots by building a funicular railroad up Manor Hill and the fifteen-hundred-foot Fairfax Incline Railway was a nickel-a-ride attraction till 1923.

The town grew slowly, and it didn't lose its one-horse flavor. Bronco Billy Anderson, the first great western movie star, filmed movies in Fairfax because it looked so much like a western frontier town.

"It hasn't changed much," as former mayor Gloria Duncan put it. An ardent conservationist, she likes it that way.

"Lots of families have lived here for generations," Ken Lippi, a former councilman, elaborated about his hometown. "People I grew up with either still live here or are hoping to come back." Many of the families descend from Italians who came in 1917 when labor was needed to build nearby Alpine Dam. When he was growing up, "the man who sold produce was Italian," said Lippi. "The lady who did sewing was Italian."

Most Fairfax residents are middle to low income, though there are lovely estates in the hills. In the 1960s, Fairfax became a haven for hippies, who camped out in the hills, lived in buses and vans, or converted old mansions into multifamily pads.

Some of that aura still clings to the town: "There's a tolerance and acceptance of many different lifestyles," said Lippi; "we're a very eclectic mix," said Duncan. Both sounded proud.

Townspeople are vocal about civic affairs. How many bars should be allowed downtown? Should styrofoam be declared illegal? And they agonize over any suggestion of growth.

Growth notwithstanding, the town looks much as it did thirty years ago, with the 1950s-style theater, restaurants like Sparky's and Pucci's, and the stores by the old railroad bed. For many, St. Rita's Catholic Church is still the cultural and religious heart of the town.

Now dormant but alive in memory as an important institution of the past is the Marin Town and Country Club. In the years after World War II the club was a major resort, with swimming pools and dance floors and picnic areas and snack bars that drew weekend crowds from all over the Bay Area. Proposals to revamp or reactivate the property—what, more traffic?—are periodically shot down. Its increasingly shabby buildings are occupied by renters.

Fairfax has another distinction as the home of the "mountain bike," a multigeared, fat-tired bicycle that in 1974 its inventor, Gary Fisher, called a clunker. His bicycles are now sold worldwide and have fathered the lasting sport of mountain-biking, which some hikers on Mount Tamalpais call a scourge but thrill-seekers call an exhilarating new way to explore the outdoors.

Civilization dwindles at the western end of Fairfax, where Drake Boulevard climbs and twists over White's Hill. There are outposts here: a horse ranch, a Boy Scout camp, and the remains of Arequipa, once a tuberculosis sanatorium for women. The north part of town disappears in much the same way, into the hills that embrace the Meadow Club and Alpine Dam. Ultimately the roads from Fairfax wind westward, over the ridge of Mount Tam, or through the valley to the sea.

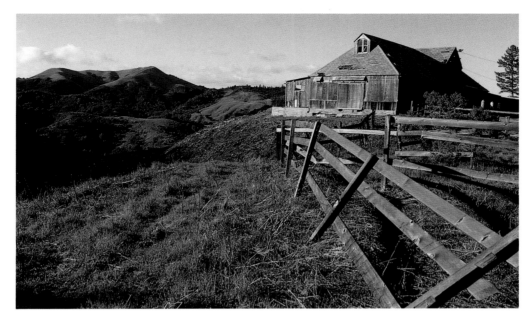

An old horse barn sits
atop a ridge near the Meadow Club
in Fairfax. (Top)
Marin Town and Country Club:
A faded reminder of this
once-thriving resort. (Bottom)

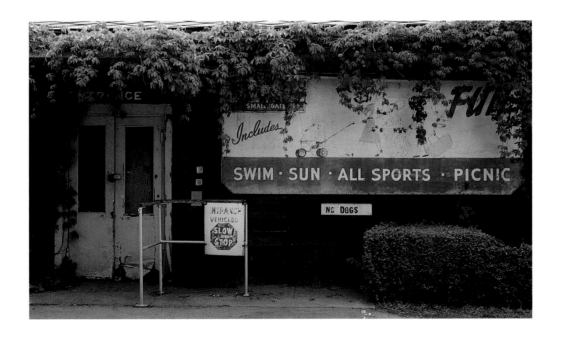

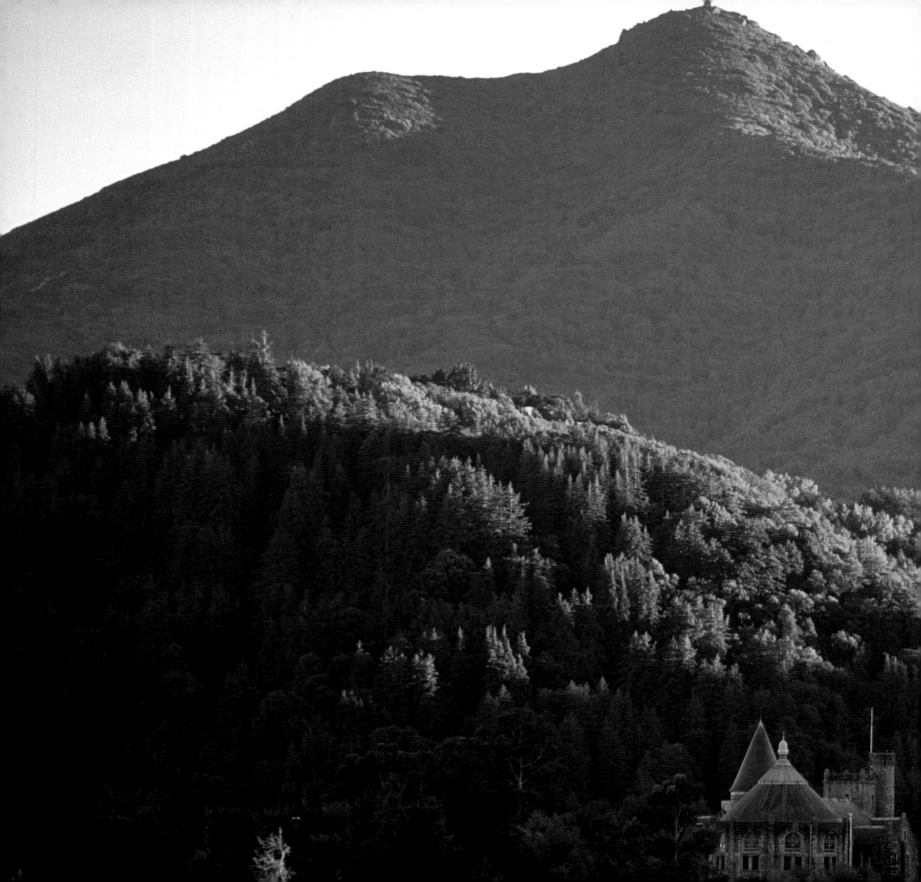

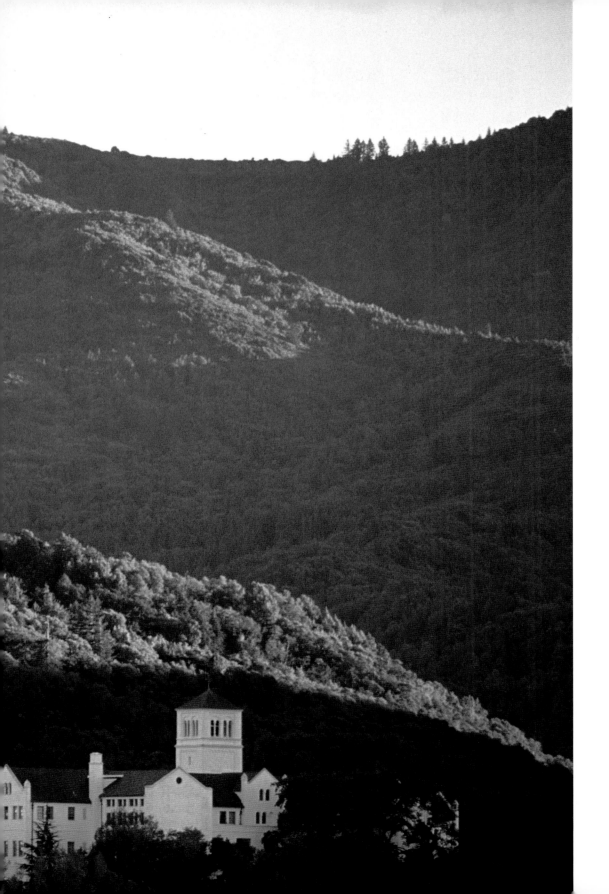

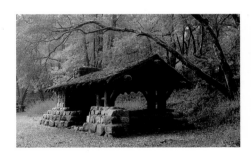

Buildings of the San Francisco

Theological Seminary

poke into sight

below Mount Tamalpais. (Left)

A flag flies over the redwood barn

next to a horse pasture in Ross. (Top)

A redwood-and-stone building

welcomes picnickers

at Phoenix Lake Park.(Bottom)

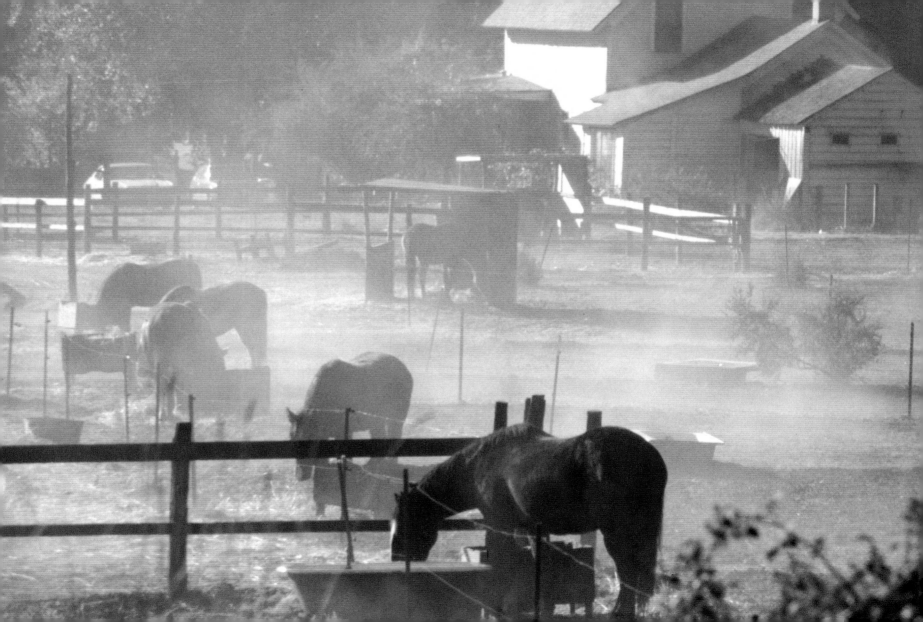

SAN GERONIMO VALLEY

San Geronimo Valley is Marin's "world between," the jumping-off place between the urban corridor of East Marin and the wide-open spaces near the sea. San Geronimo Valley is where the west begins.

Those who live in the valley—in Woodacre, San Geronimo, Forest Knolls, and Lagunitas—speak vaguely of its country-style ambiance, its live-and-let-live attitude, its free-form way of life. Those who drive through it see mile after mile of golden hills and note the movie-set Americana of a country school, a village church, and a grocery store advertising fresh-baked bread and organic produce.

Most of the homes, a mix of cabins and ranch houses, sit behind a screen of foliage next to the highway. Their yards reflect a varied lifestyle: junk heaps, art studios, vegetable gardens, and roses. San Geronimo Valley is proudly out of the mainstream of Marin, though it embodies two of the county's strongest traditions—the right to an alternative lifestyle and a fierce protective feeling for the natural environment.

Resident Marty Meade, a stained-glass artist, described the valley's loyalty to its own. When a tree demolished the Taylor house in the 1982 storm, permanently crippling mom Aniece Taylor, the community found shelter for her and her family, washed dozens of bags of their clothes (and held a "folding bee"), and maintained a years-long fund to take care of her afterward. Neighbors even built the family a new house.

Valley residents are an eclectic mix: "name your politics, attitudes, lifestyles—they're all here," said Bill Fredericksen, sitting at a table in the community Presbyterian church in San Geronimo where he was the longtime pastor. "We have wealthy, yuppie newcomers and staid, conservative old-timers; we have extreme right-wingers and extreme liberals, though the extremes are beginning to soften."

Some who live here are professional people who commute over White's Hill for jobs in East Marin, San Francisco, and beyond. Others are carpenters, mechanics, storekeepers, or retired people who have made the valley home for generations. A few ranchers remain, although their days are patently numbered. A notable group are the artists, who Meade said are not a group at all. The ceramists, painters, and sculptors do their work in remote studios and establish reputations that far transcend the valley.

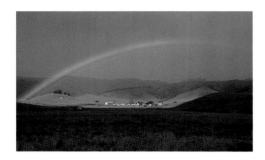

Horses feed at troughs
on a misty morning
in Forest Knolls. (Previous page)
Cows near Nicasio
are symbols of rural Marin. (Top)
A rainbow appears in the sky
over a dairy ranch on the outskirts
of Nicasio. (Bottom)
A bottle collection catches
the light in a San
Geronimo window. (Right)

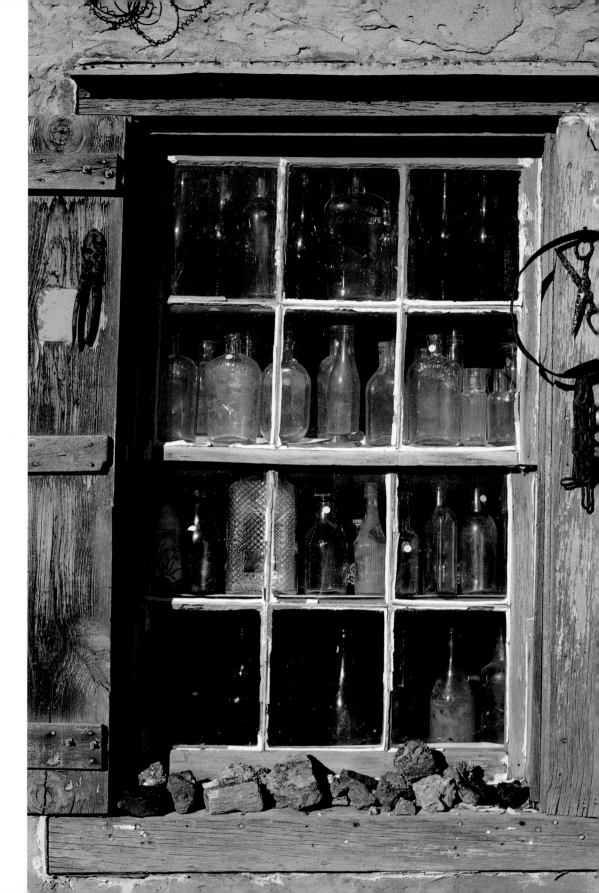

Painter Joseph Raffael lived here. Painter William Wiley still does.

When white men first came to the valley, it was a site for dairying and lumbering. Then a paper mill was built on Daniels Creek, later called Paper Mill Creek, in 1856; it made newsprint from old rags and sacks. The Pacific Powder Works was begun in 1865 on the south side of the creek. The plant was destroyed in an explosion in 1877, and was rebuilt, but was out of business by 1880. In 1874, Angelo Pedrini began a mill in Lagunitas Canyon, and several others followed. In 1877, there was a shingle mill at the foot of Nicasio Hill. Later, from 1886 to 1892, a tannery operated between the powder mill and Camp Taylor Hotel. The Camp Taylor, built in 1884, was a sprawling resort that attracted droves of weekenders who came from San Francisco by ferry and train.

The valley was once owned by Joseph Warren, a grandson of Paul Revere, and later by August Mailliard, a grandson of Napoleon Bonaparte's older brother. Mailliard built three huge ranches and brought racehorses and Jersey cattle to the valley. Mailliard's sister-in-law was Julia Ward Howe, who wrote "Battle Hymn of the Republic"; she was a guest at the Mailliard Ranch in Woodacre, as was Alexander Graham Bell, who brought his famous invention with him in a suitcase and dazzled his hosts by hooking up a telephone from the big house to the cow barn, a distance of several hundred feet. It was the first telephone in the state.

Mailliard's heirs subdivided part of Lagunitas in 1904 and sold the rest in 1912 to the Lagunitas Development Company; the taming of the valley began.

Settlement was spurred by the arrival of the North Pacific Coast Railroad in 1875. It ran through the valley en route from Sausalito to Cazadero on the Russian River. Campers came on weekends, and some of them stayed. At one point, the railroad changed from narrow to broad gauge, and was owned by North Western Pacific. There were five stations in the valley, only one of which re-mains—a wooden derelict in San Geronimo, next to the San Geronimo church.

Little towns sprang up. The Mailliard home became the Woodacre Improvement Club. World War II brought a surge of growth to the valley and summer homes were used year-round. In the 1960s, the valley became a mecca for young people who wanted to drop out of mainstream society, "people throwing off restraints," Frederickson said, "people protesting the Vietnam war."

Counterculture music came with the hippies. The Grateful Dead lived here for a time; so did Van Morrison, Quicksilver Messenger Service, and Big Brother and the Holding Company with Janice Joplin. Elvin Bishop lives here still. "The kids around here were raised on music," said Marty Meade. Everyone in Psychefunkapus, a hot 1990s band, grew up in the valley.

Each village has a distinct identity, though there's a "valley" feeling that everyone shares. "People operate on 'valley' time," said Fredericksen. "Eight o'clock means 8:15 or 8:20. People here tend to be laid back."

The town of Woodacre is probably the most like its eastern neighbors. The streets are laid out more conventionally, and there is a larger flatland, unlike the other towns, where the houses are built in the hills. San Geronimo has two landmarks on the main road: the county water treatment plant and the San Geronimo Golf Course, an improbable intrusion of suburbia. Forest Knolls is notable for its gas station-garage, the valley's only saloon, and the popular Two Bird Restaurant. The towns grow less conventional the farther west they lie. Lagunitas is almost engulfed by trees—huge sentinel redwoods that sometimes hide the free-form houses and skirt the meandering creek. After Lagunitas, civilization tails off into Samuel Taylor State Park. Beyond: West Marin.

The ties that bind the four towns together are the schools, the community center, the Woodacre Improvement Club, seasonal celebrations like the Fourth of July Parade, and the watchdog San Geronimo Planning Group:

• The school system is unique in the county, with three strong programs to choose from. There is one highly academic program, one based on open classrooms, and one following the Montessori system.

• In the early 1960s, citizen effort saved an old school building from demolition and turned it into a cultural center that now houses a day care center, art classes, and a food distribution center for the needy.

• For years, the Woodacre Improvement Club has given the valley a swim program, a senior center, and facilities for parties and weddings.

• Everyone in town turns out for the Fourth of July parade, which features kids, old-timers, and housewives. Meade's favorite in past parades was a group called The Infantry—Moms pushing strollers, doing maneuvers on the street.

• The planning group was founded in 1972 to help scuttle a county plan for the valley that called for a six-lane highway and many thousand new homes.

"We wanted to preserve the rural character of the valley," said Jean Berensmeyer, a local leader who, with others, devoted five years to rewriting the plan. "We wanted to keep the ridges free of homes and to keep the density down. Now—outside of the villages—our density is forty to sixty acres per home. I'm so proud of that."

The group continues to monitor growth in the valley, exasperating some, delighting others. Group efforts have helped keep most of the ridgeland in permanent open space.

The valley is not without its problems, some minor and some eternally major. Everyone worries that growth is inevitable, as urbanization spreads west from the county's center. So far, the towns are still more rural than citified. Homes still use septic tanks and propane, and the nearest high school, supermarkets, and laundromat are still "over the hill" in Ross Valley.

"It's still an escape spot, a retreat place," said Frederickson. "People still look out their windows and see open space."

"There's nothing more wonderful than watching the salmon spawn up my creek," said Meade. "Friday nights, my husband and I walk to the Two Bird for dinner, past the wild roses and sweet peas. One year I scattered hollyhock seeds."

NICASIO

Nicasio is a very small town, little more than a square in the road. The square was established more than a hundred years ago, back when residents were hoping the town would become the county seat, as a site for government buildings.

The square is still there, but the government buildings are not. Others stand in their place: a metal-spired church, a general store and post office, a Druids Hall, a popular roadhouse restaurant, and a paintless building that once held a blacksmith shop.

Today's square is a page from town history. "I'll bet if you could go back a hundred years, the square wouldn't look much different," said Ken Marshall, the restaurant proprietor.

Only Marshall's establishment, the Rancho Nicasio, is less than a century old; it sits on the spot where the Hotel Nicasio stood from 1867 to 1940, when this sleepy town bustled more than it does right now. Back then, Nicasio was a hub for lumber and dairying. As the geographic center of Marin it was a crossroads for farmers and businessmen shipping their goods to more urban centers.

Nicasio was once given as a land grant to the Miwok Indians who had been displaced by Marin's white settlers, but white men soon claimed it, too. An early settler was Henry Halleck, who later became a Union general in the Civil War. Gradually the land was sold off in small parcels. Sawmills made lumber from the huge oaks and redwoods.

In the 1860s, the town sought to be the county seat. The state legislature had picked San Rafael on a temporary basis in 1859, and within a few years towns outside San Rafael petitioned for a more central location. Nicasio made a strong bid against such neighboring villages as Olema. Nicasio even raised a "county seat flag." But legislators stuck with San Rafael because it was more accessible. Nicasio lost by one vote.

The lumber industry of that era is long gone, but the dairy ranches remain—huge stretches of gently folding hills, unmarked except for fences, trees, and conclaves of cows, switching their tails in the sun. West of town, the roads empty into ranch country, vast open spaces accented by weathered outbuildings and neat farmhouses, with swinging signs and mailboxes next to the road. The signs name ranchers who have been here for generations: La Franchi, Dolcini, Tomasini.

Nicasio, like the rest of Marin's ranchland, is struggling to stay rural as the pressures of urbanization push westward. The Marin Agricultural Land Trust (MALT), which buys up development rights from agricultural owners, has helped many old-timers hold onto their land, but some is already gone, carved into "ranchettes" where wealthy retirees play gentleman farmer and professional people who long for a country life build big homes with picturesque horse barns out back.

A landowner's association keeps a weather eye out to make sure Nicasio stays rural. If a new home is built, it must be hidden from the road.

There are hardly any of the modest homes left that were here when the town was a hub. County zoning now decrees sixty-acre lots, whose prices start in the hundreds of thousands of dollars. Nicasio is a small town, but an affluent one.

Nicasio sits in a valley, defined like other Marin communities by the hills that surround it. The road from East Marin passes horse farms and country estates and George Lucas's film studio, Skywalker Ranch; then for about a mile the sunlight disappears in a stand of redwoods, and suddenly—you're in the square.

If San Geronimo Valley is where the west part of the county begins, the square, said Marshall, is its gateway. Indeed, most people drive on through, slowed only momentarily by the zig-zag in the road. But many stop, perhaps bemused by the picturesque white church (St. Mary's of Nicasio Valley, established in 1867) or the western facade of the Rancho Nicasio, a wooden structure housing the pocket-size post office, a general store smelling of garlic sausage and pickles, and the restaurant that has been a destination for most of the last fifty years.

The Rancho Nicasio is a drop-in place for locals, cyclists, long-distance runners, and an occasional movie star doing work at Skywalker Ranch. Point Reyes National Seashore, a few miles distant, attracts visitors from all over the world, and many stop on the way for a beer or a burger or a full-size meal. The rancho lay idle for six years in the 1980s, after an ill-fated attempt to turn it into a nightclub with stars like the Judds, Huey Lewis, and Santana.

Now Rancho Nicasio is the family-style attraction it used to be, the site for weddings, retirement parties, property owners' meetings, and reunions. The walls are hung with stuffed animal heads, hunting trophies brought here from distant parts. Nicasio has no water buffalo or elands on its premises, but there are plenty of deer, bobcats, mountain lions, and foxes. Peacocks scream by the creek, and flocks of wild turkeys make their home in the ranchlands.

The town's social life is at the rancho, or at the Druids Hall, or with the ladies auxiliary of the volunteer fire department, which throws a barbecue every year. Kids still play Little League ball in the town square.

A little red schoolhouse, built in 1871 and preserved by its owners, the Shone family, is a landmark and source of town pride. "We still have the blackboards that came round the Horn," said Rocky Shone. "The old bell is still in the cupola."

*Deer share the quiet
of a summer evening in
San Geronimo. (Top)
A young horsewoman enjoys
a fall day in San Geronimo
Valley. (Bottom)*

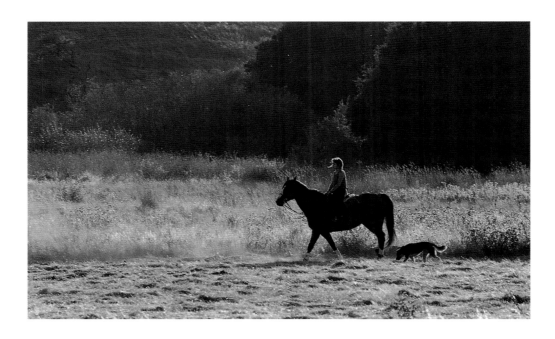

Shone is proud of Nicasio's heritage, happy it has preserved so much of its past. "We still don't have a service station," he said. "And the real estate office is closed most of the time."

SKYWALKER RANCH

The last place you'd expect to find a movie studio is among the oaks and horse farms of Nicasio. That's OK—George Lucas doesn't want you to find it anyway. Skywalker Ranch, the postproduction facility and movie think tank that Lucas built in 1985, is secluded from passersby on twenty-six hundred acres off Lucas Valley Road. Designed to look like a century-old farm, albeit a fabulous one, Skywalker is a private fantasyland. You can't even see it from the road.

The fifty-thousand-square-foot Main House where Lucas has his office is trimmed with turrets and dormers and wrap-around porches. The huge recording and editing building looks like a winery. Other offices hide out in the Carriage House and the Stable; the blue Victorian farmhouses near the entrance gate look like America, 1890.

"I didn't want people to see it and say 'why did you build it?' " Lucas said when we sat in his office, decorated with 19th-century art and wired for 21st-century technology. "I wanted them to ask 'How did you find this old place?' "

Skywalker Ranch is nestled amid the oaks and hills of what was formerly Bull Tail Ranch, a refuge for hunters and grazing land for cows. Since 1985, Skywalker has been the business headquarters for Lucas, the creator of *Star Wars, American Graffiti,* and *Indiana Jones.*

Only invited guests get past the gatehouse. "If everyone came to visit," a spokesman said, "we'd never get anything done."

The rural illusion comes hard. High-profile visitors—Michael Jackson, Robert Redford, Jack Nicholson—come and go, and Marin eventually finds out. Skywalker may be off-limits to the public, but it can't really hide.

The one-room Nicasio schoolhouse

is now a private home.

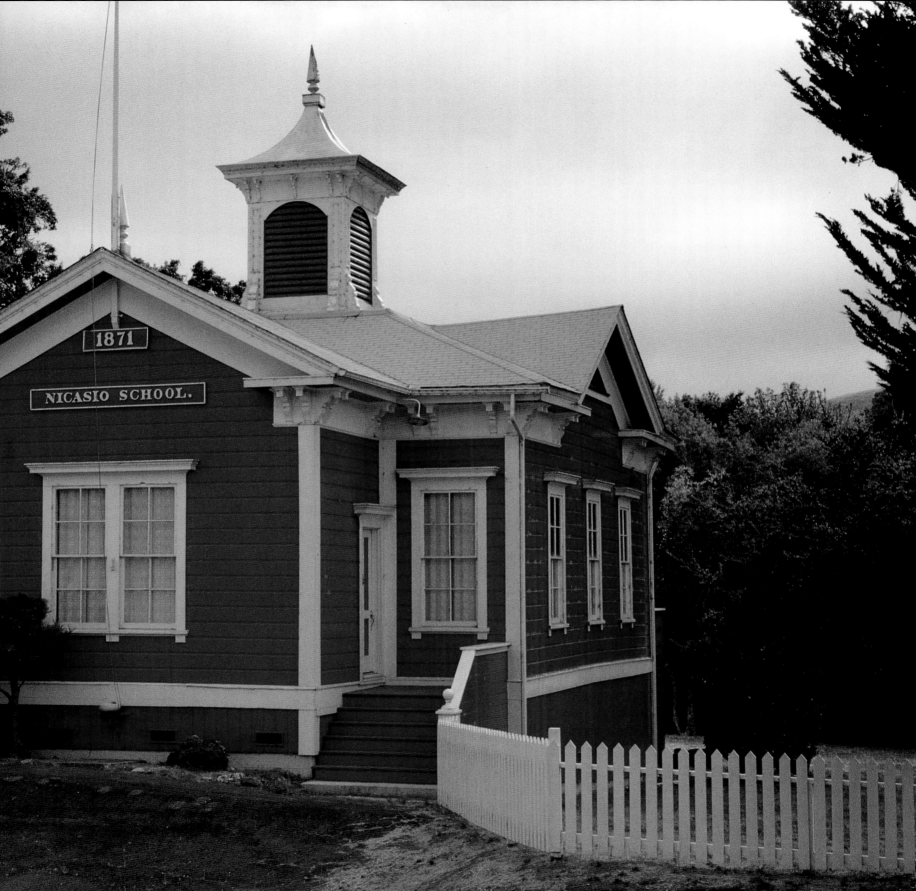

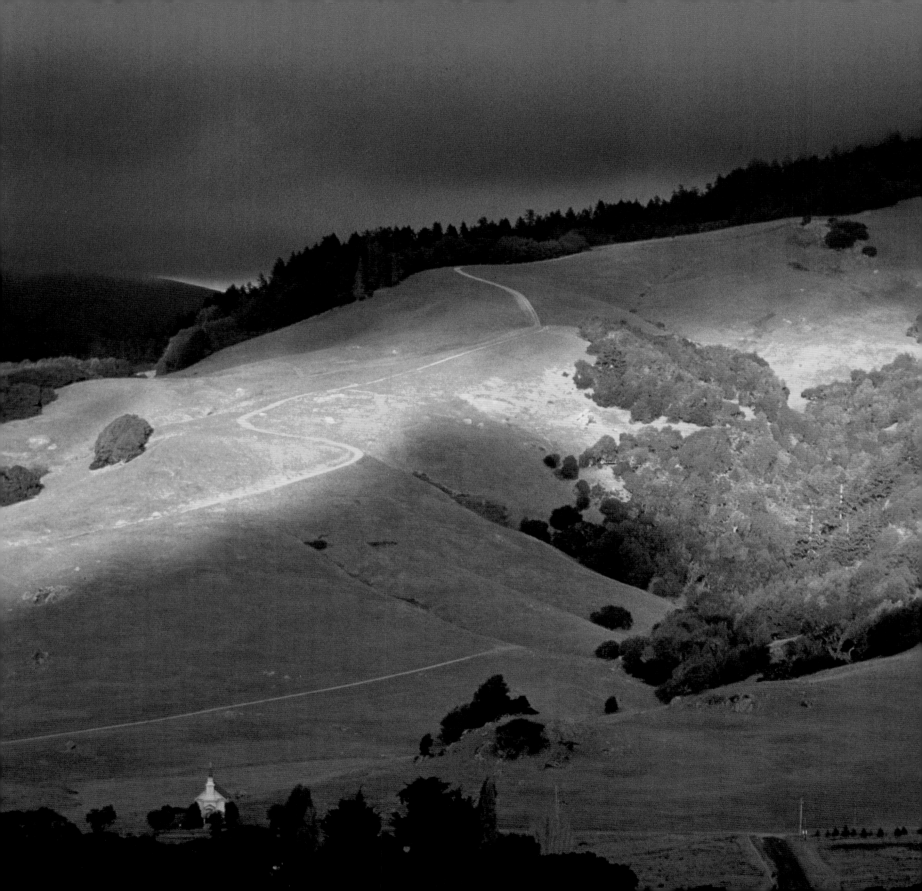

Nicasio's St. Mary's Church
gleams amid the sun
and shade of surrounding
pasturelands. (Left)
Golden hills in San Geronimo Valley
form a typical
Marin landscape. (Top)

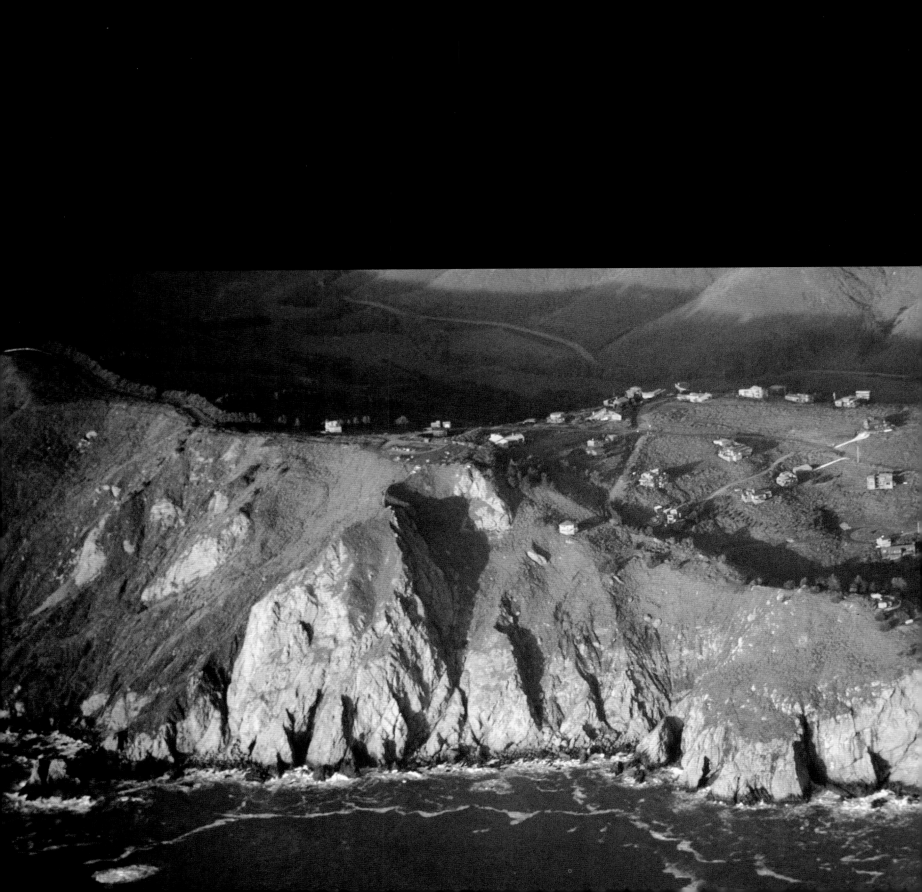

THE COAST

The coastal towns are the outposts of Marin civilization—as far as you can get from the city bustle, as close as you can get to the sea. Hardy residents put up with long commutes and foggy days to call these dream spots home. "It's a lifestyle choice," said one resident. "Do you want convenience, or do you want to really like where you live?"

The towns, ranging from Muir Beach in the south to Dillon Beach near the Sonoma border, are incontrovertibly tiny, jammed against the coast by public lands and ancestral ranches. Most have changed little since their founding, well over a century ago. Muir Beach, for one, has no place to grow. A tiny enclave hemmed in by GGNRA parklands, the town is built in tiers on a pine-covered bluff overlooking a cove. There's not much here besides houses, and villagers like it that way.

When a homesick Englishman named Charles Felix sought to build a Tudor-style inn at Muir Beach in 1979, the villagers rose up in arms. "The county simply couldn't understand that we didn't want any commercial activity here," said a resident at the time. "They said 'You don't want a general store? You don't want a gas station?' Every place in the world has a general store and a gas station!" Every place but Muir Beach, that is, which still has neither.

Pelican Inn was built anyway. Residents go there to drink ale and play darts. The real core of town is the chalet-style community center, built by volunteers and used for holiday parties, weddings, potluck suppers, and memorial services.

Well out of town is the Zen Center and Green Gulch Farm, on the southern side of the cove. The organic gardeners and followers of Zen keep as much to themselves as the residents of Muir Beach, who prize their out-of-the-way lifestyle.

North of Muir Beach is Stinson Beach, the most visited of the coastal towns. It is the finish line of the famous Dipsea Race and site of a large public beach. On summer weekends, the roads are clogged with sunseekers, eager to ride the long combers or sniff the clean salt air. Bordering the beach is a handsome park area with trees, lawns, barbecues, and picnic tables. The town straddles Highway One, with

a couple of seafood restaurants, gift shops, a book-store, art gallery, and library. On random lanes off the roadway are beach cottages and a couple of motels.

There's a salt-spray feel to the town—young people in bare feet, cars with surfboards on top, driftwood and boats in most front yards. Houses climb the hillside above the town, the olio of flatland cottages giving way to architecturally correct showplaces with gardens and ocean views.

Residential Stinson strings itself out along the shore as far north as it can. More cottages, many of them upgraded into model homes, crowd the lanes between Highway One and the beach. The posh part of town—Seadrift—is a spit in Bolinas Lagoon, with the ocean on one side, the lagoon on the other. Many of its homes are for weekend-ers, here to jog, garden, beachcomb, entertain, or enjoy the view from their picture windows.

Highway One follows the lagoon, past Audubon Canyon Ranch, and the unheralded turnoff to Bolinas. In spring, the shore is lined with people digging clams.

Each coast town is unique, separated from its neighbor by long open stretches. North of Stinson civilization momentarily disappears; all you see are trees, hills, a farm or two, cows. And then comes Olema, the gateway to Point Reyes National Seashore. Olema is little more than an intersection today, although once it was a rip-roaring pioneer town featuring two hotels, seven bars, and a racetrack. A stagecoach brought week-end visitors from San Rafael.

A back-when flavor persists in the steep-fronted buildings that remain, among them the general store, the countrified Farm House restaurant, and the Olema Inn (founded in 1876) that is now an upscale watering hole. Gone is Gamboni's butcher shop, its old-west facade sent to the Smithsonian Institution in Washington, D.C., as part of a display on the American past.

Olema is notable as well for the sizable RV park on its outskirts, and for the Vedanta Retreat, a two-thousand-acre swatch of land (complete with Italianate villa) that is operated as a spiritual center by followers of Swami Vivekananda.

Not far from Olema, the road splits off to Inverness on the west shore of thirteen-mile-long Tomales Bay. Inverness is a town of visible splendors and hidden delights. It has views: almost every house looks out on the bay. It has forests: from Sir Francis Drake Boulevard, which borders the bay, the land tilts up to Inverness Ridge, where homes of every design hide out under towering trees. It has "quaint": weathered piers, a country store, a tiny Episcopal church.

Twice in recent years, it has seen tragedy. Winter storms in 1982 brought flooding, landslides, power outages: the town was cut off from the rest of the county for days. In 1995, a fire on Mount Vision burned more than forty homes.

Once a weekend retreat, Inverness now has a solid core of year-round residents. Many artists live here, as well as builders, tradespeople, retirees, and professional people who commute to the city. There's a strong community feeling: when they lost their home in the Mount Vision fire, ex-State Senator Peter Behr and his wife, Sally, survived on the kindness of neighbors. "They've brought food and clothes, everything we could possibly need," said Sally.

Many tourists find their way to Inverness, en route to Point Reyes or the beaches of Tomales Bay. Some stop at the town's notable Czech restaurants—Vladimir's and Manka's—or at one of several bed-and-breakfast inns.

On the other side of Tomales Bay, north of Olema and slightly inland, is Point Reyes Station, looking like the stage set for a wild west movie. Point Reyes Station is the commercial hub of West Marin, but it is only three blocks long and a couple of blocks deep; many of its roads dead-end in the fields. Commerce here is oddly mixed: a bar, a

couple of restaurants, Toby's Feed Barn, and a grocery store, plus some gift shops, real estate offices, an art gallery, and a massage parlor. The most imposing structure, the red-brick Grandi Building, was once a hotel for railroad workers but now stands eerily vacant.

One of the town's claims to fame is its weekly newspaper, the *Point Reyes Light,* which won a Pulitzer Prize for its exposure of Synanon, a bully-boy cult for recovering drug addicts that hid in the area for years.

Point Reyes Station began as a railroad town; the first train came through in 1875, on its way to Tomales. A hotel was built, and trains stopped for twenty minutes so passengers and crews could have lunch and belly up to the brand-new bar. What is now the downtown was then the rail yard; the Red Barn community center was the engine house, the post office, the depot. The rail-road disappeared in 1933, a victim of the auto car, the trucking industry, and newly paved roads.

The town remained as a service center for surrounding ranches, a home for artists and the self-employed, and a getaway destination for those who love rural life. They live in an agglomeration of period cottages and ranch-style homes, many with picket fences and tidy gardens. A tiny church has been remodeled as part of the modern community Dance Palace, where arts and exercise classes are held every day. Here and there is a touch of the 1960s—tie-dye curtains, rainbow graffiti, and bumper strips for neglected causes.

Public and private agencies in town serve the region's elderly, the indigent, and a sizable population of Hispanic farm workers, many of whom speak no English. The majority of Hispanics come from one town in Mexico, Jalostotitlan in Jalisco, and now live on remote dairy ranches, typically in trailers supplied by the ranchers.

Point Reyes Station is surrounded by such ranches, operated by families who have been here for years. For miles along the shore of Tomales

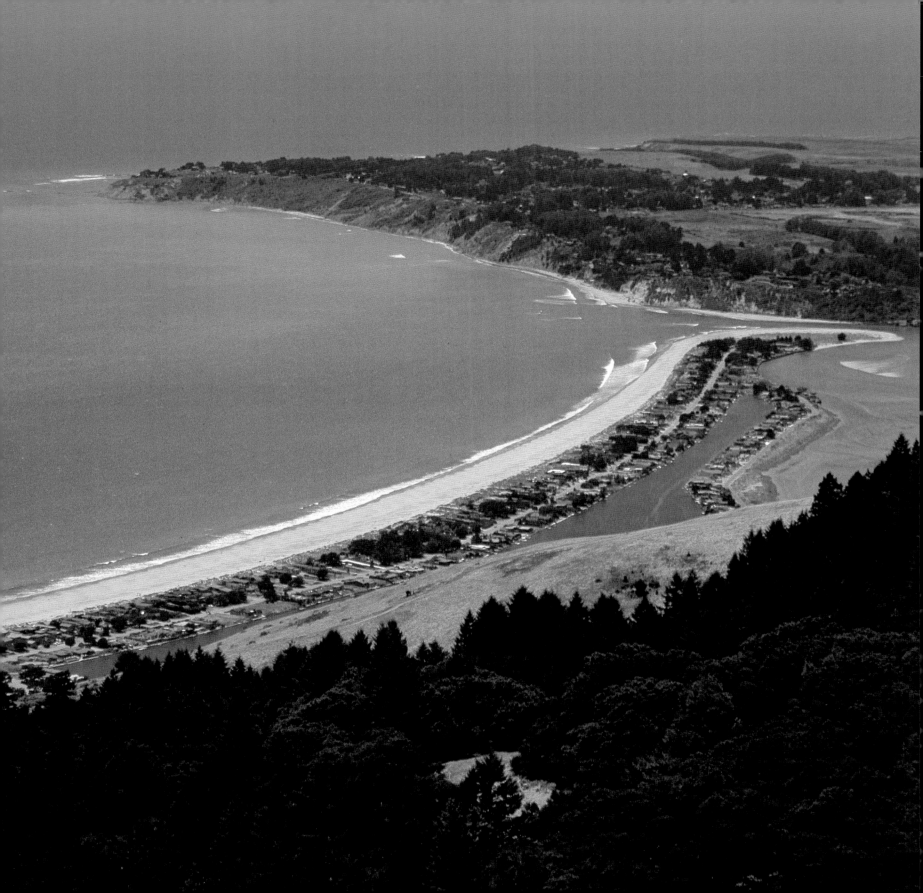

Bay, farms make up much of the landscape. Driving north, you come to the Tomales Bay Oyster Company, the oldest in California, where restaurants and drop-in customers buy as many as ten thousand oysters a day.

Marconi lies alongside a cove filled with skiffs and sailboats and fishing boats; it is not really a town but the site of the Marconi wireless station, named for the inventor of radio. Marconi's station is now a conference center. Built in 1913, the trans-Pacific wireless station was a marvel of its day, part of a communications system that circled the world. A two-story Mediterranean-style hotel was built on the property and still stands today.

Marconi runs into Marshall, which was born as a railroad town but grew up as a resort for hunters and fishermen. Today it harbors two oyster companies, a seafood restaurant, and the sprawling Marshall Boat Works. The shore is lined with boats of all kinds, at anchor, on blocks, and on trailers. A few houses cling to the narrow roadway, their feet dipping into the bay. The town is not thriving—what was once a tavern is boarded up and losing its paint—but if charm counts, it will surely survive.

The road from Marshall leaves the coast and follows the path of the long-gone trains along Walker Creek to Tomales. The remains of a rusted railroad bridge still stand in the creek. Just outside of Marshall you pass tiny St. Helen's Church, a Victorian-age jewel and a harbinger of things to come as you wheel into Tomales.

Tomales has two old churches of its own—the ornate, steep-roofed Church of the Assumption with a tall, four-cornered belfry, and behind, the squared-off Tomales Presbyterian Church, with a tree-bordered graveyard at its rear. The churches stand at the highest point of what's called Upper Town; once there was a Lower Town, founded by potato farmer John Keys in 1850. Tomales has another potato farmer in its history: horticulturist Luther Burbank lived here briefly a quarter-cen-

tury later. While in Tomales, he developed the Bodega Red potato.

The churches aren't all that remains of Tomales's past. There are the William Tell Hotel-restaurant-bar, the arcaded U.S. Hotel, the barnlike town hall, and Diekmann's General Store with its oldtime Victorian front. You'd almost expect wooden sidewalks.

East of Tomales is an anomalously modern high school that serves farm families for miles around.

Marin County Supervisor Gary Giacomini, who has a slew of rancher-relatives in West Marin, calls Tomales a "redneck town," but he does so fondly. Every West Marin town is different, he said, united only in the fight against change. Tomales might not mind a little growth, but not at the expense of its heritage.

Driving north out of town, you're on the road to Dillon Beach, the last town before the Sonoma County border. Located at the mouth of Tomales Bay, where the bay runs into the sea, Dillon Beach is mostly beach cottages and tourist attractions. The Lawson family designed it that way; they operate the general store, tourist cabins, a day beach, and a huge campground for RVs. The town has three levels: the beach, the small houses above the beach, and a modern-day development (Oceana Marin) on the high ground beyond.

The first settler in the area was George Dillon, an Irishman who came in the 1880s. He built a hotel and dining room at the mouth of the bay, and he ran a stagecoach to Tomales to find customers. The hotel was bought by the Lawson family in the 1920s. In 1926 Howard Lawson began marketing the area as "The Family Playground of Marvelous Marin County." His brother Walter Lawson bought the adjoining ranchlands. Today, Lawson family members operate both Lawson's Resort (the town) and Lawson's Landing (the campground). On the beach by the RV campground, day visitors and campers dig for horseneck clams, some as big as your fist.

Dillon Beach is the end of the road; back in Tomales Highway One continues north a few miles, before Marin runs out at the Sonoma County line.

AUDUBON CANYON RANCH

Audubon Canyon Ranch is strictly for the birds and for bird people. It's one of the largest rookeries on the West Coast, where two hundred egrets come to mate every spring. A single egret—snow white, regally graceful—is a sight to behold. Egrets by the dozen can be dazzling.

The annual ingathering of the giant birds, with wing spans of four and a half feet, draws more than twenty thousand visitors each year.

The egrets, along with dozens of larger great blue herons, nest in a grove of redwood trees in a hollow of hills facing Bolinas Lagoon. From Highway One near Stinson Beach, what you see is Bourne House, where the resident manager lives, but behind it is the milking barn that is now redesigned as a museum. Photo displays tell the story of the egrets and herons and the ecosystems that flourish in the regions nearby.

The best view of the birds is from Henderson Overlook, a half-mile from the building up the Alice Kent Trail. Mounted telescopes allow a close-up look at the birds, who begin to arrive in late February and March. The birds build treetop nests, and within two weeks of mating females lay their jumbo-size eggs. Four weeks later the fledglings are born, and visitors can watch the big birds feed their young.

The birds' nourishment comes from Bolinas Lagoon, where they stalk food in the shallows. Male and female birds divide equally the task of guarding the nests and feeding the babies. Despite such care, half of the nestlings die.

Most of the survivors disperse south, as far as Baja and Mexico; some stay year-round in the lagoon. Others find their way to creeks and wetlands elsewhere in Marin, an ongoing visual joy.

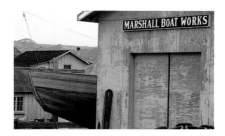

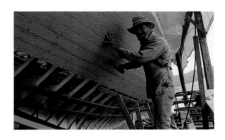

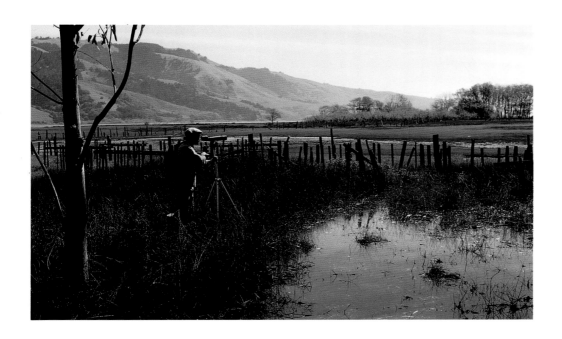

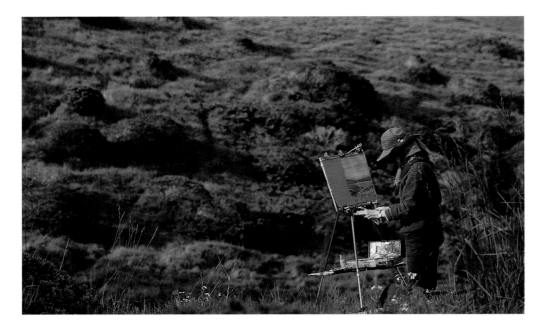

Cliffs near Muir Beach. (Page 84)
Stinson Beach. In the upper crescent,
Bolinas; in the distance,
Duxbury Reef. (Previous page)
A bird-watcher in wide open
spaces near Bolinas,
and a painter near Kehoe
Beach. (Left, top and bottom)
A handmade, wooden-hulled boat
at the Marshall Boat Works,
and with his own, Babe Lamerdin.
(Above, top and bottom)

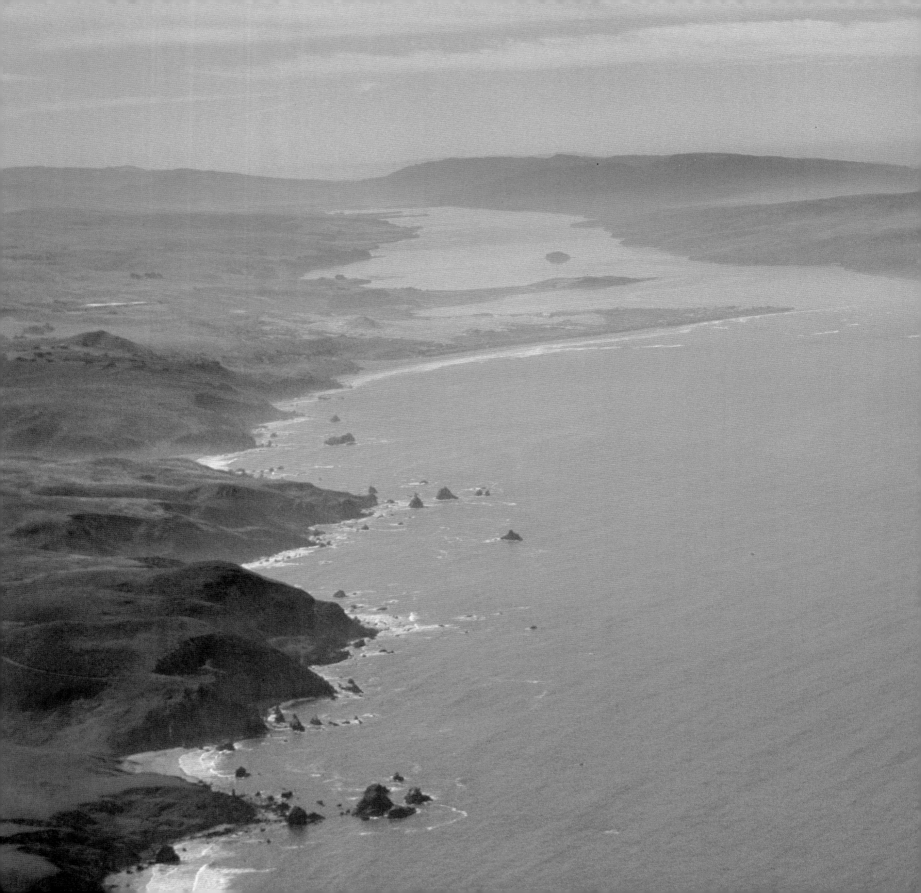

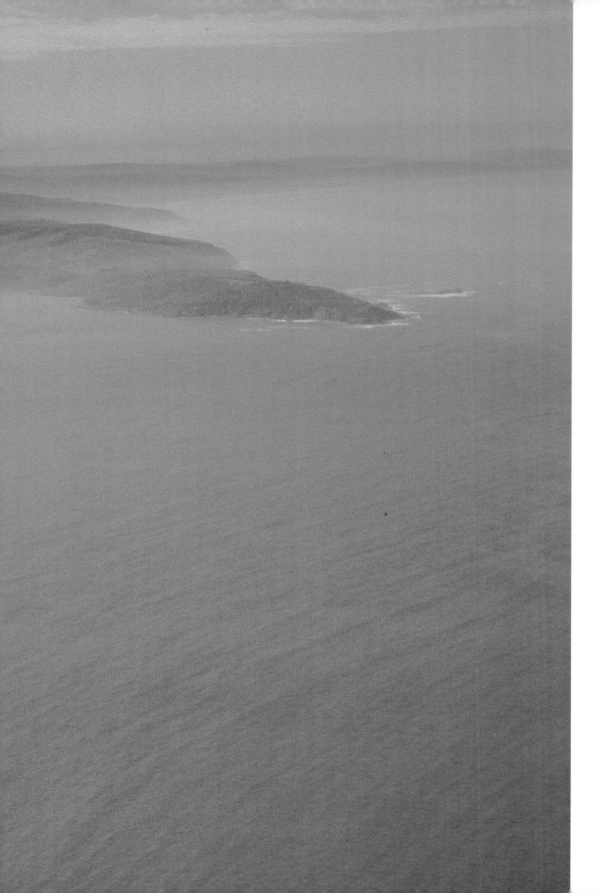

An aerial view shows
Tomales Bay and (at right)
Point Reyes Peninsula,
which geologists believe is moving
northward about two inches a year. (Left)
The Pelican Inn: A bit of
Old England at Muir Beach. (Top)

Bolinas—the town that dare not speak its name.

That's the popular image of this small coastal village near Stinson Beach, a couple of miles off Highway One. For twenty years, residents have been pulling down the signs announcing the turn-off to their town. When state highway crews put up new ones, down they come, to show up later as dart boards or Ping Pong tables in residents' homes. The idea is that Bolinas wants to be left alone, to stay forever as it has been since the turn of the century—a small-town charmer unspoiled by tourism and technology.

"Bolinas has always been full of characters," long-time resident Don Deane commented to me, "most of them rugged individualists."

The town is barely big enough for the five thousand who already live there, hemmed in between Highway One and the sea. Its southern boundary is the 1,034-acre Bolinas lagoon, which years ago served as a harbor and now, after siltation from excessive logging in the nearby hills, is a shallow tide flat, a feeding ground for egrets and herons and a basking place for harbor seals on a warm sunny day.

The road into town sweeps past the lagoon through a colonnade of eucalyptus trees, wends its somewhat crooked way past a farmhouse or two, and ends abruptly "downtown" at a jumble of buildings that include an art gallery, a museum, an arklike general store, and spiffed-up cottages containing a bakery, a dress shop, and a couple of bed-and-breakfasts. Cars clog the street—some drivable, some part of the permanent landscape near Bolinas Garage.

At one end of Wharf Road is Smiley's, the town bar, which claims to be one of fourteen saloons in the state in permanent operation for more than a hundred years.

Near Smiley's the road veers right, past a string of cottages sitting on stilts in the lagoon. The road ends in a slab of beach. Here, at the mouth of the lagoon, combers from the ocean break into sun-filled ripples that dance inland. The town itself has about seven hundred houses, half in the tiny downtown or in Gospel Flats (there were once three churches there); the rest are strewn willy-nilly across the mesa, where a strong wind blows most of the time and half the streets are unpaved to this day.

Bolinas began life as part of a Mexican land grant to a soldier named Rafael Garcia, who gave the Bolinas portion to his brother-in-law, Don Gregorio Briones. The Briones hacienda, built in 1849, still stands near the Olema-Bolinas Road, probably the oldest house in Marin. First used as grazing lands for cattle, Bolinas became a logging center when the Gold Rush brought a building boom to San Francisco. Lumber felled on the Bolinas ridge (and butter, hogs, cattle, and hides) were carried to the city on schooners loaded in the lagoon.

Eventually Bolinas became a tourist destination with three hotels. Its resort status changed forever when the 1906 earthquake dumped two of them into the lagoon. Change crept into the tiny town anyway, accelerated in 1927 by the carving of the mesa into home lots, many problematically small.

In the late 1960s, Bolinas became a haven for hippies fleeing San Francisco's Haight-Ashbury. Nature lovers discovered it in the 1970s, first when an oil spill on the shore in 1971 brought hundreds of volunteers to Bolinas to save oil-drenched birds and animals.

Who lives here now? People of every stripe, from retirees to ranchers, tradespeople to artistic recluses, Portuguese farmers to commuters who work "over the hill" in East Marin, San Francisco, the East Coast, or Europe.

"It's a refuge for most of us," said Deane, who owns Smiley's bar. "American history is people going west," said bakery owner Dave Sobel, whose organic-flour breads and carrot cakes are a town institution. "Bolinas is as far west as you can get."

"Outsiders say 'Bolinas is a circus, it's full of hippies,'" said environmentalist Kenny Feld, who has combined a career in entrepreneurship with a crusade to save the rain forests of Mexico, "but in fact the people are well educated and very, very bright. They're reasonable, compassionate, considerate. It's just that a lot of them have rejected the hypocrisy and other things in our society that don't make sense."

Villagers come together for town celebrations. A parade of one-man bands and homemade floats marks the Fourth of July; the postmistress sings "The Star-Spangled Banner," and a team from Bolinas holds a tug of war across the mouth of the lagoon with a team from Stinson Beach.

On Labor Day there is dancing in the street, and on Thanksgiving a come-one-come-all feed at the community center. For years there was a Sun Festival to celebrate summer: "Lots of weird and wacky costumes," says Deane, "and a spectacular event at the beach—a creature rising out of the sea."

Bolinas has its serious side, too: Bill Niman and Orville Schell run their organic beef cattle ranch on the mesa; Michael Lerner runs Commonweal, a health and environmental research organization; Full Circle operates a farm-home-school for troubled kids. At the end of the mesa is the Point Reyes Bird Observatory, which monitors bird migrations and does research on the Farallone Islands.

On the crooked lanes, in the motley houses, and behind the picket fences and wild beach gardens are book publishers, movie makers, computer whizzes, and hard-working artists of all kinds. They came here for peace, and they're determined to keep it.

"Twenty years ago I thought the keep-out attitude was unfair," said Deane, sipping coffee at Smiley's bar. "But after seeing what's happened to communities like Mendocino—a depot for bric-a-brac imported from San Francisco—I am not so sure."

"I'm not a person who tears down the signs," said Feld, shaking his head. "But I support the people who do."

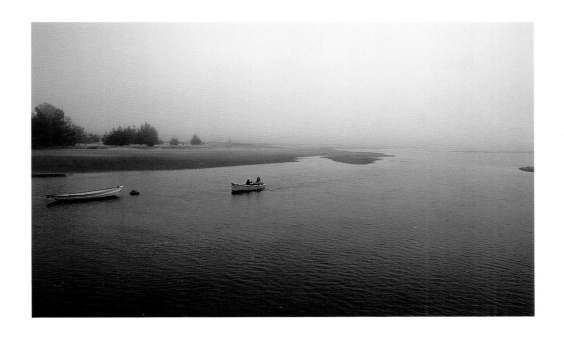

Seadrift is at left, Bolinas at right
in this portrait of the entrance
to Bolinas Lagoon. (Top left)
Surfers approach waves
at Drake's Beach. (Bottom left)
Bird-watchers at Audubon Canyon
Ranch watch egrets and herons. (Top)
A couple enjoys sunset
on Drake's Beach. (Bottom)
Hog Island, Cypress Grove,
and two sailboats create a tranquil scene
on Tomales Bay. (Following page)

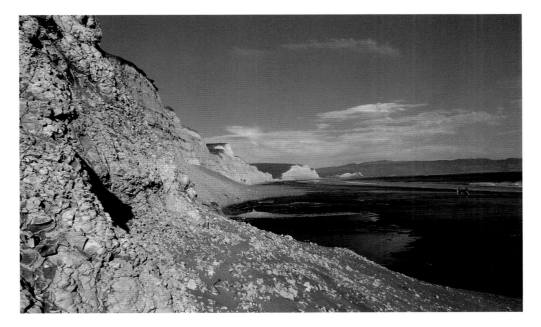

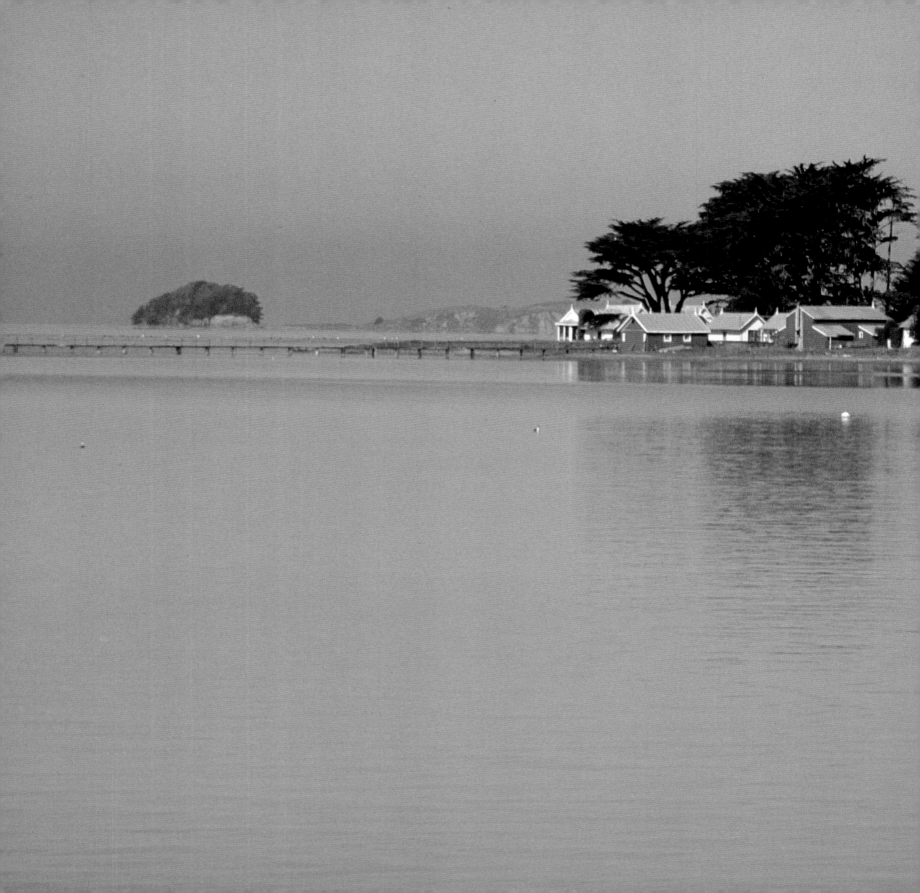

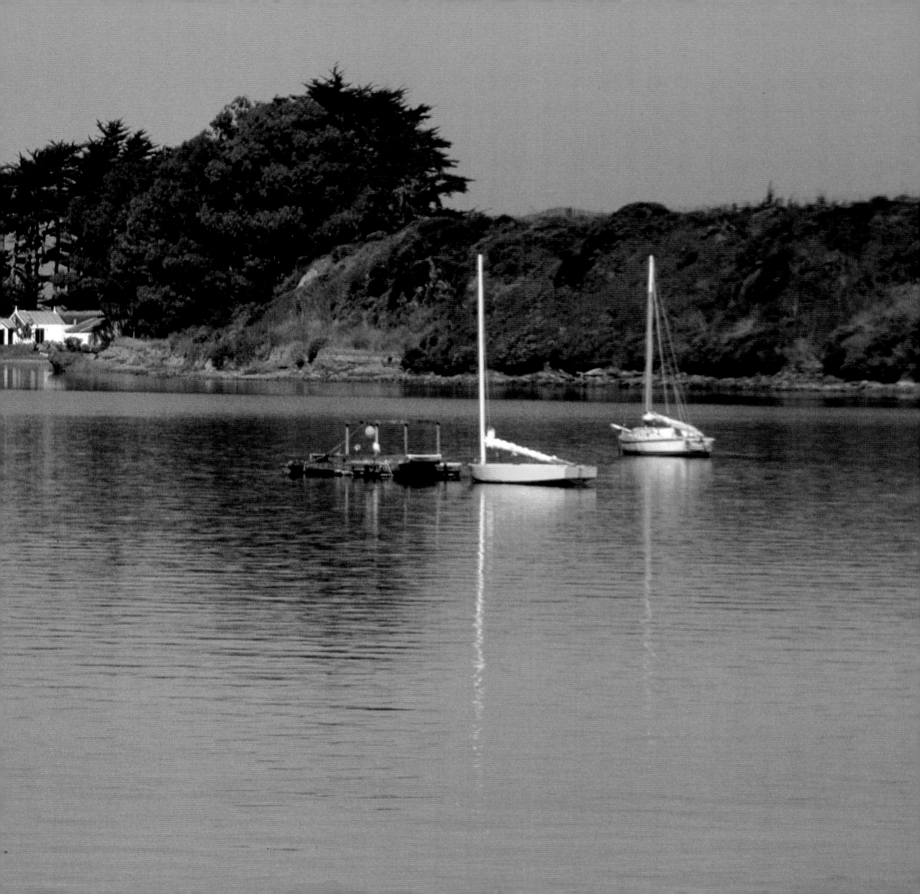

You can't get more far out than this—the awesome wilderness at Point Reyes, where Marin juts ten miles out to sea. Once earmarked for subdivisions, later designed as a multiuse park, Point Reyes National Seashore is nature in the raw, sixty-five thousand acres of surf-pummeled beaches and windswept moors, sprinkled with wildflowers and wind-carved trees, home to jackrabbits, deer, and wild tule elk.

It is part of a seaside greenbelt that runs north from the Golden Gate Headlands all the way to the county line. Triangular in shape, separated from the "mainland" by the San Andreas fault, the peninsula is known as "an island in time." It is a landscape almost unchanged over hundreds of years, a stone's throw from curried suburbia.

Point Reyes' beauties aren't lost on the rest of the world. More than 2.4 million people visit the peninsula park every year to hike, to camp, to eyeball the views, and to get a taste of what life must have been like before white men came more than four centuries ago.

The Indians lived here first; the number of Indians on the peninsula then was larger than the whole population there now. Coast Miwok lived in small settlements of tepeelike bark houses; they hunted deer, elk, bears, and mountain lions, fished in the bays from rush canoes, and took clams and mussels from the sea.

In 1579, the English pirate-explorer Sir Francis Drake landed here—historians still argue exactly where—in the ship *Golden Hinde;* he built a small fortress on the shore and readied his ship for the long voyage home.

The Indians crowned Drake with a cap of feathers. To a post in the ground he tacked a plate of brass, taking possession of the land for Queen Elizabeth. He named it Nova Albion (New England), perhaps reminded of home by the white cliffs of what is now Drake's Bay, perhaps inspired by what his chaplain described as "thick mists and most stinking fogs."

A visitors center at Drake's Beach claims Drake's Bay as his landing place, but fanatics of other persuasions say he landed at Bolinas Lagoon, Agate Beach, Bodega Bay, or San Quentin Point.

The Indians met the white man again in 1817, when Franciscan friars established the mission at San Rafael and recruited Coast Miwok as workers and Christian converts. Many died of smallpox, and when the missions were secularized and the Indians freed, many more died of starvation.

The Indian culture was nearly wiped out, leaving behind only burial grounds and middens. But near park headquarters, Indian descendants and devoted volunteers have brought back to life a Miwok village called Kule Loklo, complete with bark dwellings, an underground "sweat house," and a ceremonial log roundhouse where males once danced and shamans practiced their secret arts.

Today, the Indian descendants celebrate life with a Big Time dance festival at Kule Loklo the third weekend of every July. They hold a Strawberry Festival in spring and an Acorn Festival in fall. Outsiders may come, but the Indians are completely in charge.

Kule Loklo is near the headquarters of the National Seashore in Olema. Walking trails radiate out from the Olema Valley, across the pine-covered Inverness Ridge, and through lush meadows and forest peaks to the lonely reaches of scrub that extend along the sea.

The roads across the point are narrow and winding, but they reach into magical places: the Point Reyes lighthouse, on a promontory 600 feet above the surf; Chimney Rock, at the entrance to Drake's Bay; Pierce Point, where herds of tule elk are being reestablished after huntsmen killed them off years ago.

From the main road, there are two access roads to Great Beach, the eleven-mile stretch of whitish sands that stretch from the lighthouse north. Walking paths lead off the Pierce Point Road to Kehoe Beach and Abbott's Lagoon. McClure's Beach is down a steep trail at its end.

These beaches are wild, full of salt spray and driftwood and the cries of gulls. Signs warn against swimming and list the dangers—perilous tides, "sneaker" waves, and great white sharks close to the shore.

Here and there on the peninsula are unique signs of civilization. Johnson's Oyster Farm is on the shores of Drake's Estero. At the AT&T station on the road to the lighthouse, radio transmissions are heard from all parts of the Pacific. On most of the Point Reyes Peninsula, however, civilization is a sometimes thing. The ranches are almost all that remain.

After the missions were secularized in 1834, Mexican governors divided the peninsula into two giant land grants—Rancho Punta de los Reyes and Rancho Tomales y Baulenes. After the American conquest of 1846, most of the land ended up in the hands of two brothers from Vermont, Oscar and James Shafter, plus Oscar's son-in-law Charles Howard. The Shafter-Howards began leasing the lands for dairy farming. Today's Nunes and Mendoza ranches were established in 1859. Ships carried their ranch butter and live hogs from Drake's Estero to San Francisco.

Beginning in 1865, a stagecoach ran twice a week between San Rafael and Olema. Olema flourished. North Pacific Coast Railroad trains arrived in 1875, and James Shafter, looking for quick profits, sold lots on the shore of Tomales Bay to create the town of Inverness. The Shafter-Howards also had other bright ideas for the land: they plumbed it for oil and gold; they set up sportsmen's clubs and sold memberships; they envisioned (but never built) a massive development on Drake's Bay.

During Prohibition, the peninsula became a haunt for rumrunners; Pretty Boy Floyd made regular runs from Sausalito to buy whiskey from Canadian

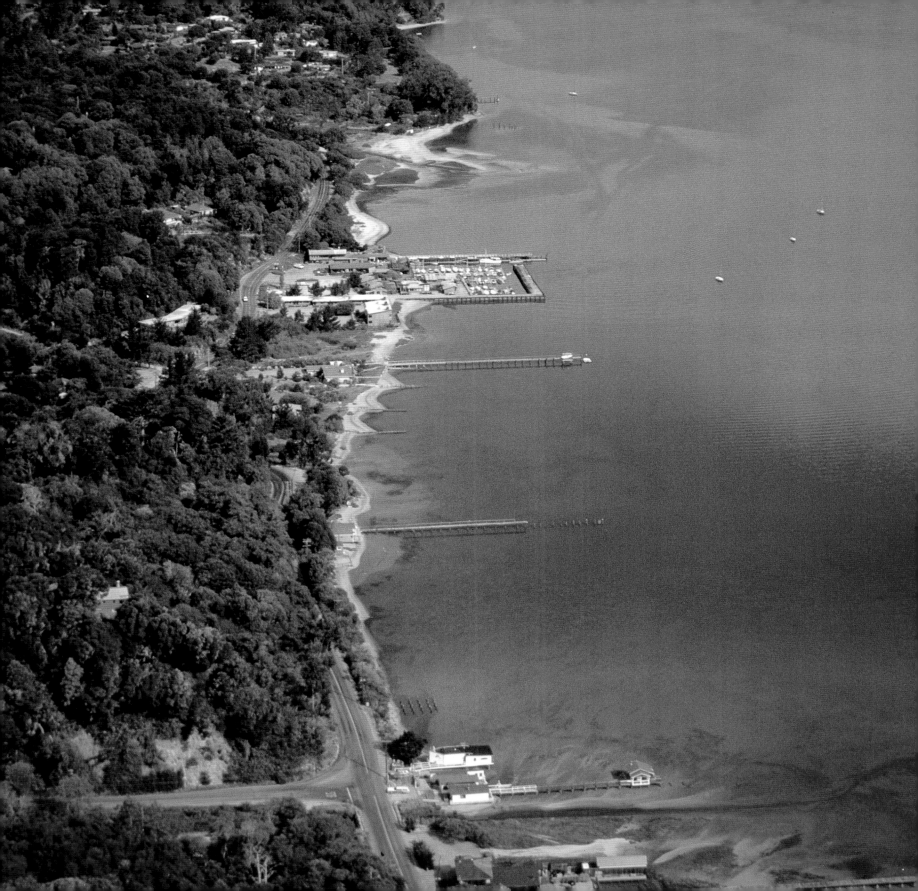

The Inverness Yacht Club and other

piers jut into Tomales Bay

in this aerial view

of Inverness. (Previous page)

Low tide strands boats on the Inverness

shore of Tomales Bay. (Top)

The southern tip of Point

Reyes peninsula is visible in this view

of beaches that reach north

to Tomales Bay. (Bottom)

Light and shadow pattern the hills near

Point Reyes Station. (Opposite)

ships offshore. In the 1930s, a Los Angeles syndicate planned to turn it into a posh subdivision—deluxe houses, polo grounds, a golf course—but their plans were thwarted by World War II.

The idea of a park on these lands had first surfaced in the 1930s, but conservationists say it is a miracle that the land was still there, still wild, when the park finally became a reality in 1962. By then, loggers were already cutting on Inverness Ridge, and surveyors were marking off lots above Limantour Spit. Credit for saving the seashore as a park is given to Congressman Clem Miller, U.S. Senator Clair Engle, State Senator Peter Behr, and thousands of enthusiastic conservationists.

Most Marin residents (aside from developers) favored a park, but many ranchers opposed it. Environmental writer John Hart, in *Wilderness Next Door,* quotes a ranch wife: "Every bit of that land was acquired by the sweat of the brow. If they take my land for defense, well, you have to sacrifice. But for recreation?" She was horrified. Ultimately the ranchers sold their lands, but negotiated long-term leases so they could continue farming.

Originally the park was planned for intensive recreation, including motor boats, camping, trailers, and dune buggies. But acquisition of the land was held up due to lack of funds, and by the 1970s, sentiment had swung toward preserving it as a wilderness. Today the only camping is at hike-in sites for backpackers. Horses are allowed; dune buggies aren't.

Anyone who has ever looked for shells or driftwood on Kehoe Beach, or seen seal pups on the rocks near the lighthouse, or driven the lofty ridge looking down first at the ocean and then at Tomales Bay—anyone who has tasted the life-giving joys of this untamed land—is humbly grateful for the experience. Point Reyes National Seashore is the favorite recreation ground for millions of people. It is, as County Supervisor Gary Giacomini puts it, "the lungs of the Bay Area."

EARTHQUAKE COUNTRY

You can love Marin and be scared of living here at the same time. Marin is in earthquake country—as old-timers will tell you, and as the Point Reyes peninsula proves. Here, where the peninsula juts out into the ocean, is where two giant portions of the earth's crust meet and continually glide past each other.

Millions of years ago, Point Reyes was attached to the continent three hundred miles farther south. It keeps moving northward, about two inches a year. In 1906, it moved twenty feet in a few seconds. Evidence of the great San Francisco earthquake can still be seen on the Earthquake Trail near the park headquarters—two parts of a fence moved six yards apart. The San Andreas fault, the juncture of the two tectonic plates, runs southwest under Tomales Bay, the Olema Valley, and the Bolinas Lagoon. It crosses the county and the San Francisco Bay.

Medium-force quakes occasionally send shivers through the populace. Newspapers warn repetitively of the Big One to come, and predict that the county will break off in the sea. But few people are scared enough to leave. Most willingly put up with an earthquake or two, to stay in their private paradise.

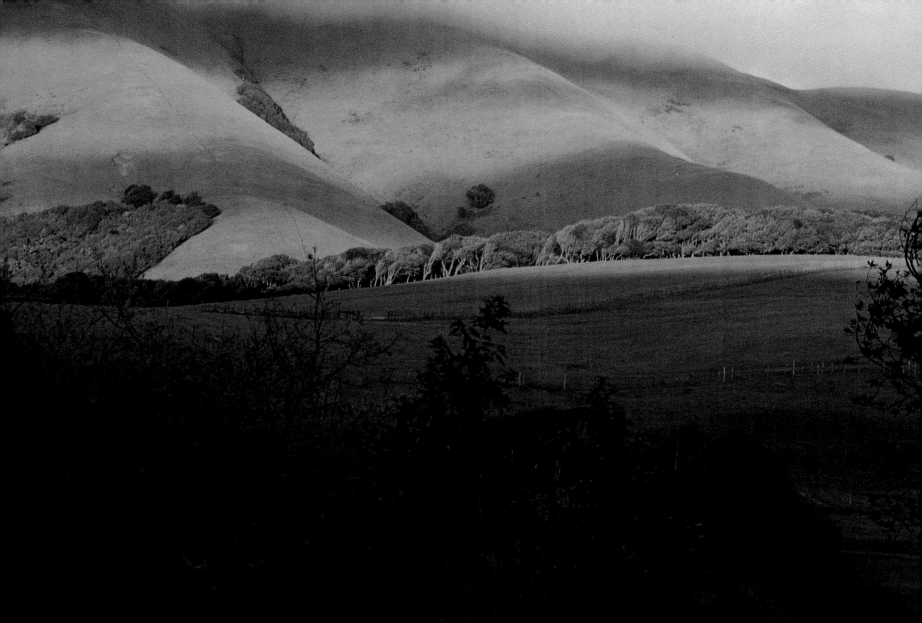

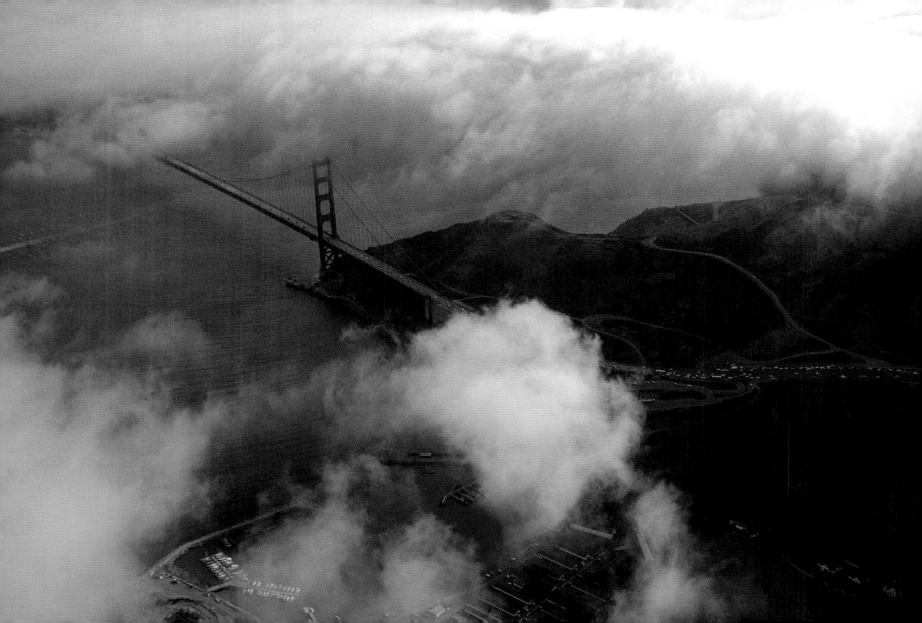

THE FOG | THE LIGHTHOUSES

Fog is at once a curse and a blessing. In Marin it's sometimes so thick you can't see five feet in front of you. It slows traffic to a crawl. It lops off the top of Mount Tam. On those days you beg it to go away. But other days it rolls in so artfully that you watch it with awe and delight: it reaches fat white fingers through valleys that were sunny a moment before, or sends cottony cascades down hillsides that are otherwise clear as a bell.

The fog that can be so beautiful can also bring the moisture that alleviates months of dry weather or gives needed nourishment to Marin's precious redwoods. Coastal redwoods won't grow without it.

Marin's most famous fogs occur in summer. Off the coast, the air cools as it moves over the cold water of the California Current. Moisture in the air condenses and forms a thick bank of fog atop the water. Topography and meteorology combine to suck this fog onshore.

In the American Southwest, in summer, high temperatures create a large low-pressure area that reaches all the way to the Mojave Desert and California's Central Valley. The fog layer at sea moves into the low pressure area inland. As meteorologist John Monteverdi of San Francisco State University told the *Marin Independent Journal:* "Low-pressure areas create a vacuum—and nature hates a vacuum." As the fog moves inland it flows like water, over the tops of hills and around the hills, into valleys. It persists until the inland areas are cooled, and does not reappear until the heat again takes over, and a new vacuum is formed.

Fascinating as it is to watch, welcome as it is in hot weather, the fog has its down side. Ships must navigate the tricky Golden Gate with only radar to guide them; cars are all but helpless when fog smothers the roads. People who love California for its sunshine curse and shiver under the woolly blanket. Didn't Mark Twain say the coldest winter he ever spent was summer in San Francisco?

Certainly the fog is as much a part of the Bay Area reality as the sunshine. Even tourists who have come to see the Golden Gate Bridge are fascinated when the fog pulls its disappearing act. They may fail to see the bridge, or Mount Tam, or the panoramas they have read about in their guidebooks, but they still have something to write home about: our fog is famous, too.

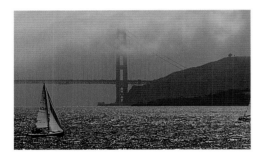

Fog all but obscures
Fort Baker and the Golden Gate
Bridge. (Previous page)
Point Diablo light station. (Opposite)
Point Bonita lighthouse in storm
and sun. (Top and middle)
Fog pours through
the Golden Gate. (Bottom)

THE LIGHTHOUSES

Point Reyes is said to be the foggiest place in North America. Earlier in history, the Golden Gate was the most hazardous harbor entrance in the country. That explains the existence of Marin's lighthouses—Lime Point, Point Diablo, and Point Bonita inside the bay; Point Reyes lighthouse on the far-out peninsula. They warn seafarers of the rocky coast that has shattered more than its share of ships.

During the heyday of the Gold Rush, before the light was installed on Point Bonita, more than half the ships trying to enter the Gate were lost on the rocks. In the past hundred years, at least forty-six ships have sunk off Point Reyes. Even today, ships perish in the treacherous fog and tides. The lights are far from just a beacon for sightseers (though thousands drive to see them every year).

Two of the lighthouses are mundane in appearance if not location: Lime Point is a squarish installation to the east of the Golden Gate Bridge, its automated light attached to the fog signal building. Point Diablo's light, in a station that was never manned, is operated automatically from Lime Point. The other two are another matter: towered buildings that once held powerful lights, beaming off rocky shores. Today they are beacons for tourists.

Point Bonita lighthouse in the Marin Headlands sits on a precipitous upthrust of rock at the entrance to San Francisco Bay. At first it was located on the bluff higher up, but it was moved to get it under the fog. A steep path leads down a wind-scoured nearby hillside through a rock tunnel and over a bridge to the lighthouse itself. Once manned, the light now runs automatically, flashing every five seconds, rain or shine, daytime or darkness. It has been spotted eighteen miles out to sea.

From 1899 until the mid 1940s, a lifeboat rescue station operated from the nearby cove. Today the lifeboat station, the only one still operating in the bay, is based a few miles away at Fort Baker where the surf is a lot less dangerous.

Early on, the light was supplemented with a fog signal—a cannon, then a bell, a siren, and ultimately a compressed-air horn whose blast became famous in a soap commercial. It seemed to say "bee-oh" (for "body odor," which the commercial exhorted against).

The Point Reyes lighthouse is located on the last bit of land on the Point Reyes peninsula, down a 307-step stairway a quarter-mile from the road. From Christmastime through March, people come here to see migrating gray whales, en route from Arctic waters to the warm lagoons of Mexico. About twenty-one thousand pass by every year.

The lighthouse, established in 1870 and automated in 1975, was a hardship post for keepers and crew in the years it was manned. The point is plagued by fog for nine months of the year; winds sometimes blow at 130 miles per hour. Personnel were in constant melancholia or rebellion. In 1899, the lighthouse keeper recorded that his assistant had gone crazy and had been handed over for safekeeping to the constable in Bolinas.

In its day, the Point Reyes light was a marvel. It could be seen even farther than Point Bonita's, twenty-four nautical miles from shore. The old light station is still operable and is open to visitors, but its job has been taken over by a small, swiveling, decidedly unromantic beacon on a platform nearby.

A lifesaving station was established in 1889 on the Point Reyes Beach; historian Ralph Shanks, Jr. says the surf at Point Reyes may well be the heaviest in California. In his book *Guardians of the Golden Gate,* Shanks records the heroism of the surfmen, who sometimes had to haul huge carts of lifesaving equipment, including breeches buoys and Lyle cannons, for miles across the sands to get close to a shipwreck offshore.

The old station at Point Reyes, the last to operate on the Pacific Coast, is now a National Historic Landmark. Its marine railway and one of its lifeboats are still extant.

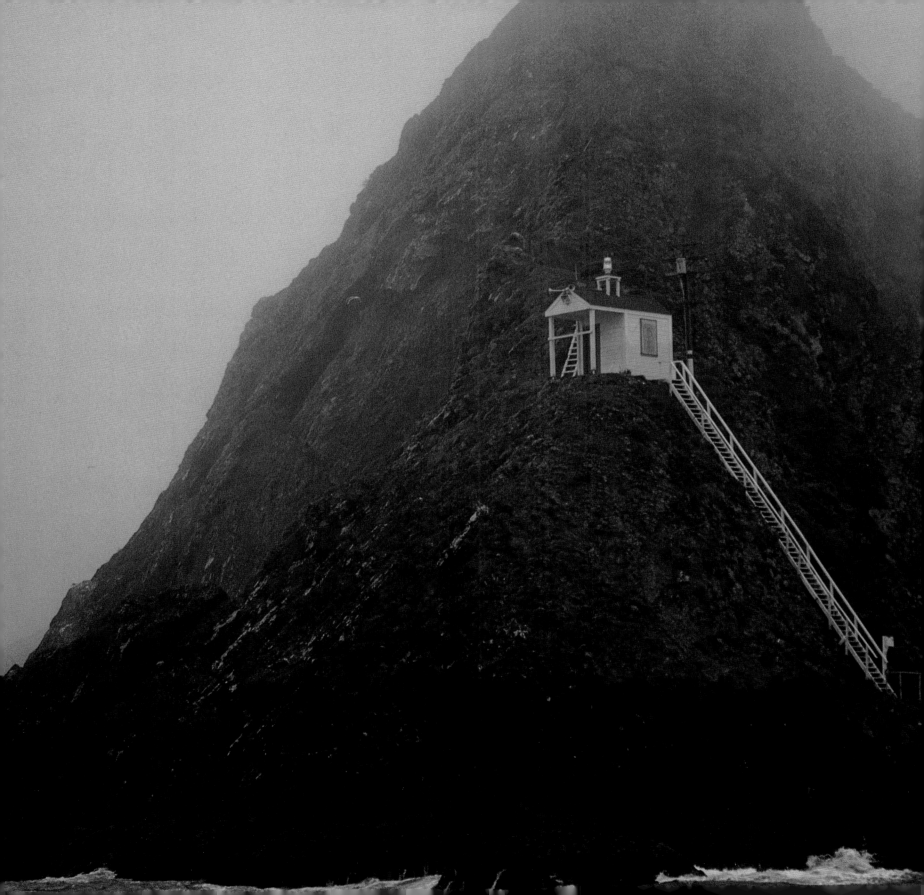

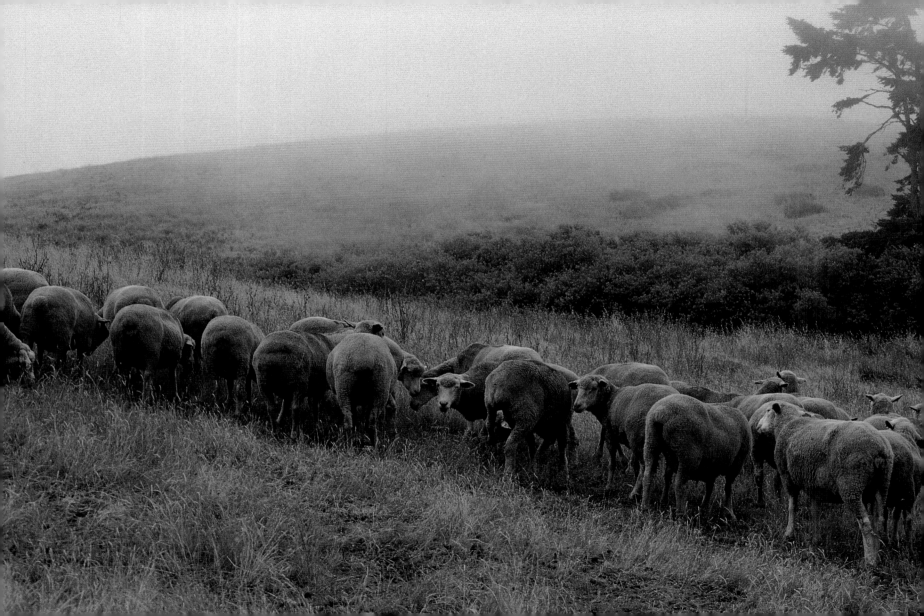

Rural Marin is more than its parklands and tiny coast towns. It's all the rest, too, not least the vast central area of hills and valleys and farms that separates the urban corridor of East Marin from the oceanside strip of the west. Back roads dip and wind through a wide-open landscape that could be Anywhere, U.S.A.

THE FARMLANDS

Sometimes all you can see here are fences, sheep, cows, or an occasional biker—an alien in Spandex tights and helmet. Hawks circle overhead. Red-winged blackbirds sit on weathered fenceposts in the sun.

The climate is ideal for farming, being mild and often sunny, with plenty of fog and moisture from the sea. The land is golden much of the year—resembling the rounded humps of camels or Hemingway's "hills like white elephants." In spring the grass is acid green and ablaze with flowers.

Here and there in the vastness is a farmhouse, a cluster of outbuildings, a pond. The land holds sheep ranches, dairy ranches, horse farms, and a couple of farms raising llamas.

The roads through the land are all "back roads," and on the remotest of them are three one-room schoolhouses, reminders of a past that is very much present. The schools look considerably alike—tiny wood-frame Victorians with bell towers on top.

This idyllic land does not exist by accident. Citizens and circumstances conspired to preserve it, despite pressure to fill it with cities. Saving the ranches is a big part of why Marin is what it is today—the best of suburbia next to a farm culture much as it was a century ago.

At one time, the ranchlands nearly went under. After World War II land was leaping in value, and the ranches were only marginally efficient and profitable. Ranchers began to think of selling out, taking "the last harvest" in money from developers who were ready to buy.

The founding of the Point Reyes National Seashore pushed the process along; county planners began to design a community to go with the park. A 1962 plan called for a sprawl of subdivisions and shopping centers, a population of 125,000 people. Six-lane roads were sketched in across the ridgetops from San Rafael to Point Reyes.

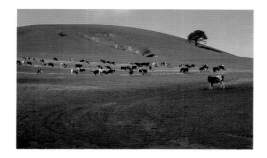

Sheep are accustomed to fog on ranches
near the coast. (Previous page)
Where every road is a backroad:
the rolling hills and pastures
of central Marin. (Top)
Hay bales and a weathered fence on vast
Marin pasturelands. (Middle)
Dairy cows graze in wide-open
farmlands. (Bottom)
A quail hunter braves early morning fog
in West Marin. (Right)

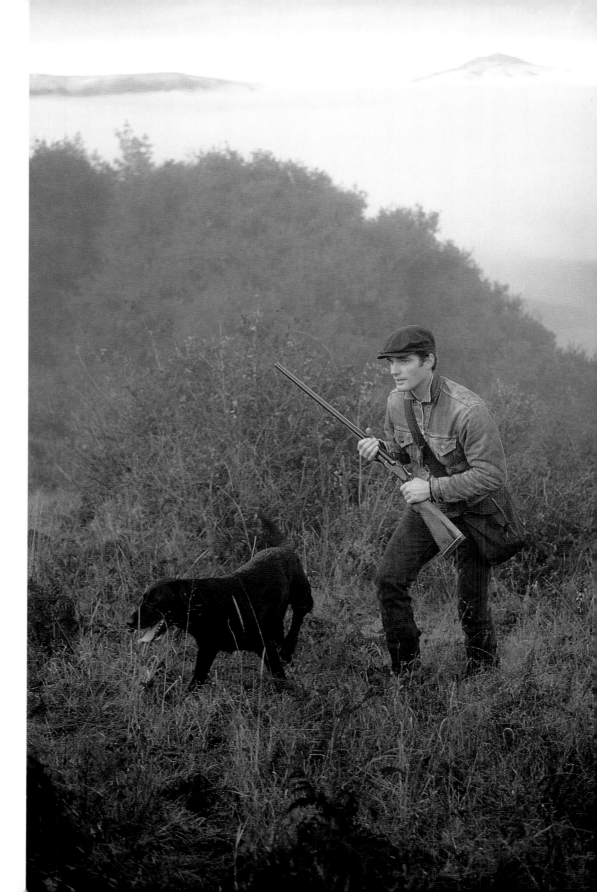

"People went crazy when they heard about it," County Supervisor Gary Giacomini told me, leafing through old maps and planning tracts over lunch in a Novato restaurant. "The (Golden Gate) bridge would have had to be twenty-four lanes wide."

By 1971, a forward-looking county government had drawn up a plan to conserve the environment. It cited "planning, with nature, for people, for the long run." The plan specified three distinct corridors: urban East Marin, the rural center, and West Marin, marked for recreation.

Ranchers, who saw their lands as their nest eggs, were appalled by the decision to ban high-density subdivisions. When the county implemented its plan with A-60 zoning (allowing lot sizes no smaller than sixty acres), ranchers chafed at the notion that politicians in East Marin were controlling their fate. But circumstances—including sympathetic environmentalists and some forward-looking ranchers—brought all sides together. In the drought years of the mid 1970s, when ranchers had to truck in water for their livestock, the county helped pay for it. In 1977, when a milk-price war threatened to drive ranchers out of business, county officials and environmentalists came to the rescue and lobbied for a price increase.

Ranchers began to see the benefits of A-60 zoning—land values didn't go down, they went up. The battle to save rural Marin appeared to be won.

A-60 zoning can be changed any day, however, by a vote of the board of supervisors.

"The terror I have," said Giacomini, "is that five years from now, it's all down the drain."

It hasn't happened yet, and Marin's sturdy environmentalists probably won't let it. A lesser danger worries some environmentalists; moneyed people have been buying sixty-acre "ranchettes," which, if they proliferate, could change the face of agriculture, too. That problem is being met in part by the Marin Agricultural Land Trust (MALT), which was founded in 1980 to raise funds and pay ranchers for their development rights, giving them the profits they would have made had they sold out to a developer but allowing them to continue farming their land. Little by little agriculture is strengthening its grip on the slopes of central Marin. At last census, the number of livestock on these lands stood in the thousands—4,700 beef cattle, 15,000 sheep, almost 13,000 dairy cows (Jersey, Guernsey, and Holstein).

Day to day, most Marinites probably regard the farmlands as little more than what they must drive through to get to their destination of choice. But in the long term, they place enormous value on the lore of these lands—the "roundups" of beef cattle in the spring, the annual sheep-shearing in northern Marin, the beauty of loneliness, and the rhythm of a life tied so closely to earth.

When they drive the back roads, they feel the pace slow, and their pulses quicken. This land is our land, they say, and it's one of the blessings that count.

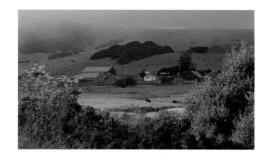

Dust swirls about a tractor as a farmer discs the fields. (Top) Lincoln School is one of three one-room schoolhouses still operating in Marin. In this one, the traditional bell tower is missing. (Middle) The last rays of the sun peek through fog at a dairy ranch near Lake Nicasio. (Bottom)

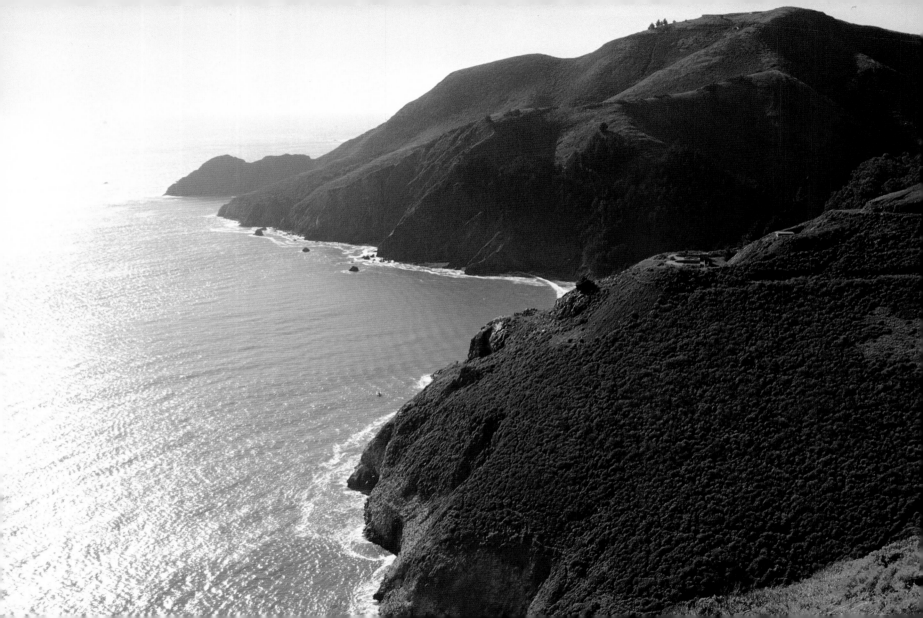

The Marin Headlands, a wild hunk of land on the north shore of the Golden Gate, has a world-famous view: the phantasmagoric sprawl of San Francisco, through the orange strands of the Golden Gate Bridge. This viewpoint is the southernmost beginning of Marin's famous "wilderness next door," the juxtaposition of untamed nature and the

THE HEADLANDS | THE ISLANDS

awesome creations of man. This is where visitors start saying "wow."

The Marin Headlands are part of the Golden Gate National Recreation Area, thirty-five thousand acres of public lands that skim the coastline from the southern reaches of San Francisco to Alcatraz Island and the cliffs of Marin. Notable views within the headlands themselves include Point Bonita Lighthouse at the edge of the sea and the beach at Fort Cronkhite, where long combers unfurl and pelicans cruise overhead.

An hour in the headlands is a minivacation, a respite from the urban pace. It can be seen on foot, by bike, by horseback, or by car. Some visitors ask no more than the spectacular view of San Francisco, which extends beyond to Half Moon Bay in the south and to Berkeley and Oakland in the east. But the headlands have lots more to offer. Generations of kids come to visit the hidden coves reached by almost impassable trails; they camp on the shallow beaches and watch huge cargo ships glide out the Gate. History buffs are drawn by the old tunnels and fortifications that once guarded the harbor entry. The guns are gone but the bunkers remain.

Markers tell the lonesome story of the crews that manned the batteries from the Spanish American War to the height of the Cold War. In the 1850s, cannons were trained on the Gate, ready to sink incoming enemy ships; in the 1940s, huge guns practiced firing seventeen miles out to sea; in the 1950s, Nike missiles lined up on a concrete launch pad, ready for global war. When the last guns were scrapped, Gillette bought some of the metal and used it for razor blades.

One marker proclaims what few visitors know. This passage to glory wasn't named for the orange-colored bridge, but for the vision of pioneer John C. Fremont, who mapped the area in 1848: "Between these points is the strait about one mile broad in the narrowest part and five miles long from sea to bay. To this gate I gave the name Chrysopolae, or Golden Gate."

The geographical headlands really begin at East Fort Baker a swath of greenery that lies, mostly hidden, next to Sausalito and the northern pillar of the Golden Gate Bridge. Among the deserted army buildings is a children's Discovery Museum, a fishing pier, and a tiny yacht harbor. The headlands rise up from here, extending along the edge of the Golden Gate all the way to the ocean. Scrub and wildflowers blanket the otherwise barren hills. Once there were huge dairy ranches on this land; a couple of generations ago, the army was here in force. A few whitewashed buildings, some in mournful disrepair, are all that remain of Forts Barry and Cronkhite. A few old barracks and storehouses have been converted to peaceful uses: the Headlands Center for the Arts, where resident artists find creative solitude; Chris Hardman's Antenna Theater, where avant-garde plays are designed; and the youth hostel, where travelers lay down their backpacks and spend a few hours by the sea.

Near the Point Bonita Lighthouse, which sits like calendar art at the rocky entrance to the Gate, is the Point Bonita Conference Center. Farther west, above Rodeo Lagoon, is the Marine Mammal Center, where largely volunteer crews minister to injured seals, sea lions, whales, and porpoises and then give them back to the sea.

Rodeo Lagoon is a marshy stretch of water a short stroll from the beach near Fort Cronkhite. Birdwatchers come here to spot grebes, loons, shearwaters, willets, and turkey vultures, tanagers, ravens, and sparrows.

Higher up in the headlands bird fanatics find nirvana from late August to early December. on Hawk Hill they can watch birds of prey—ospreys, kites, eagles, and falcons—on their annual migration from Alaska to as far south as Argentina. More raptors fly over Hawk Hill than over any other lookout point in western North America.

Nature lovers can easily become besotted on a tour of the headlands, which look out at a National Marine Sanctuary, home to an incredible variety of sea life: salmon, herring, clams, and crabs; humpback whales, harbor porpoises, sea lions, and elephant seals. The Farallone Islands, twenty-five miles off the coast, provide one of the largest seabird nesting sites in America.

Preserving this wilderness was not easy. Once a city of eighteen thousand, to be called Marincello, was proposed for the headlands, and offshore oil drilling has been an ongoing hazard of modern times. A vigilant citizenry and some visionary politicos teamed to keep it forever in public hands. Marincello died in the face of relentless opposition. In 1972, the Golden Gate National Recreation Area was created, largely from surplus military land, to become one of the first great urban parks of our nation.

THE ISLANDS

Angel Island, they say, contains all the beauty of the Bay Area in one square mile. On the Marin mainland, it's here-a-view, there-a-view, most of them sensational, but from Angel Island you get every view there is.

"Get ready to blow your mind," said docent leader Sharon Callahan, preparing to show off Angel Island. From the 781-foot plateau atop Mount Livermore, visitors get a 360-degree look at the whole Bay Area, from the Richmond Bridge around all of the East Bay to San Francisco and the Golden Gate, past Sausalito to Belvedere, Tiburon, and San Rafael and back to the Richmond Bridge.

Angel Island is an oasis of greenery less than a mile off the coast of Tiburon. It is reachable by ferry or private boat and is used by two hundred thousand visitors a year—picnickers, hikers, bicyclists, and campers. Beyond Ayala Cove, where the ferry lands, a road orbits the island and connects with two walking trails. The island has hidden coves, beaches, sunny meadows, and groves of trees. Its beauty, particularly in the sweeping water-filled views, would more than justify preserving it as a park, but it is a trove of history besides.

The island was first a refuge for Coast Miwok Indians, who fished and hunted offshore. In August of 1775, Juan Manuel de Ayala, a lieutenant from the Presidio at Monterey, became the first European visitor; he anchored his ship in the cove while his crew mapped San Francisco Bay. He named the island for Our Lady of Angels.

After 1808, Russians from Fort Ross came to the island seeking otter. In 1814, a damaged British sloop, the *Raccoon,* was careened on the shore, giving its name to the Raccoon Strait.

The Mexican government in 1837 gave most of the island as a land grant to Antonio Maria Osio, and he used it for five hundred cattle.

The island has a long military history. Camp Reynolds was established during the Civil War to protect San Francisco from attack, and during the Spanish-American War three gun batteries were built looking out to the Gate. The empty gun emplacements remain today. So does Camp Reynolds, lacking its old barracks but looking much like its old self, with a commandant's house, officers quarters, one fully restored home, and a bake house. On the parade ground every weekend a Civil War cannon is fired.

Fort McDowell was built in 1910, and it became a major induction facility and a processing station for soldiers going overseas. During World War II it was the largest processing station in America, handling seventy thousand men in 1942 alone.

After 1892, Ayala Cove became a quarantine station for ships arriving from foreign ports. The USS *Omaha* fired up its boilers in the cove, then, after passengers had gone ashore, shot steam into the ships, killing rats and vermin on board. Passengers suspected of carrying contagious diseases were detained at the station, which had both a hospital and a crematorium.

Perhaps the most poignant buildings on the island are those that remain of the old immigration station, which operated from 1910 till 1940. The "Ellis Island of the West," Angel Island received a

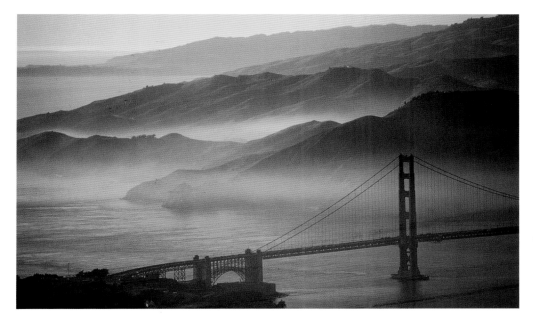

Headlands form a dark outline against the ocean on a winter afternoon. (Previous page) The Marin Headlands are bathed in late afternoon sun and fog: a view from San Francisco. (Top) Pleasure boats are a familiar sight in Hospital Cove, Angel Island. (Bottom)

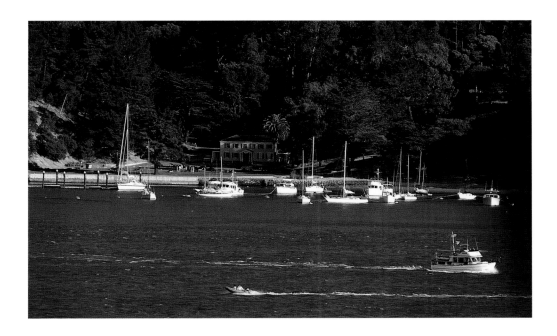

The Marin Islands
are silent outposts in the bay
near the east shore
of San Rafael. (Above)
West Marin Island is
a rich breeding ground
for herons and egrets. (Opposite)

flood of immigrants, many from Russia and Japan, most of them from China. Old records, and poems carved in calligraphy on the walls of the detention center, tell the sad tale of the many Chinese who were detained on the island for months and years, victims of Chinese-exclusion laws.

During World War II the immigration station became a prisoner of war camp, where hundreds of Japanese and some German POWs were interned. The first prisoner of war at Angel Island—the first-ever American prisoner of World War II—was Kazo Sakamaki, who was captured in Hawaii when his two-man sub ran aground on Pearl Harbor Day.

Docents spin boggling tales of island history—about the Army's first black chaplain, Lt. Col. Allen Allenswood, who was stationed here at the turn of the century and later built a whole town near Bakersfield; about Juliet Nichols, the lighthouse keeper who rang the fog bell by hand when the mechanisms broke, twenty straight hours one day, twelve hours two days later. History is everywhere on the island, even in the deserted launch pads where Nike missiles squatted throughout the 1950s. But for most, the lure of the island isn't history, it's location, location, location. Nowhere else in the Bay Area are there views to compare with these.

When the U.S. government declared the island surplus after World War II, a band of concerned citizens persuaded the State Parks Commission to acquire it. In 1958, Mount Ida at the top of the island was rechristened Mount Livermore to honor Caroline Livermore of Ross for her role in making it a park.

Angel Island is the big brother of Marin's two other offshore islands, East and West Marin Islands, which can be seen from Mount Livermore. The Marin Islands lie off the shore of San Rafael, north of the Richmond Bridge. They are much smaller than Angel Island, and for decades were extremely private.

History suggests that it was to these islands that Chief Marin and his Indian ally Quintin fled after the 1824 insurrection at the San Rafael mission. Quintin was captured here; Marin was not.

The islands later belonged to the U.S. government and were tailored for military use. In the early days of San Quentin Prison, until at least 1862, 150 prisoners lived on the larger island, quarrying rock for government use. At least one inmate and one officer were killed in escape attempts.

In 1927, Crowley's Harbor Tug and Barge Company, owned by Thomas Crowley, Sr., bought the tree-crowned islands for twenty-six thousand dollars. Oak and buckeye trees and poison oak were the primary vegetation at the time. Crowley planted palms and fruit trees and Monterey pines, and he hauled fresh water to the islands to sustain the plantings.

On ten-acre East Island, Crowley built a small steam railway to carry building materials eighty-five feet to the top, where he built a one-bedroom, two-bath stone house that his family occupied summers. Later Tom Crowley, Jr. hired a ship's carpenter to build a second house, a remarkable construction of redwood and teak with no nails. In 1983, the Crowleys offered both islands for sale for $4.25 million.

Meanwhile tiny West Marin Island (three acres) had been acknowledged as the richest breeding ground for egrets and herons in the North Bay. Wildlife officials say that East Marin Island could also become a nesting area if it reverts to its natural state. Through donations from public agencies and private individuals, the two islands were purchased in 1992 and are now under the protection of the California Coastal Conservancy in permanent open space.

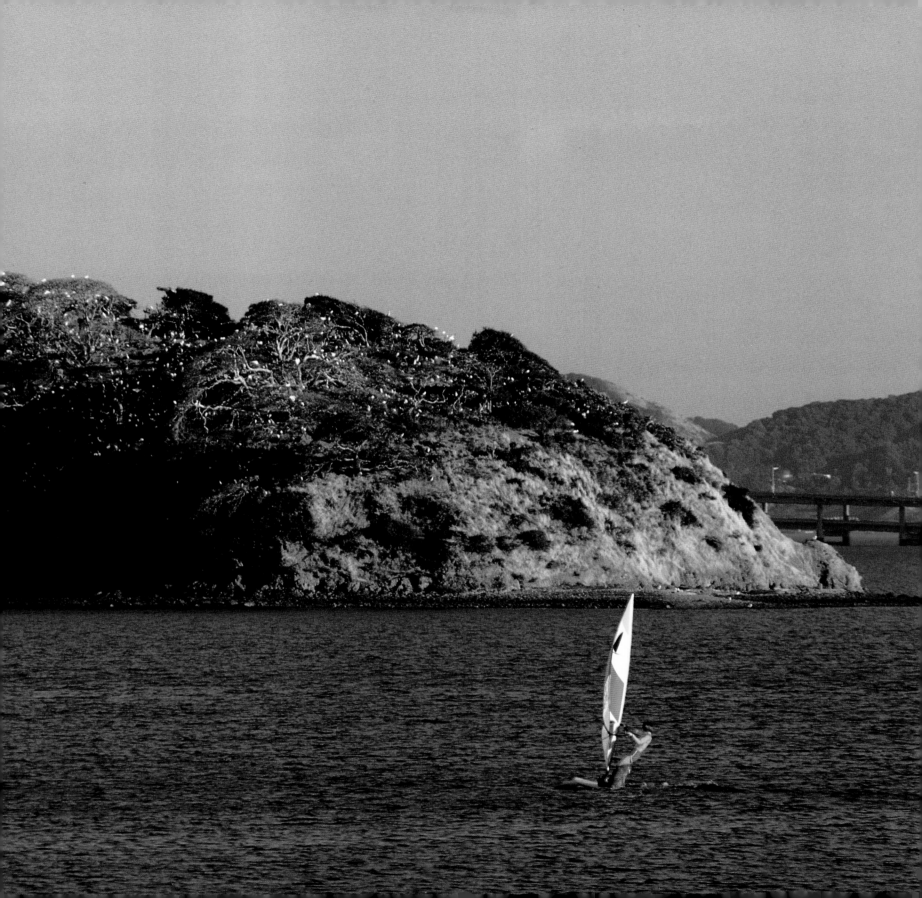

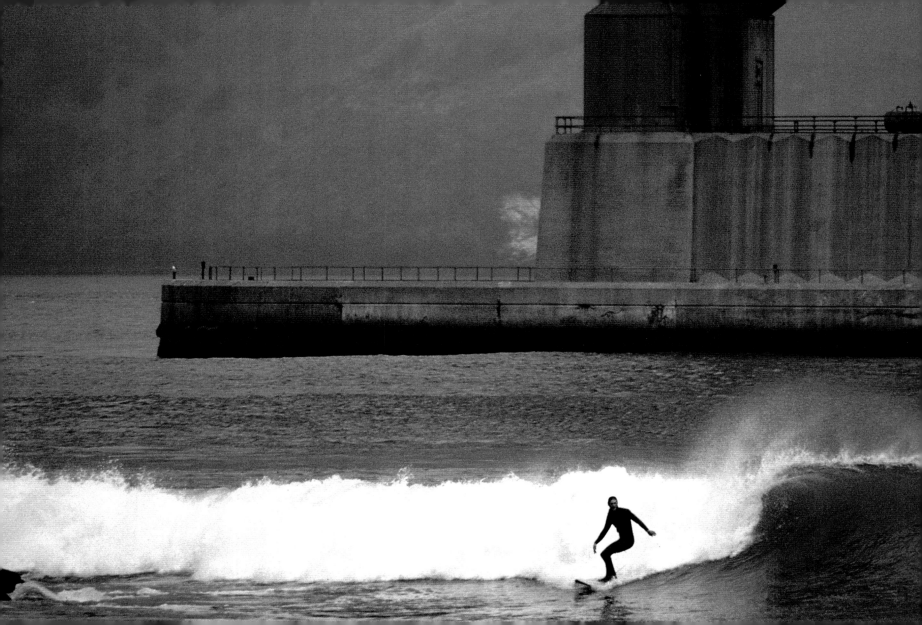

Wherever in the world a Marinite may travel, people will know where he comes from. North of the Golden Gate Bridge? Of course! The most famous bridge in the world! Marin starts at the north pier of the Golden Gate Bridge, a fitting portal to the ballyhooed county beyond.

THE BRIDGES

One joy of the bridge is you can have it both ways—driving north on Highway 101 toward the unmarked Marin hills, or driving south, when you first see the bridge through the Waldo Tunnel. Crossing the bridge is mind-altering, a vision of cities and islands and water and sky. On the one hand is San Francisco and the cities around it; on the other is the Pacific Ocean, rolling endlessly toward the Far East.

The bridge is a view in itself, its orange minarets rising out of the water and its profile a study in grace. Other bridges are gray, but this one is gloriously bright, an orange contrast to the blue water, the white city, the green hills. Below the bridge are the boats—sailboats and fishing boats, ocean liners, cargo ships, and submarines. Tall ships sail in here like ghosts from the past; in 1975, a new *Golden Hinde* arrived from England. The walkways are often full: pedestrians and joggers on one side, bicyclists on the other. Japanese visitors take pictures of each other posed against one of the towers. Bus tours pause on the Marin end of the bridge, at Vista Point, to catch a view of the city, an incoming ship, or an unfurling bank of fog.

This glorious bridge is the culmination of a dream that began before World War I and became reality at the height of the 1930s Depression. Emperor Norton, a comic and legendary figure of San Francisco's Gold Rush years, decreed that a suspension bridge should be built as long ago as 1869. But the first real agitation for a bridge came in 1916 from a Marin newspaperman, James Wilkins, who commuted to San Francisco on the ferry, the only transportation then available. Whatever enthusiasm he aroused was dampened by World War I, but he revived it soon after. In 1919, the city attorney of San Francisco invited three engineers to submit designs for a bridge, among them Joseph Strauss of Chicago.

Strauss's first design was an ugly one, or so says Tom Horton, who in his book *Superspan* describes it as "jarringly alien to the great natural beauty of the land and the sea." But enthusiasm for a bridge was growing. In 1923, Governor Fred W. Richardson signed a bill authorizing a tax district to pay for a bridge.

It's hard to believe now that many opposed it. The War Department worried that if bombed by an enemy a bridge would block the bay. Purists worried that the beauty of the Gate would be ruined. Skeptics worried that a bridge would be doomed to collapse in an earthquake. Still others said that with Marin so sparsely settled, who needed a bridge anyway?

The Depression itself almost killed it. Though the bridge would provide many jobs, there was a long time when no one would buy the bonds to finance it. At last A. P. Giannini, founder of the Bank of America, stepped forward. "San Francisco needs that bridge," he said. "We will take the bonds." Construction began in January 1933.

The long delay conspired to create a more beautiful bridge. Engineering advancements by then made a clear-span suspension bridge possible, replacing Strauss's first cumbersome design. It was possible, but not easy. Building the bridge was an awesome undertaking: 6,450 feet of construction over one of the most treacherous stretches of tide in California, where fog was a frequent companion and winds blew at forty miles an hour.

The saga of construction is recorded in numerous black-and-white photos of the time. First came the anchorages, then the miraculous towers, then the gracefully looping cables, which sewed two counties together. Little by little, thanks to know-how and courage, a road was laid over the abyss.

Eleven men died in four years of construction, ten in one horrendous accident when the bridge was almost done. A scaffold under the roadbed collapsed and fell into the safety net; the net tore and twelve men fell in the water. Incredibly, two survived.

The bridge opened to pedestrians on May 27, 1937, and two hundred thousand people walked across. Twenty-five thousand cars crossed the span the next day. Those days were, to quote Tom Horton, "the beginning of a celebration that has never ended."

The rest is history. Ten months later, Strauss, the visionary chief engineer, had died. By 1941, the ferries had gone out of business. By 1961, the bridge was already overcrowded, and civic leaders talked of building a second deck or another span.

Traffic on the bay had come full circle by 1969. To ease gridlock on the bridge, the Bridge District went into the ferry business. The first ferry went to the Ferry Building from Sausalito, and in 1977, three ferries and a twenty-five-million-dollar ferry building were added at Larkspur Landing.

The bridge is virtually unchanged since its opening, except for earthquake strengthening underneath (1952), new suspension cables (in the mid-1970s) and a roadway replacement (in the 1980s). It is continuously being repainted. For its fiftieth anniversary, lights were added to the 746-foot towers, subtly highlighting their Art Deco design.

In the bridge's long history, it has been closed four times, in December 1951 and in the winters of 1982 and 1983, when gale force winds set it swaying ten feet from side to side and the roadbed undulated like a snake. It was closed again in May 1987 for a fiftieth anniversary party, when more than 800,000 people walked across it. More than 1,000 people—the total may never be known— have committed suicide from the bridge. At least a dozen jumpers have survived.

Marin has another huge bridge, though it less celebrated and much less traveled than the Golden Gate. When the Richmond–San Rafael Bridge opened in 1956, it became an immediate boon for tourists. Since then, they have been able to cross three world-class epic bridges while circling the San Francisco Bay.

The Bay Bridge, linking San Francisco with the East Bay, came first: it opened seven months before the Golden Gate Bridge, in November 1936. It is less spectacular, perhaps, than its more famous sister, but it is a well-loved presence in the bay, reaching gracefully from San Francisco to Yerba Buena Island, then on to the Oakland shore.

The Richmond Bridge has its admirers, too, but bridge historian Bob Halligan said some people hate it. "They say 'At the height of the Depression, they built two of the most beautiful bridges in the world. At the height of affluence in the 1950s, they built one of the ugliest!'" The Richmond Bridge, he said, "looks like a bent coathanger."

The five-mile-long bridge does lack the symmetry of the one over the Golden Gate, but it has a charm of its own, twisting roller-coaster style across the bay, veering here, swooping there. At night, when jeweled with lights, it rises like a vision from the water.

For years, the Richmond–San Rafael Ferry was the only direct transport to the East Bay. Long lines of cars waited an hour to an hour and a half for a berth on the cumbersome boat. The postwar boom made it urgent to speed up traffic. Support grew for a bridge after the Richmond–San Rafael ferry company was struck for the third time in three years. The Marin Board of Supervisors and the Richmond City Council agreed then to finance a study for a crossing, and after debate in the legislature over funding (and objections to its design), construction of the bridge began in 1953.

Two main spans, both cantilever types, cross two channels. To save steel (and thus money) the bridge dips in the middle, giving it a swayback look. When it opened, it was the second longest high-level steel bridge in the world. It remains one of the safest bridges in the world. Because it has two decks, there is no occasion for head-on crashes.

Because it has no pedestrian walkways, it has little allure for suicides. Although each deck has room

for three lanes, only two are opened, leaving a substantial shoulder for cars to pull off. The third lane may be opened one day soon, since ever-larger numbers of East Bay residents are using the bridge for access to jobs in Marin and Sonoma.

The shoulder was invaluable to Marin during the drought of 1976-77. A huge pipe was laid in that lane, carrying East Bay water to dried-up Marin. It stayed in service for a year but was later removed as a hazard to traffic.

The bridge has been closed only once. In the winter of 1982-83, the approach roads on the Richmond side were so badly flooded that cars couldn't get on or off the bridge. Heavy rains and collapsing hills had closed the Waldo Grade in Marin at the same time, shutting down much of the traffic on the Golden Gate Bridge. For twenty-four hours, Marin was cut off east and south. It was back to square one—back to the time when Marin lived in semi-isolation, before the outside world crossed its bridges and the new era of possibilities had dawned.

A surfer catches a wave

near the south tower of the Golden Gate

Bridge. (Previous page)

Runners race through the fog at dawn

on the Golden Gate Bridge. (Top)

The Richmond–San Rafael Bridge

zigzags across the water

from the East Bay to Marin. (Bottom)

The Golden Gate Bridge rises

out of the fog. (Page 120)

INDEX